THE MASTERS OF
NATURE PHOTOGRAPHY

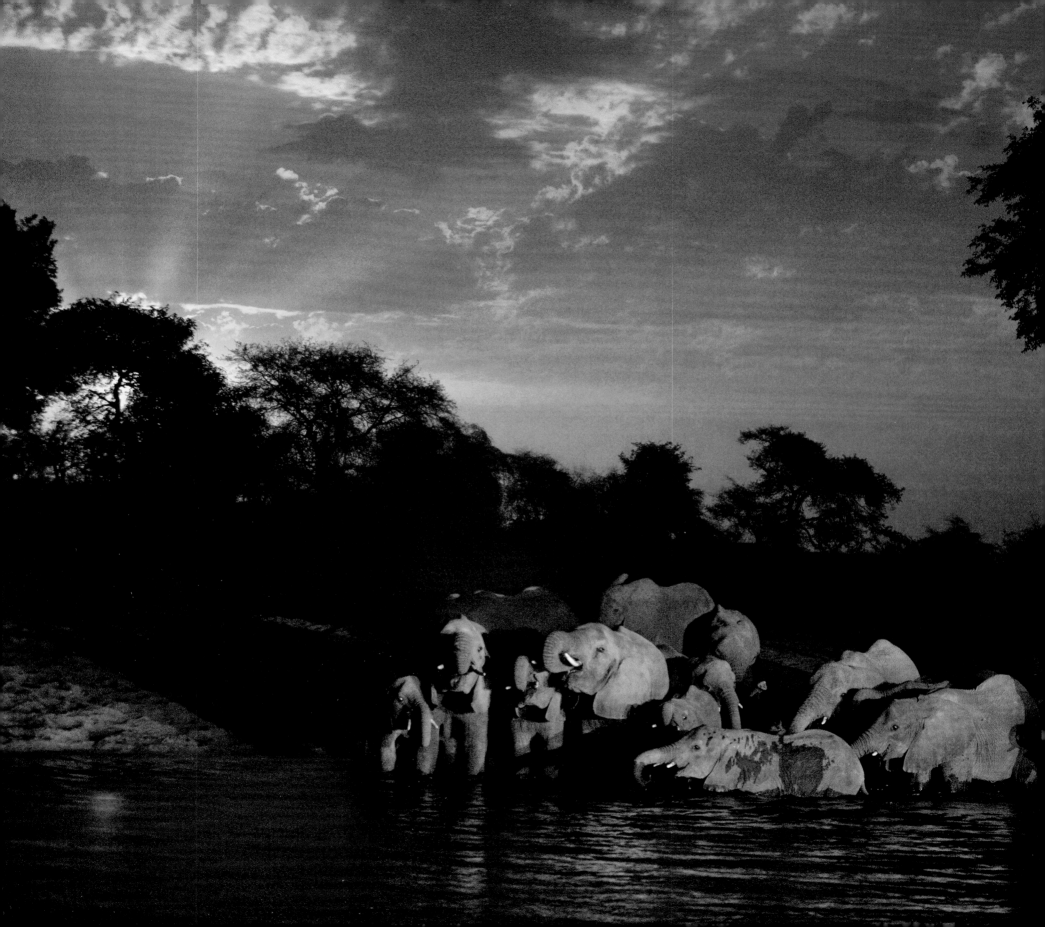

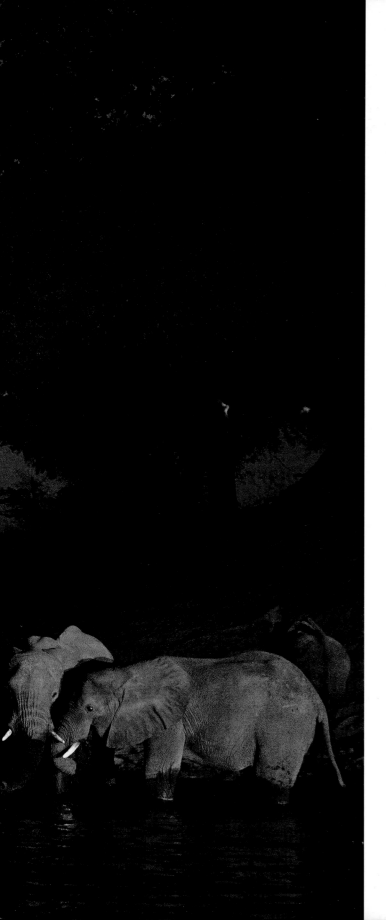

THE MASTERS OF NATURE PHOTOGRAPHY

ROSAMUND KIDMAN COX, EDITOR

JIM BRANDENBURG
DAVID DOUBILET
PÅL HERMANSEN
FRANS LANTING
THOMAS D MANGELSEN
VINCENT MUNIER
MICHAEL 'NICK' NICHOLS
PAUL NICKLEN
ANUP SHAH
CHRISTIAN ZIEGLER

FIREFLY BOOKS

CONTENTS

INTRODUCTION

The photographers whose work is exhibited in this book have three things in common. They have all chosen wild places and wild species as their lifelong subjects, they have all been honoured in the Wildlife Photographer of the Year competition, and they are all passionate about their art. Some of them are legends, others are younger masters, but all have a deep respect for their subjects and high ethical standards.

The 10 photographers have each chosen 10 of their images that they consider representative of their work. All would say that there are other nature photographers of equal stature, who like them have been honoured in the competition. But together these 10 represent a collection of work that spans 30 years, different nationalities and different ways of seeing the natural world. A number of them have worked in the heyday of magazine photojournalism in the 1970s and 1980s, when there was financial support for talented photographers, through magazines such as *National Geographic*. Today, photographers have to be self-supporting. Though the tools they work with are far better than in the days of film, tools are just tools. Knowledge and experience, and vision and passion, are still

the most crucial elements. All them say that spending intense periods of time in wild places, absorbing and watching, learning about light and animal behaviour and how to catch the moment have taught them more than any formal education. All of them, however, also say that the generosity of older photographers and access through books and magazines to the work of the other artists – photographers and painters – has inspired them.

Half of the pictures reproduced here were taken on film, when what could be captured was limited by both film speed and camera technology. The digital age has changed the photography of nature more than any other genre, particularly photography under water, where surfacing to change film after just 36 shots is no longer necessary. The speed of digital capture has resulted in photographs of behaviour never seen before, and digital sensors have allowed photography in the lowest light conditions. Being able to see the results instantly has been a liberation. Yet many of the pictures shot on film remain among the most beautiful and memorable.

Some of the 10 masters are the nature equivalent of street photographers, focusing

on the energy of the moment, others aim to encapsulate the emotion of the place or moment, others a painterly rendition of it, and many of them use their work to tell stories or convey messages. Their key works, though, all merit the label of art, not illustration. Yet in the world of art photography, those who choose nature as their focus and inspiration are seldom given the acknowledgement they deserve.

But the true reward for these photographers, whose reverence for nature fuels their passion, is the knowledge that their work can effect change through its beauty and originality, more so than any other genre of photography. They can show what will be lost through destruction of the natural world, can tap into human values and can lead to the preservation of wilderness as well as wild species. For photography, that is real power.

Rosamund Kidman Cox

Opposite: Impala, Serengeti National Park, 1985, by Frans Lanting.

Page 2: Elephants at moonrise, Zakouma National Park, Chad, 2006, by Michael 'Nick' Nichols.

Page 4: Reflections, Judd Lake, Minnesota, 2001, by Jim Brandenburg.

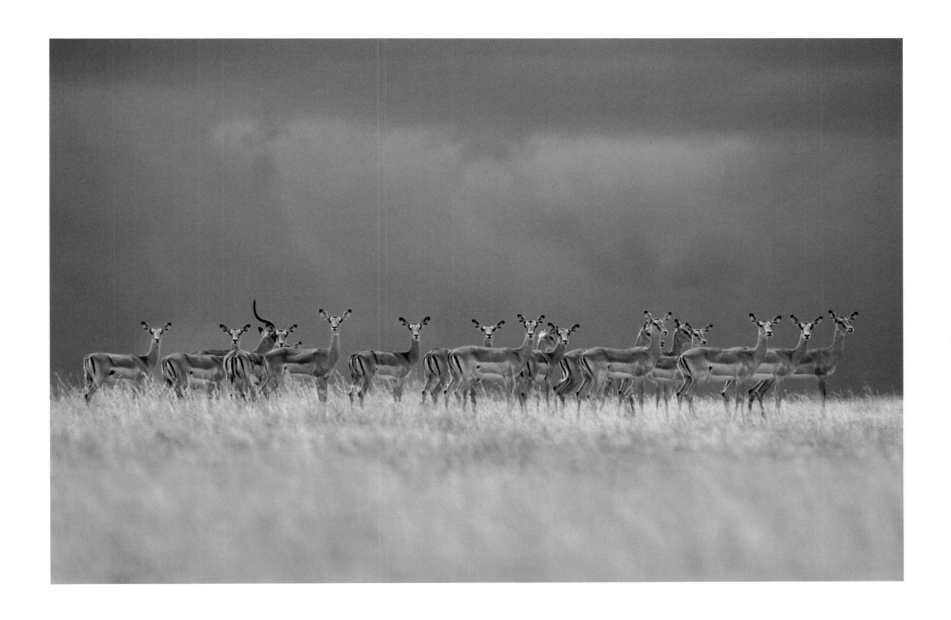

JIM BRANDENBURG

Jim Brandenburg describes his passion and the focus of his work as 'painting nature's beauty with a camera'. His art is his ability to convey the spirit of an animal or place – the wildness of it – with a skill that can transform a picture into a glimpse of an intimate story. It is this ability that has made him an inspiration to a generation of photographers, perhaps even more so in Europe than in his native USA.

His formal accolades are many. They include the Wildlife Photographer of the Year Award (1988), the National Press Photographers Association's Magazine Photographer of the Year award (twice), World Press Photo, a Lifetime Achievement Award from the North American Nature Photographers Association and the World Achievement Award from the United Nations Environment Programme. But he is not a photographer who enjoys the limelight, preferring to work alone and to immerse himself in a wild place.

Brought up on the tall-grass prairies of Minnesota, Jim regards the wide-open spaces of the prairie as his true classroom. He took his first wildlife picture aged 15 – a portrait of a prairie fox – with just a $3 plastic camera but using practised fieldcraft to get close.

He describes the discovery of 'the magic and mystery of capturing the likeness of a wild animal with a camera' as a revelation. A shy boy, he also discovered that photography provided 'a visual language to express myself'.

Rather than photography, he majored in art and history of art at the University of Minnesota (later to award him an honorary PhD), absorbing the styles of painters from the French Impressionists to the Japanese masters. He went on to work as a photojournalist for a local paper, but all the while taking pictures for himself. 'I constantly envisioned a world that appeared unscarred by man, a world as it might have looked before humans became so numerous and destructive. I tried to capture this world in every photograph I made.' The first pictures he sold to *National Geographic* were of his beloved prairie. These would lead to him being hired by the magazine in 1978.

The other formative childhood experience was summer holidays in the fairy-tale 'north woods' of Minnesota. From this came a dream of one day living in a log cabin in the wilderness where wolves and other wild creatures lived. It was a dream he was to achieve with the creation of Ravenwood, his home and the

location of so many of his photographs over the past three decades. Wolves became a fascination. 'If a country is wild enough for wolves, then it is wild enough for the human spirit.' But in the early years, he managed to take only seven pictures of wild timber wolves, only one of which satisfied him.

It was the white wolves of the winter prairie-like wilderness of the high Arctic that were to make him famous as a photographer. He ended up spending six months over three seasons on Ellesmere Island in the 1980s, and he regards the pictures he shot there for *National Geographic* – featured in his award-winning book *White Wolf* – as 'the most important story I will ever do'. These photographs have never been bettered and might never be possible to take again. He also went on to make the National Geographic/BBC film *White Wolf*, which premiered at the Sundance Film Festival in 1995.

There followed another best-selling book, *Brother Wolf*, with a powerful story told on behalf of timber wolves, and in particular the wolves of his north-woods home. But the success and years of high-pressure *National Geographic* assignments had burnt out his

love of photojournalism. Tired of the life of a globe-trotting photographer, he retreated in 1994 to the sanctuary of Ravenwood – his dream log cabin in the woods of Minnesota. From this retreat came a new artistic journey.

His camera gave him a way to immerse himself in nature. To get back to the soul of his work, he decided to shoot just one picture a day, with no second chances, for 90 days between the autumnal equinox and winter solstice, just for himself. In the process, 'something cleansed me,' he says, 'something very, very powerful.' The pictures went into a drawer until a visiting *National Geographic* editor, aiming to tempt him with an assignment, saw them and took them back to Washington. The result was the longest story the magazine had ever run, the book *Chased by the Light*, and another life-changing decision – to continue using his photography for the more philosophical, simple pleasure of searching for the joy and beauty in nature. It also led to his sequel book *Looking for the Summer*.

After more than half a century of photography, Jim is still creating and innovating, grounded in his environment and with the desire 'to pass on what I see'. One story he continues to

tell is that of the tall-grass prairie – its beauty, riches and loss. In 1999 he and his wife Judy set up the Brandenburg Prairie Foundation, which created the thousand-acre Touch the Sky Prairie, extending a national wildlife refuge. Profits from the sale of his photos in his home-town gallery go to educating people about the prairie and supporting its restoration. 'Fate has been good to me,' he says. Now a great pleasure is seeing his art give back to nature what it gave to him.

Today, he is working more and more in Europe, refreshing himself with new subjects and a new cultural heritage and finding new ways to paint nature with his camera.

JIM BRANDENBURG

TERN OVER THE MAGICAL SLOUGH

It was windy on that North Dakota prairie, so windy that it was unnerving. It was also midday, and knowing that the light isn't good at that time, I was sitting in my car eating a sandwich. I looked out on the slough, at the sooty tern going back and forth and the bending reeds and thought, I wish I had a movie camera. I stuck my lens out of the window and casually shot a few frames, then went on my way and thought no more about it. When I finally saw the picture, it was a big surprise. This is one of those cases when something changed, where the picture looks different than I remembered. It was early in my career, and I took this and my other prairie pictures and showed the story to *National Geographic*. They were fairly shoulder-shrugging about it: 'Well, we'll get back to you.' So I went to New York and showed this photograph to *Audubon*. They kept it for the cover. I then got a call from *National Geographic* wanting to hold it for a story. It was my first encounter with the two biggest magazines in America, and I was in an awkward situation. The picture ran in *Audubon*, and thankfully *National Geographic* still gave me what was to be my first assignment for the magazine.

North Dakota, USA, 1975; Nikon F2, 640mm Novoflex lens, 1/250 sec at f11, Kodachrome 64.

' Good photographs, like wolves, are elusive;
good photographs of wolves could define
elusiveness. It was a humbling realisation, but
a challenge, too – one that would inspire me. '

BROTHER WOLF

This is one of the two most important pictures in my life, pictures that changed my career.
But the actual encounter was such a brief one. I wasn't far from my cabin, walking quietly in
a white cedar grove. I have no idea how long the wolf had been watching me. But I saw it only
for a moment, and then it was gone. I wasn't even sure I'd captured the moment as I'd only
glimpsed him. When the film came back, I saw the frame and thought, that's interesting, and
put it back in the yellow box. But it quietly grew on me. The photograph speaks of the wolf's
elusive and mysterious ways and it pulls you in. The picture led to a photographic homage to
wolves and, in a sense, a journey back to the north woods. It's been a 30-year private challenge
to get to know the wolves living in the wilderness surrounding Ravenwood, my home and my
sanctuary. These wolves are secretive, always just out of sight, but they have always been
accepting of me. That's what makes the resumption of legal wolf hunting in Minnesota so very
troubling. That they will be shot now because of that accepting quality breaks my heart.

Ravenwood, Minnesota, 1986; Nikon F3, 300mm, 1/250 sec at f2.8, Kodachrome 64.

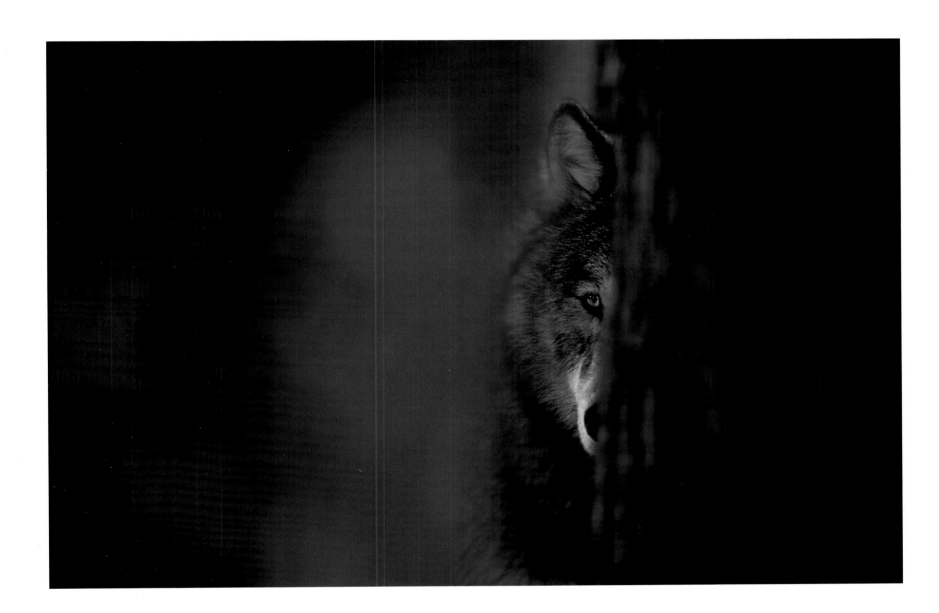

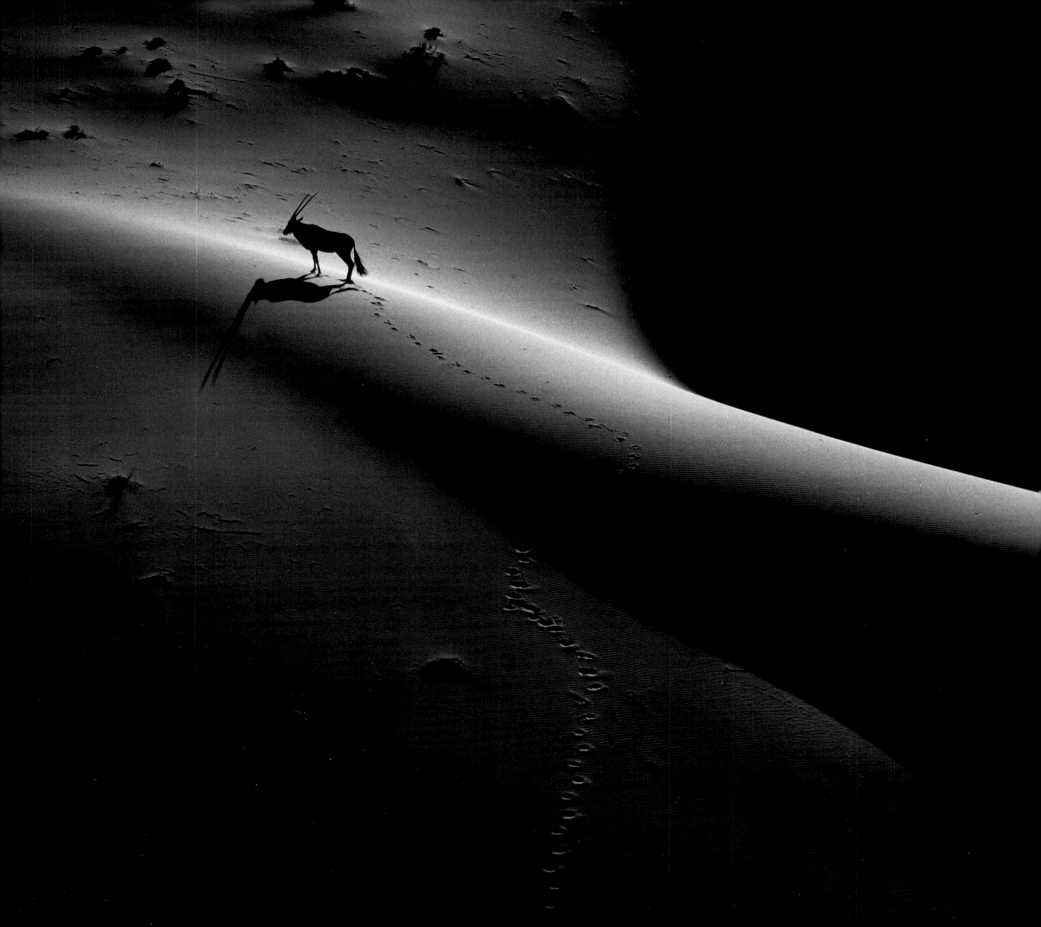

DUNE ORYX

I worked three weeks on this quest. That
was in the golden era of assignments. It
was a picture I'd envisioned before I went to
Namibia. These oryx were almost mythical,
and I wanted one in dramatic light on their
stage, the great sand dunes. I worked my
arse off on that picture. On this occasion,
I previsualised an ideal situation. In my
career, that doesn't usually work. It's rare
that I ever capture my imagined image.
The light isn't right, the animals leave early,
time runs out. It's usually on the way to and
the way from that I get my best shots. In
this case, I was on one of my few *National
Geographic* assignments that wasn't a nature
story. I'd been sent to shoot Namibia's war of
independence. But I just couldn't ignore the
magical landscape. Everything came together
late one afternoon – light, subject and
composition. I can count on one hand the
number of times this has happened.

Namib Desert, Namibia, 1987; Nikon F3, 80-200mm
lens, 1/125 sec at f8, Kodachrome 64.

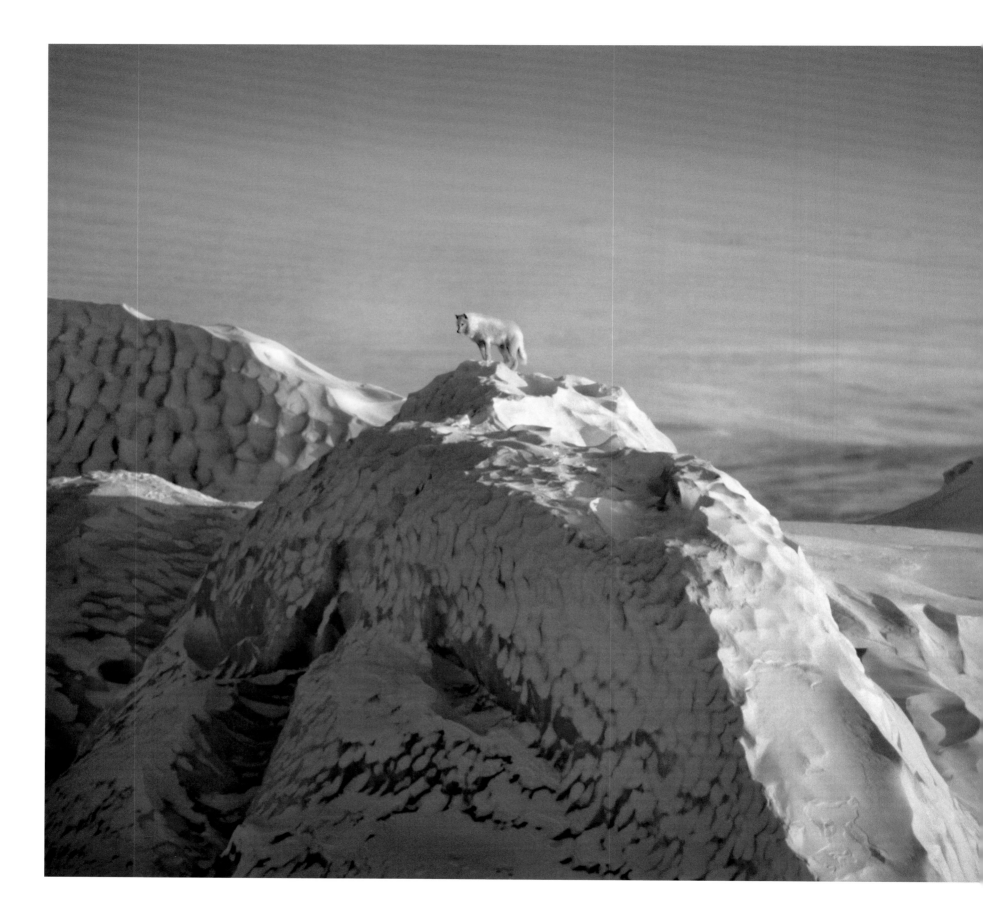

ICE WOLF

The late-winter sun touched the frozen
sea behind with the warmth of candlelight,
illuminating the wolf while leaving most of the
iceberg in blue, muted shadow. It seemed
like the most exquisite composition nature
had ever provided me. Even the texture
of the ice was perfect: a pattern of toothy
grooves, chiselled by the summer sun and
wind and filled during winter by repeated
dustings of snow. It was March, and the
sun had only been up a week. I was using a
telephoto lens that required a lot of light, but
the sun was so low and soft, I had to use a
dangerously low shutter speed, even though
the wind was gusting. It was also bitterly
cold, and the film broke in the camera while
I was shooting. In the process of changing
cameras and film, I managed to fog several
of the frames. Sometimes I look at this
picture and think I can't believe I shot it.

Ellesmere Island, Canada, 1986; Nikon F3, 300mm lens,
1/125sec at f8, Kodachrome 64.

JIM BRANDENBURG

WHITE WOLF LEAPING

The story of these Arctic wolves was made in heaven. It's the one that defines my career. I lived with the wolves for three summers. Once I had shot the story, I knew I would never top it – would never be able to equal it in terms of magic, personal experience, photographic potential, new ground. And I never did. I have no bad memories of that time. The air was bitter, and the snow was so dry that it squeaked under your feet. But when you love doing something, it seems easy. On this occasion, I was following the pack as they scavenged on the beach. It was probably 2–3am, when the summer sun is permanently on the horizon. Buster, the alpha male – I named him after my dad – was in the lead as usual, running around in the water. I wasn't even sure I'd got the shot. It was just an instant, as he leapt from one bit of ice to another. But it was the shot that finally convinced my photo editor at *National Geographic* to let me tell the story of these wolves (I was meant to be on assignment on a North Pole expedition). It was the second picture that changed my career. And the extraordinary thing is that it was taken within a month of Brother Wolf. When I finally saw it on the light table, it blew me away. It's one of those images that I revisit on occasion and get a little emotional about. I lived with these wolves and they were like family to me. But none will be alive now.

Ellesmere Island, Canada, 1986; Nikon F3, 1/500 sec at f8, Kodachrome 64.

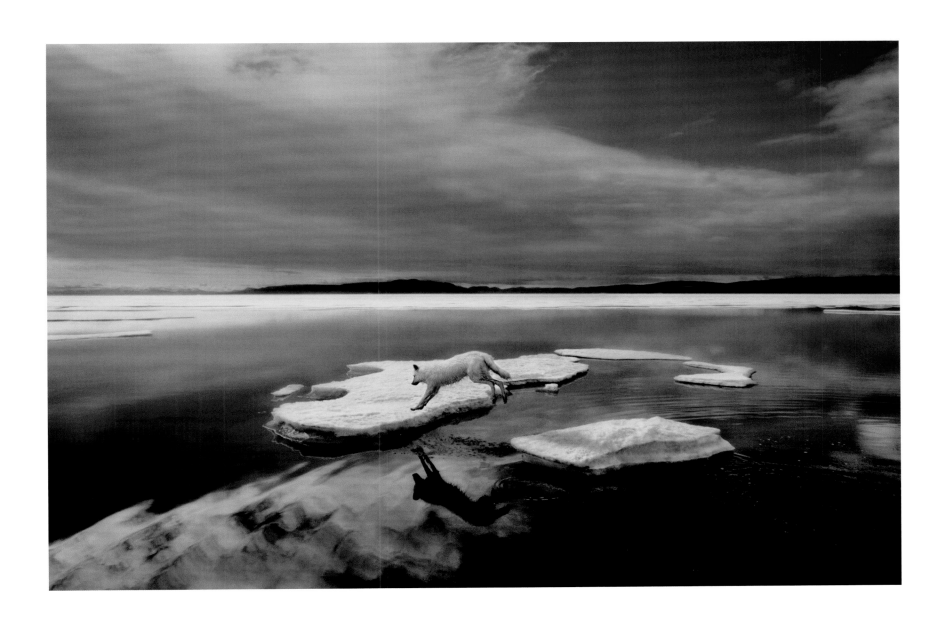

' My endeavour is not to shoot trophy pictures but to use a wide-angle to show the animal in the landscape. My mission is to attempt to tell all in one frame. It's subconscious, and I try not to overthink it. '

CHASED BY THE LIGHT, DAY 10

This is in our beloved Boundary Waters – canoe country, a three-million-acre wilderness park, half in the US, half in Canada. My house is just over the far hill. It was day 10 of my very personal challenge, to make only one picture a day between the autumn equinox and winter solstice. At this point, it was becoming too stressful. I was really tired, I wasn't getting very good pictures and I was thinking of quitting the project. It was sunrise, the magical hour of the day, and I was by myself, canoeing, when I saw this immature loon wrapped in fishing line. I went back to shore, found a landing net, caught the loon, took the hook out of its neck and unwrapped the line around it, released it and stood up just as it swam away. I made an instant decision and took a single wide-angle frame. I didn't know if I had the wing-flap or if I had just missed it. When I saw the contact sheet a few days later, I realised I had something. I see the picture on many different levels: the loon, icon of wilderness, happy at being free, flexing its wings, as if waving thank you, symbolic of a random act of kindness; a turning point that made me determined to continue with the challenge. It's also my favourite picture of the 90 days.

Boundary Waters, Ely, Minnesota, 1987; Nikon F3, 20mm lens, 1/125 sec at f8, Fuji negative film.

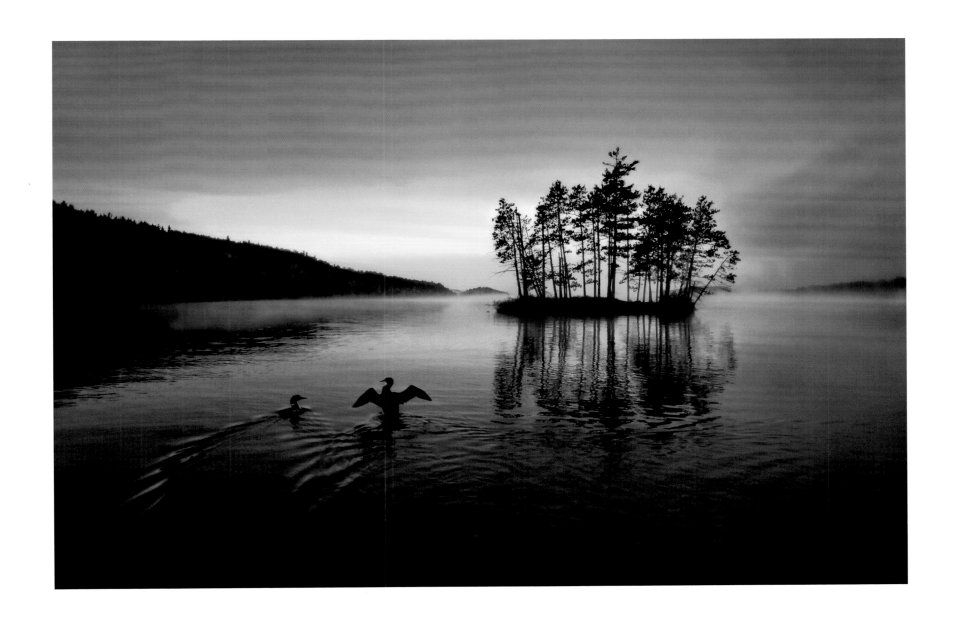

DREAM BACK THE BISON

This was shot on my all-time favourite
assignment in terms of joy: the anniversary
of Columbus, featuring places that hadn't
changed in 500 years, which meant going
to all the places in America I loved and just
photographing pure, uncluttered nature. This
location is truly the Wild West – 100 square
miles of bison range. It's where *Dances with
Wolves* was filmed. These bison had broken
out of the fence in a stampede after being
chased by dogs. Now a bunch of cowboys
was trying to chase them back to the ranch.
I could hear them before I could see them.
They were coming really fast, and I started
shooting like crazy. They had been running
half the day, and what you see is not dust
but steam rising from them into the cold air.
I cropped the picture, and it's soft, but that
impressionistic sense is what I like about it.

Houck Ranch, Fort Pierre, South Dakota, USA, 1990;
Nikon F3, 300mm lens, 1/250 sec at f4, Kodachrome 64.

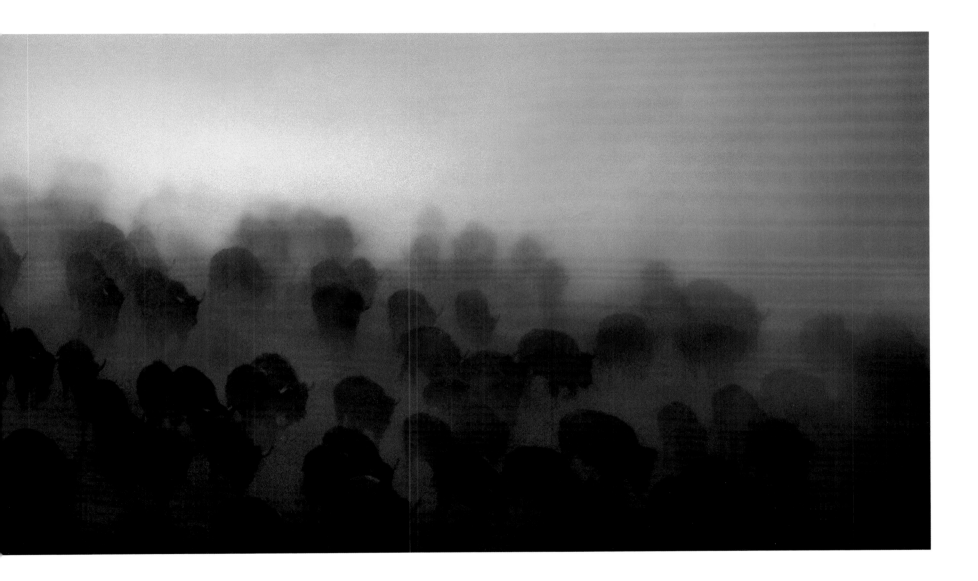

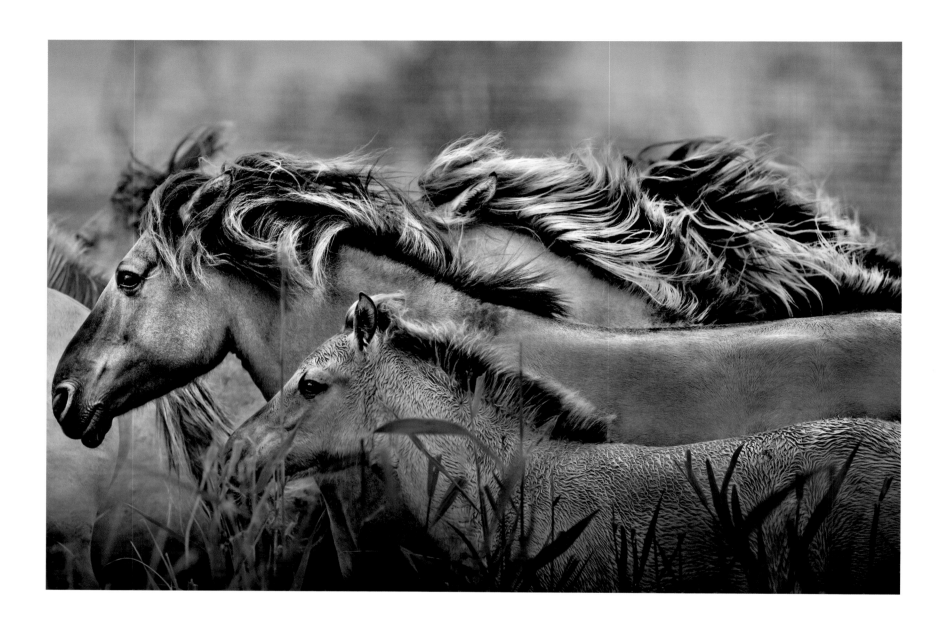

HORSE SPIRIT

These horses truly have a wild spirit – the most I've ever seen in horses – which is what
I wanted to capture. But when the herd raced past with great exuberance, I wasn't quite ready.
I'd gone to this unique wildlife refuge north of Amsterdam to test new camera equipment.
But my fingers weren't yet familiar with the camera, and I was using a long telephoto with a
2x extender – a combination never to use with the sort of flimsy tripod that I was borrowing.
The resulting images were a surprise. One might even call this frame quite a lucky accident.
I particularly like it as it reminds me of the ancient paintings of horses on the walls of the
caves in southern France – a subject close to my heart. This refuge is a rewilding experiment
to replicate Europe's prehistoric past, and these Polish konik horses are the closest we'll ever
get to the tarpans that once roamed Europe. I was simply doing what my ancestors did with
their cave paintings 30,000 years ago, trying to capture the magic of animals – nearly the same
animals. Little has changed in this quest, though I don't think we've yet matched that cave art.

Oostvaardersplassen Preserve, the Netherlands, 2010; Nikon D3S, 700mm lens, 1/1250 sec at f9, ISO 1600.

'The wonderful thing about nature photography is that you are continually humbled and amazed by the delightful surprises that come from it – and horrified and disappointed when it doesn't work as you predicted. '

SUNLIGHT MOMENT

I studied art and art history and was a painter before I was a photographer. The French Impressionists were a powerful influence on me. I have also spent more of my time in France shooting than in any other country outside the US. There is an elusive kind of inspiration that comes over me when I see a scene in France that has the qualities that moved those impressionistic painters. When I saw this scene, I was moved and laboured over making the image. I tried different angles, crops and exposures. I'm not sure I got it quite right, and it is certainly not a profound statement. It's simply an uplifting moment that celebrates light. When I walk out of my door in North America, it's wild. But in Europe the land has been intensely used for thousands of years. Somehow it moves me to find tamed beauty here. Perhaps it's the unfamiliar that refreshes me.

Brittany, France, 2009; Canon EOS-1Ds, 105mm lens, 1/30 sec at f32, ISO 500.

WINTER SOLSTICE

I'm out nearly every day, looking, thinking. I don't shoot a lot, but when I see something that moves me, I may get into it quite deep. This was one of those times, on the shortest day of the year, literally 50 feet from my back door. It was the greyness of the ice and the strangeness of the black, electrified cracks that intrigued me – a juxtaposition of beautifully odd elements. The pond was covered with oak leaves frozen into the thin ice. Every time they froze, strange nerve patterns developed around them. It must have then thawed a little, and then rained, and as it was freezing, the fox walked by. I've been intrigued by animal tracks since I was a boy. Before I moved to wolf country, the wolf's smaller relative, the fox, was my favourite animal to track. Framing the footprints wasn't easy. I wanted to show a starkly clean canvas. So I kept going back and reshooting the ice until the light was right. I waited to position the reflection of the overhead sun on the point of the second leaf-melt. In the end I took six shots and stitched them together. It's a haunting image, simple but at the same time complex.

Long Lake, Minnesota, 2011; Nikon D7000, 24-70mm lens, 1/8 sec at f22, ISO 100.

DAVID DOUBILET

David Doubilet is credited by his peers as having turned underwater photography from record shooting into an art form. To have done so required not only the acquisition of knowledge of the vastly different marine natural world but also the mastery of the technical skills needed to take pictures under water at a time when equipment was both limited and constraining. Yet after nearly 50 years making underwater pictures, and though he still spends a third of his year on or under the water, David says he is still striving to find ways to show the true beauty of what he sees there.

David was eight years old and at summer camp when he first put on a facemask and looked below the surface of a lake. He was immediately 'hypnotised by the beauty of the light' and spent hours floating, just looking. Though he had asthma, he found he had no trouble breathing through the snorkel. It was his entry point into a beautiful world. When he got back to his New Jersey home, his parents gave him a mask, snorkel and fins, and he was set to follow a lifetime passion.

Used cameras were cheap in the 1950s, and once he had saved up for a Brownie Hawkeye,

he set about making a housing for it out of a rubber anaesthesiology bag given to him by his father, a surgeon, and the faceplate from a mask. It worked, but his pictures still didn't resemble what he saw in the books and magazines he was now avidly reading. When he was 12, he acquired a 35mm Argus C3 camera. But with no way of controlling the exposure through the housing, he decided to shoot in black and white and learn to adjust the pictures in the darkroom.

David's dream now was to follow in the wake of the underwater pioneers Hans Hass and Jacques Cousteau. His first proper ocean experience came when he was 13 and his father took him to the Bahamas. Here he got a holiday job filling tanks at a new dive resort, and having obtained his dive certificate in New York, he began diving properly. He returned there every holiday until he was 22 to work as a dive guide. When he was just 15 he sold his first image and went on to win money through competitions. At 16, he was selling his pictures to magazines. He now started to look at the work of great black-and-white street photographers. But the limitations of his Rollei Marine camera were hugely frustrating, restricting him to 'a medium-distance square

shot', which meant a relatively round subject and no vistas. Playing around with filters improved the lighting, and with comparatively few shots per roll of film, he was by now a disciplined shooter. A new camera came out with close-up lenses, but he was still limited by flashbulbs and just 12 shots per roll of film.

It was when he was at university, majoring in photography, that wide-angle lenses arrived and the first dome port. Together, they would allow him to capture anything from a shrimp to a shipwreck. Now he could start selling more pictures. In 1971 he managed to accompany the film-maker Stan Waterman and biologist Dr Eugenie Clark on a *National Geographic* expedition to study garden eels in the Red Sea. Always the inventor, he modified his housing, and using a tripod, remote cord and trigger and a hide, he took a shot of the eels that went on to be published in the magazine as a double-page spread.

He'd made his mark, and the following year he had his first commission with the magazine. He has since done more than 70 assignments for it. He credits his success partly to the influence of mentors, including Luis Marden, a pioneer of colour photography, Harold Edgerton,

the 'father' of strobe photography, Bates Littlehales, who invented the Ocean Eye camera, and colour master Jay Maisel, who showed him how to go beyond 'the obvious decisive moment and happy accident'.

He has photographed in most of the key dive sites the world over – 'each new dive a voyage of discovery'. Going under water and away from the office also gives him sanity, as does his partner and life-companion, biologist and photojournalist Jennifer Hayes. For David, friendship and working as part of a team remain important elements in his career.

He claims his favourite picture 'is the one I haven't taken yet', but his work has opened the eyes of a generation to the wonders of the marine world. Many of his classics have been published in one of the most famous books of underwater imagery: *Water Light Time*. He has also won many prestigious awards and is a longtime Rolex Ambassador and a member of the Academy of Achievement.

The final breakthrough in his career, as for many underwater photographers, has been digital technology. No longer does he have to travel with quite so much gear, and now he

can shoot almost as many pictures as he wants on a dive. 'The batteries and optics are better, the strobes are more sophisticated and the ISO speeds faster. The bad news is that a camera system can cost as much as a car.'

Today, he sees underwater photographers as having a major role to play communicating not just the 'incredible beauty' of the oceans but also the silent devastation happening below the surface. 'Photography is a universal language, with the power to convince the unconvinced to act.' The greatest challenge he believes is to find a way to show the role the oceans have in everyone's lives – that 'the ocean truly is the Earth's engine.'

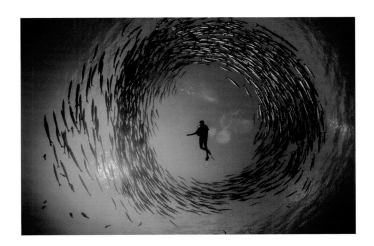

‘ When you put your head under water, civilisation vanishes. Most people pass through that molecular-thin surface very quickly, but sometimes the door to the house is as important as the house. Half-and-half pictures are a way of translating the move from the world of air to the world of water. That transition is magical – truly a "through the looking glass" moment. '

AIR AND WATER, STINGRAY AND CLOUDS

It was a hot June day, and the sea and air were almost the same temperature. The shallow waters of Grand Cayman are popular with divers and snorkellers, who come to feed the gentle stingrays, but by the afternoon, everyone had gone, and it was silent, except for the wind and the lapping of waves. The sand was perfectly raked by the waves, there were boiling clouds in the sky, and the water was as clear as the air. It was a distillation of the ocean. Stingrays fly. They can use their pectoral wings to accelerate or ripple them to hover. In this shallow sound the rays become ocean ambassadors to thousands of tourists who visit this place and experience a sea creature face to face for the first time. What I love about this picture is the simple elements of air and water. Of all the half-and-half pictures I shot there, this has the wonderful moment where the curves of the stingray's wing are echoed by the waves. The ship adds a touch of humanity, and though the stingray is in shadow, there is enough ambient light in the shadow to match everything else.

North Sound, Grand Cayman, Cayman Islands, 1990; Nikon F3, 18mm lens, split diopter, neutral-density filter, 1/60 sec at f22, 64 Kodachrome, Aquatica housing.

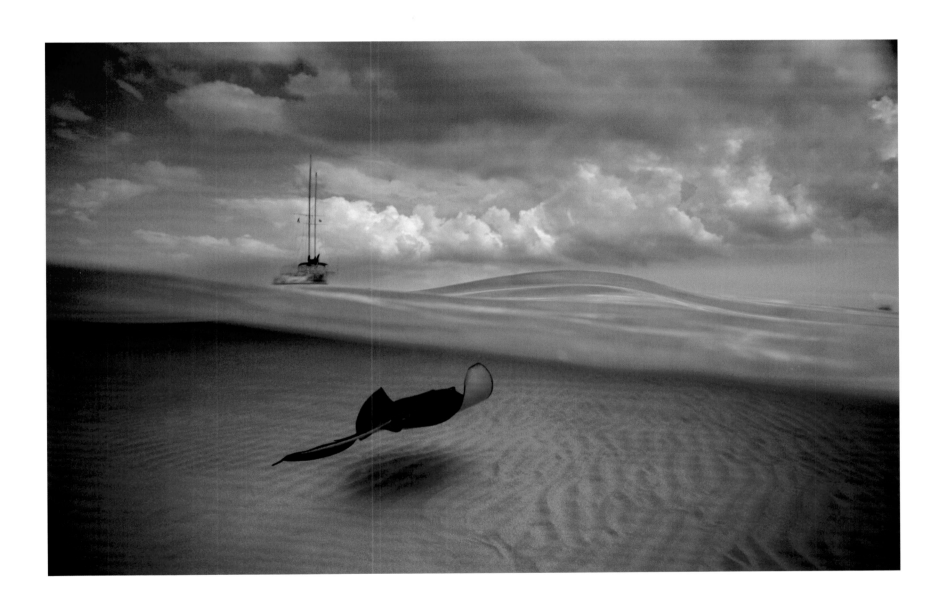

' It's an extraordinarily beautiful, mysterious environment under water, where even the rules of how you photograph things are all changed. It's a world for the curious, where there's always somewhere fascinating to explore, something fascinating to pursue, and unlimited potential for incredible images. '

SEADRAGON IN A FOREST OF KELP

Diving in the deep waters off the southeast coast of Tasmania is a fantastical experience. Cold water wells up at the base of the dramatic cliffs, which is where the kelp forest grows – the same kelp that you find in California. The prevailing winds roll over the top of the sea, but by the cliff face it's generally calm. It really is an underwater 'Land of Oz' down here – everything is so odd and wonderful. Weedy seadragons feed on lice at the base of the kelp, looking like metal tintype dragon toys from the 1950s. I wanted to make a picture of them higher up in the water column. So I followed this foot-long male as it cruised up and down. And it really is a forest down there. I exposed to create the impression of swimming through one, catching the afternoon sunlight filtering through the fronds. I used two strobes both to spotlight the seadragon – one from the left slightly above looking down and one from the right, low and slightly across – and to emphasise the mysterious nature of the place.

Waterfall Bay, Tasmania, Australia, 1994; Nikon F4, Nikkor 20mm f2.4 lens, 1/15 sec at f16, Fuji Velvia, Nexus housing, Sea & Sea YS-200 strobes.

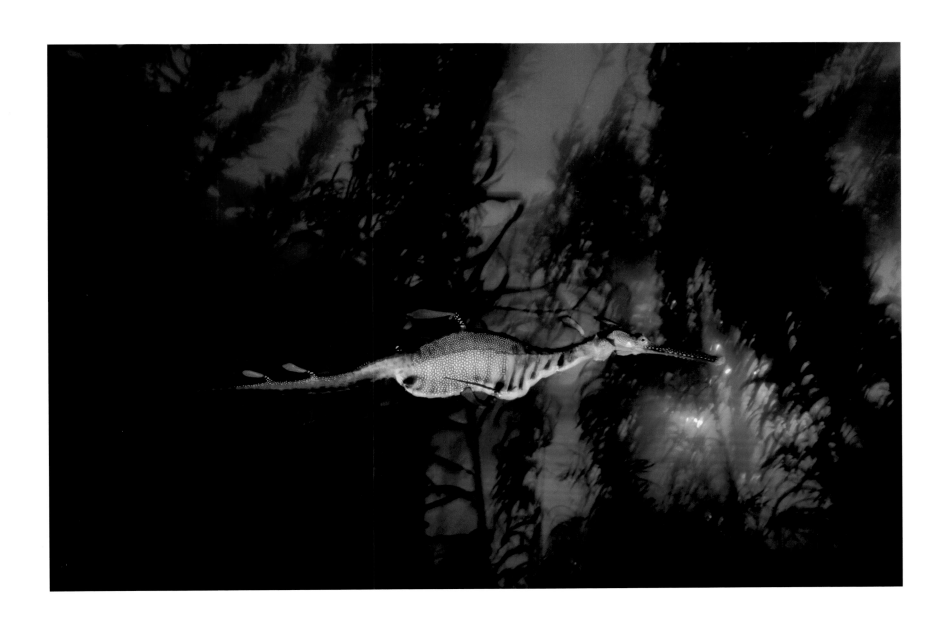

DAVID DOUBILET

UNDER THE SPELL OF THE OKAVANGO

We were told the Okavango Delta was the most beautiful dive place in the world. We were also told that we were 'mad as hatters' to think about diving there, that we would be eaten or worse if we did. It was indeed the most beautiful place, a dream-like garden, yet wild and crazy and full of clear, green water and waterlilies that bent with the flowing floodwater. It was delicate and dangerous because, wherever we went, there were crocodiles under water nearby. It was like swimming with dinosaurs, and we were wary and looking over our shoulders all the time.
We never dived in a place twice, because once the crocodiles felt our presence through vibrations in the water, they would find their way there and wait like the perfect ambush predators they are. Once I pleaded with our guide to take us back to a perfect 'little studio' spot, but as we rounded the bend, there was a 17-foot croc waiting where we had been photographing the night before. But this northern region, the panhandle, was so special – like a kelp forest created by an interior designer with no restraints – that we couldn't stop diving there. This shot is perhaps my favourite from that time. I was searching for bream when this fisherman appeared above me in a mokoro (a dugout that's the jeep of the delta) pushing across with a wooden ngashi. He stood statue-like peering into the water, the noon sunlight silhouetting him and casting a shadow across the waterlily forest like an African sculpture. That's the bit I love. It's a surreal image – the very essence of Africa.

Ncamasere Channel, Okavango Delta, Botswana, 2002; Nikon F4, 15mm f2.8 lens, 1/60 sec at f16 , Fuji Velvia, Nexus housing, Sea & Sea YS-200 strobes.

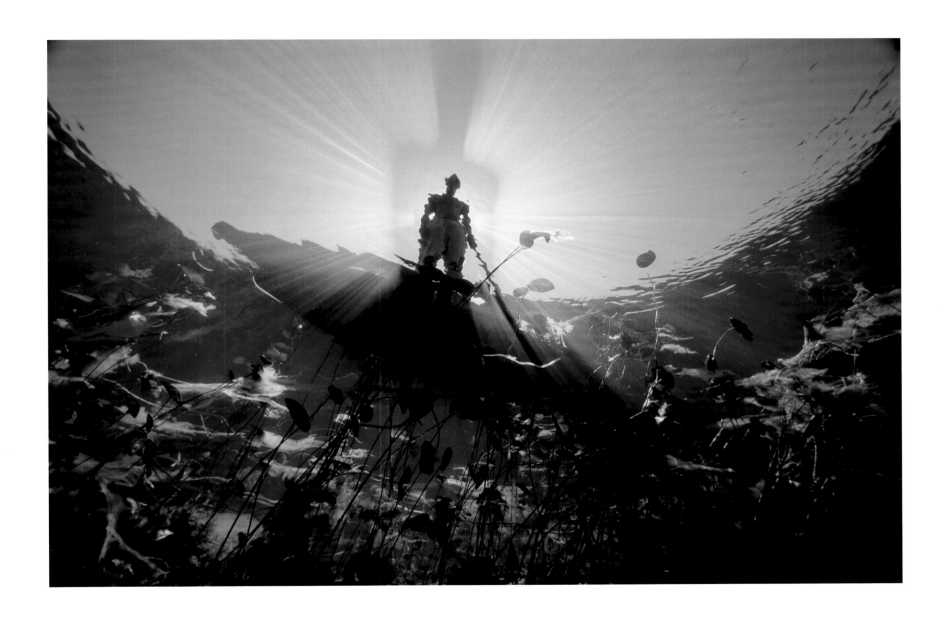

NILE BABY

The Bayei people of the Okavango have
a poem they teach their children: 'I am
the river. My surface gives you life. Below
is death.' We were to learn the truth of that.
I set out looking for big crocodiles, hoping
that, in winter, the cold water would make
them sluggish. But after warming up in
the sun in the day, they were often active
in the cool of night. We'd drift down the
channel and find them by the reflection
from their eyes or find them submerged.
We would slowly drift near to estimate how
large the croc was. If it was under three
metres, I would get in the water. We would
spot baby crocs here and there while
working on other subjects under water. This
little baby, hiding out in the algae, was even
more vulnerable than I was – a meal for birds
and fish as well as his larger relatives. I was
captivated by the scene. Gentle top-lighting
reveals the colour and texture – the soft
green swirls of algae, the red strokes of the
waterlilies and the gold of the crocodile skin.

Okavango Delta, Botswana, 2003; Nikon F100,
60mm f2.8 lens; 1/60 sec at f22, Fuji Velvia,
Nexus housing, Sea & Sea YS-200 strobes.

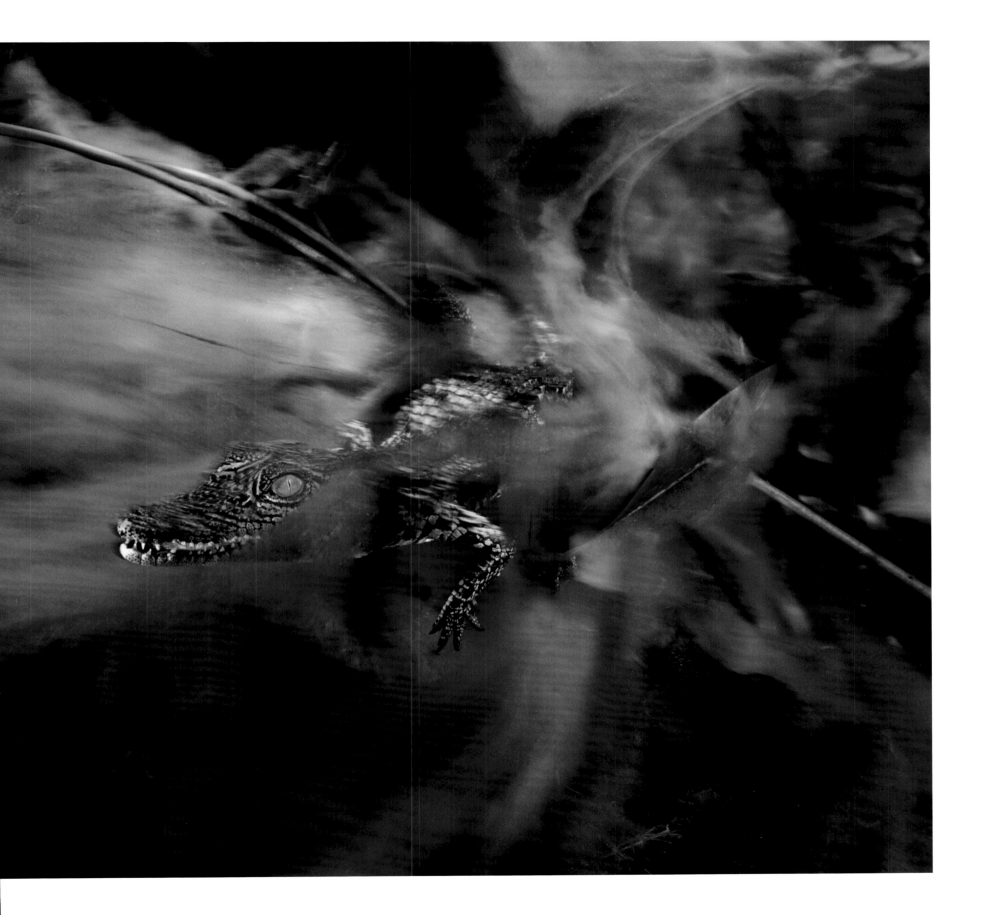

DAVID DOUBILET

THE JOY OF ELEPHANTS

The strange beauty of this image comes from both the colour, of the tannin-rich, clear water flowing over the yellow-gold sand of the Okavango Basin, and the texture, of the interface between water and air and the skin of this great creature. What I love about the picture most is that it shows elephant joy. This youngster is one of a group of elephants that has been reintroduced to the wild in Botswana. He's heavy. It's hot. His skin itches and cracks. But now he's weightless in a world of cool water and not surprisingly is behaving like a kid in a holiday pool. He's on his knees, blowing bubbles. He's also polishing his gleaming tusks in the fine sand. Lighting the bed of golden sand provided the perfect tableau for this surreal, burnished scene.

Okavango Delta, Botswana, 2003; Nikon F100, 16mm lens; 1/125 sec at f11, Fuji Velvia, Nexus housing, Sea & Sea YS-200 strobes.

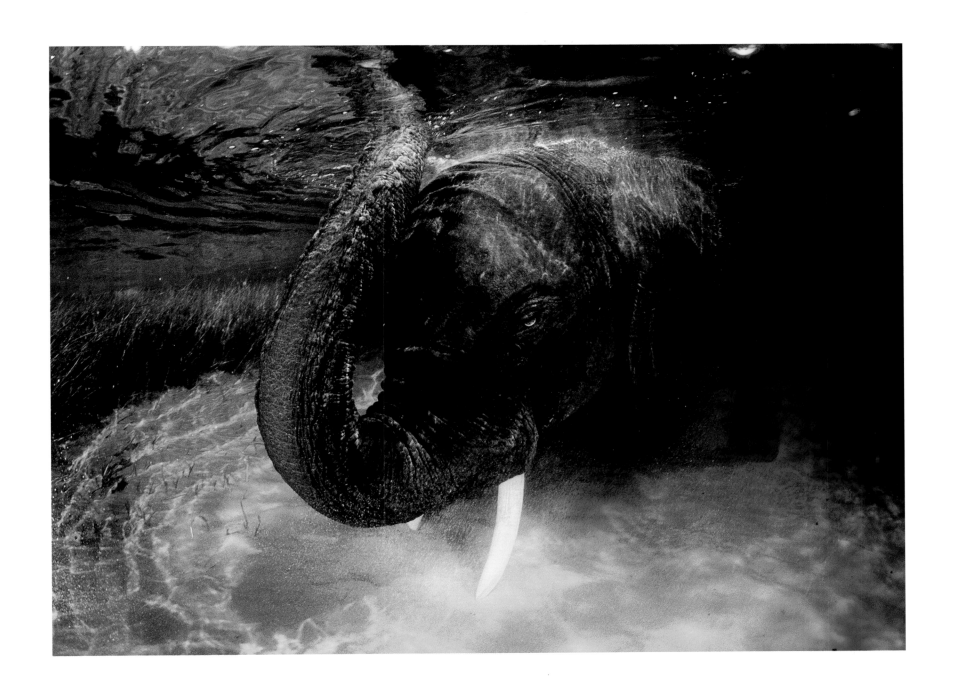

DAVID DOUBILET

' Underwater photography is a combination of visual dreams and intense curiosity, driven by a passion for the underwater world. And as underwater photographers, we have a role to show to those who will never go beneath the surface just what an amazing world it is and why it is important to all life on this planet, not just to those who go under water. '

THE GOLDEN MOMENT

The underwater world of Raja Ampat is so rich and colourful that it's almost impossible to capture the dynamic scenes in photographs. This particular day was rainy, and we had had poor diving in another location. We were on our way back to the lodge when we spotted a group of fishermen clustered by one of the many small, forest-topped, mushroom-shaped islands, its coral base eaten away by wave action and borers. I jumped in the water, and immediately realised why the fishermen were there. An enormous shoal of silver baitfish was sweeping round and round the island. With my back against the coral, I looked up at the fisherman above me and raised my camera midway above and below the surface, just as the rain stopped and the sky cleared, turning the sea a golden yellow. I carried on shooting until the strobe batteries died. Then I just watched and absorbed the moment. What were the fish doing? Maybe they were spawning. Maybe they were waiting for darkness so they could feed. So often we go to such magical places and don't know for certain what we are a part of or looking at, but the moment stays with us for ever.

Raja Ampat Islands, West Papua, New Guinea, Indonesia, 2004; Nikon D2x, 12-24mm lens, 1/60 sec at f22, ISO 200, Seacam housing, Sea & Sea YS-350 strobes.

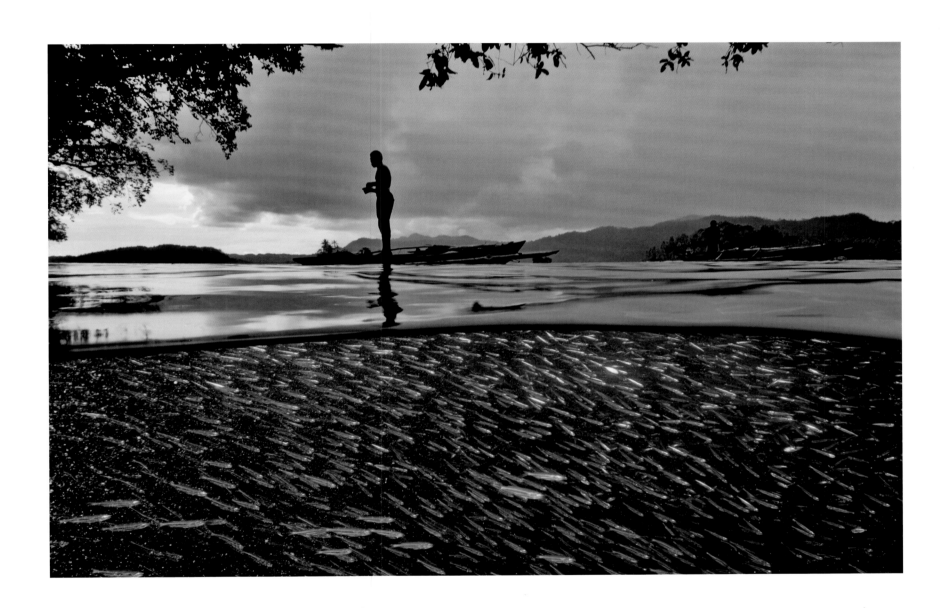

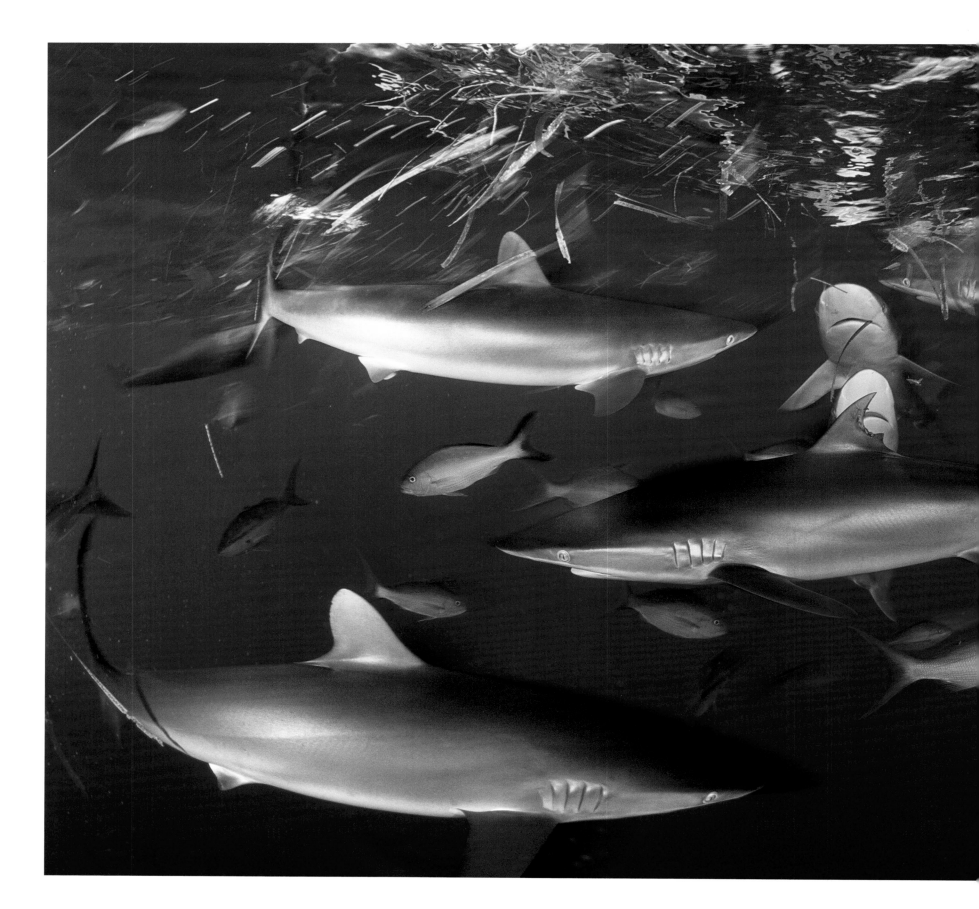

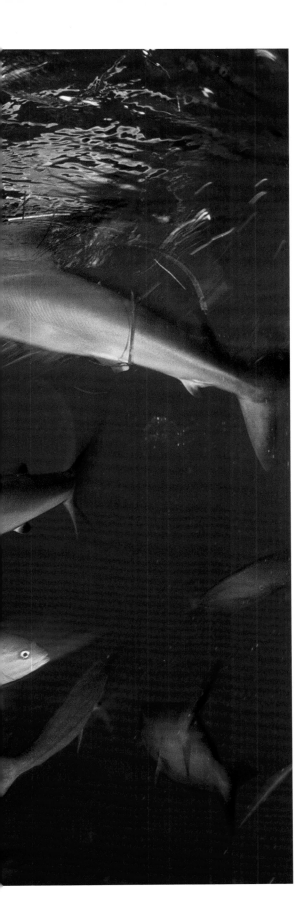

A SWIRL OF SILKY SHARKS

This was taken just under the surface.
The silky sharks are milling around, feeding
alongside yellowtails in the outgoing tide
in the Gardens of the Queen – a bluewater
mangrove sanctuary. Most of the sea
around Cuba is a politically inspired
de facto marine sanctuary. It's the richest
place in the Caribbean – what the whole
Caribbean used to look like 50 years ago.
The combination of strobe lighting and long
exposure has brought in the lovely even-blue
Caribbean light. There's a magical juxtaposition
that makes not the decisive moment but
the decisive ballet moment – the swirl of
movement, the positioning of the sharks'
mouths combining to drive your eye into
the middle, and the shifting light burnishing
the silkies' skin. There is no sound in a
still picture, no motion, no dialogue, and
so everything we do with a still has to be
an allusion to something – it has to be a
distillation. This picture flows and moves,
and I guess that's why it works for me.

Gardens of the Queen, Cuba, 2000; Nikon F4,
16mm lens, 1/15 sec at f16, Nexus housing, Sea & Sea
YS-200 strobes.

BABY CLOWNS

I see underwater photography as a combination of visual dreams and intense curiosity. Marine creatures are truly fascinating – and we know so little about them. I try to find a way to convey a subject's character and its own unique beauty so that the viewer will connect with it, too. This can mean hours of just observing and waiting for the moment. Clownfish make striking portraits, but the joy is in finding a way to do more – revealing them as creatures as fascinating as any land animal, and I can never resist taking pictures of them and the anemones that host them. Only 10 species of anemones host clownfish, most of them in the Coral Triangle, protecting not only the adults but also their young. In return, the clownfish nip anything that tries to nibble the anemones. It's a beautiful relationship. This male tomato clownfish is guarding his clutch of developing eggs, gently fanning them with his pectoral fins to make sure they have enough oxygen and plucking out any dead embryos or debris – a tender and diligent parent. The anemone has withdrawn a little, possibly because of the strobe, revealing the eggs enough for me to take the shot. Focusing up close on the paternal care both helps create a strong composition and conveys the intimacy of the moment.

Anilao, Philippines, 2009; Nikon D2x, 105mm lens, 1/50 sec at f4.5, ISO 125, Seacam housing, Sea & Sea YS-250 strobe.

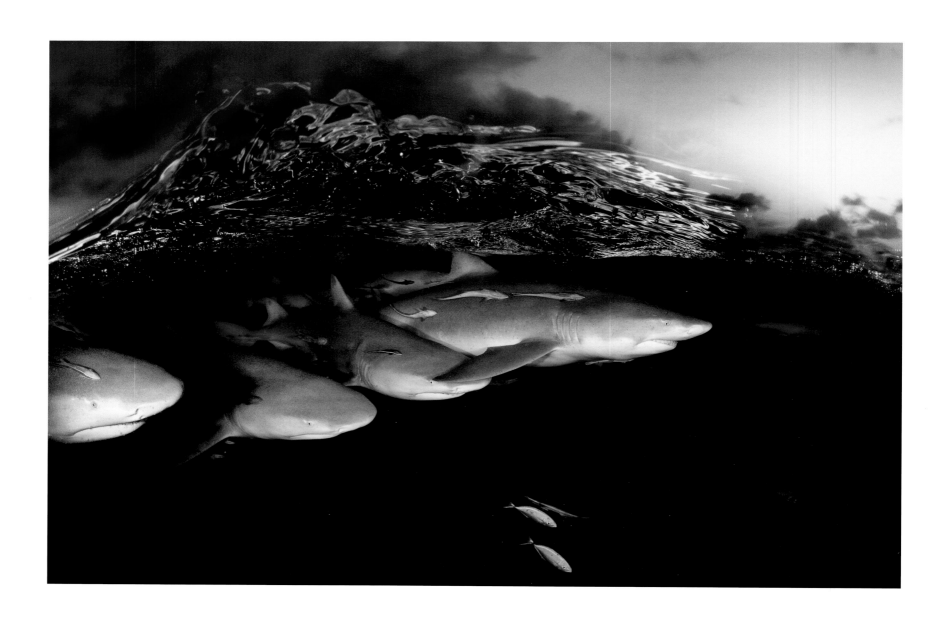

' The whole business of underwater lighting is
not about being a paparazzo – not about having
a strobe on a camera – but rather thinking
about swimming inside a giant studio called
the sea and thinking about how light moves
through that studio as the day changes…
It's about reading the light and waiting for
the definitive moment. '

SHARK PATROL AT SUNSET

It was evening over the Bahama Banks, the wind was coming from the east, and it was rough.
We hadn't had any luck with tiger sharks, but we'd anchored, and now the lemon sharks had
come to check out the boat. I waited until the light started to fade and then slipped off the back
of the boat into the water. The sharks were large, some of them 10 feet long. They would come
in groups, like bad boys patrolling the street. They weren't interested in my legs dangling like
bananas, but they were interested in the strobes' electrical output and would come in for a small
taste-test of them. The waves were sloshing about, and I was tossed up and down, trying to see
through the viewfinder. Just as the sun was about to set, the moment happened – when the strobe
light hitting against the breaking waves turned them crystalline. I love the way the sharks move
through the picture, and the wave texture adds another visual layer. For me it's as much about the
wave and the light as it is about the sharks.

Bahama Banks, Bahamas, 2010; Nikon D2x, 10.5mm lens, 1/15 sec at f18, ISO 400, Seacam housing, Sea & Sea YS-250 strobes.

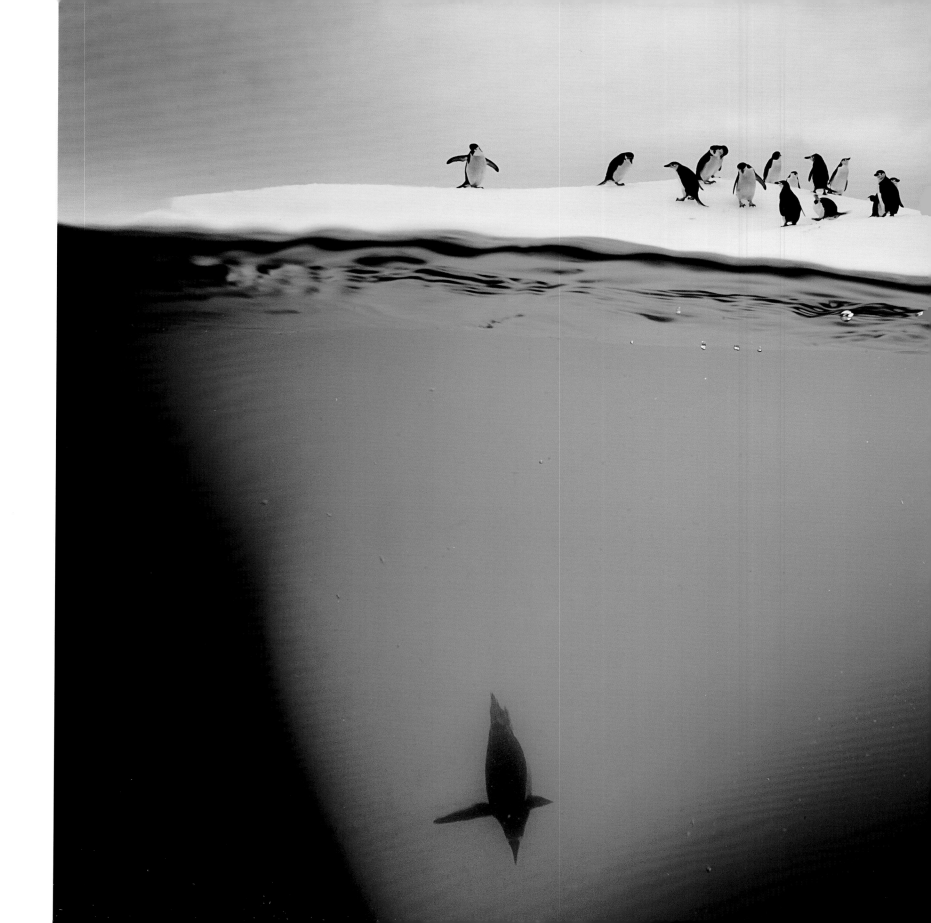

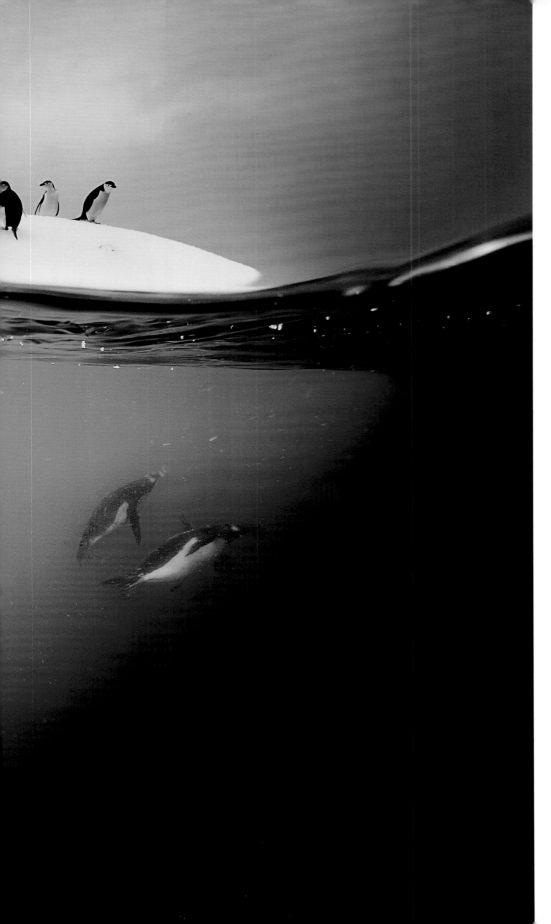

DAVID DOUBILET

PENGUINS, ICE AND LIGHT

I came late in life to the ice, but now ice is in my blood. I've been seduced by icebergs, and over the past few seasons, I've been working on them at every opportunity. I think of icebergs as a perfect metaphor for the sea – only a small percentage is visible to us. We were lucky to find this bergy bit with a small group of chinstrap and gentoo penguins squabbling on top of it. I made a few frames of the idyllic scene before they began to push each other off, and slide down one side, pop up on the other and start over again. I love the combination of grey sky, white ice and black penguins against the colour of the water, and the curve of the wave with just a little bit of reflection underneath. I was excited when two gentoo penguins circled the ice under water, providing perspective. Look how much ice there is below water. One of the greatest joys of shooting half-and-half is that there's always a surprise – especially the way the surface receives the light.

Danko Island, Antarctica, 2011; Nikon D3,
14-24mm lens, 1/125 sec at f22, ISO 400,
Seacam housing, Sea & Sea YS-250 strobes.

PÅL HERMANSEN

There is something about the way Scandinavian photographers use light that so often makes their work distinctive. And it's hard not to believe that the very different quality of light to be found in the far north and the long, dark days of winter have something to do with it. Certainly, the work of Norwegian photographer Pål Hermansen reflects his passion for the polar regions, in particular Svalbard, and a fascination with light and dark contrasts.

Pål also regards the exploration of nature through photography as the highest form of photographic art, given that it deals with the most important things in life. He also sees photography as a type of scientific activity, in the sense that the camera can reveal things that have never been seen before and record them with accuracy as well as artistry.

Pål's strong interest in nature and nature conservation was born of a childhood spent roaming the forests around Oslo, Norway. He began to experiment with images in the 1960s, starting out by making short Super-8 films. But when he bought his first SLR camera, he fell in love with still images,

setting up a darkroom so he could experiment with processing. In 1971 he decided to become a professional photographer. At that time, it was almost impossible to make a living as a photographer of nature, and he didn't want to end up being a wedding photographer or for-hire freelance. So he trained as a dentist and a homeopath to provide a second income when times were hard.

In 1985, Pål published the first of more than 30 books, many with text by him (he loves the creative process of writing almost as much as he does photography), covering many topics involving nature but also incorporating a human presence. His books include *Bird Magic* – birds and particularly the motion of birds in flight are one of his passions – and *Out to Play*, which looks at the importance of children being able to use the natural environment as their playground.

Relatively recently, Pål undertook a degree in art and photography, to more fully appreciate the history of art and understand the diversity of contemporary photography. His desire is to have his work appreciated as art involving nature rather than being labelled as

nature photography. He has certainly achieved that in Scandinavia, where his pictures have been widely exhibited and he has had more than 25 solo exhibitions.

With a restlessly curious mind and a science training through dentistry, he sees the scientific aspects of his work as inextricably linked to the creative. Photography, especially the technical innovations of digital photography, is 'a way to enter realms that are not seen with the naked eye – motion, macro world, time, night, and so on'.

Pål is fascinated by the ability of photography to both 'freeze the split-second action and compress a longer period of time'. But he also is aware of the danger of the technical solution becoming the aim. 'To me, the story – the idea, the depth for interpretation and the emotions it evokes – has to be the most important aspect of an image.'

Today, he is working on ways to 'integrate nature photography into the landscape of contemporary photography' and to make people part of the photograph and so highlight the relation between us and nature.

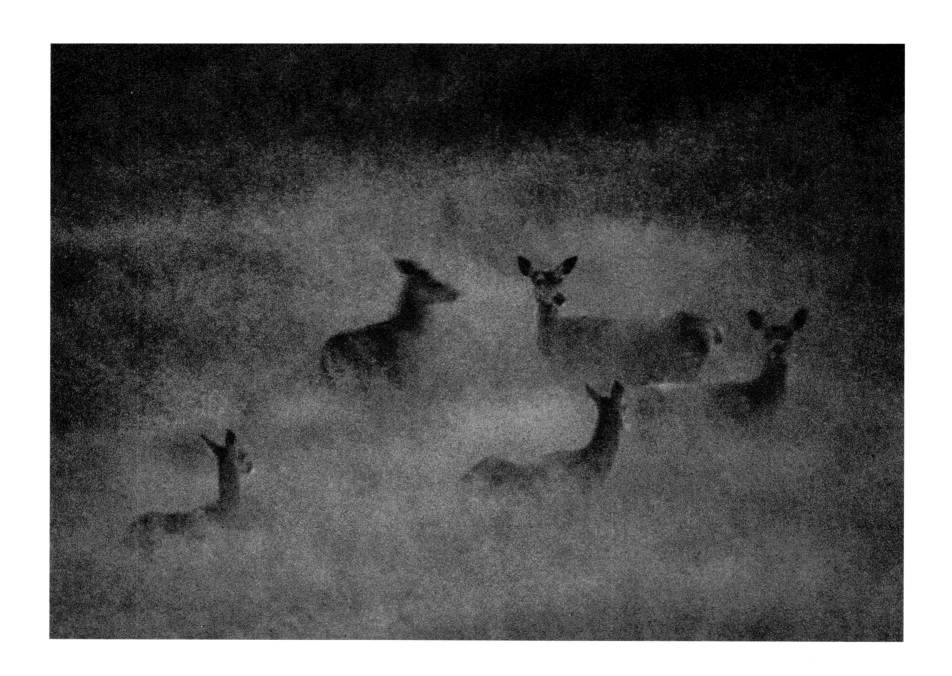

' Exploring nature photographically is the most existential and essential activity you can do with a camera. In nature you deal with the basic questions of life and death, which is not something you can say about many other branches of photography. '

NIGHT MAGIC

Today's cameras offer fantastic exposure–speed possibilities. But sometimes these can be too good. This image is the oldest in my selection, made before the digital era. It was shot on a summer night on the coast of Trøndelag using what was then an incredibly fast film with an ISO of 1600. The blue night light and the mist haze over the field is enhanced by the grainy film. There is no need to show any more detail of the red deer – the roughness contributes to the night magic.

Trøndelag, Norway, 1988; Nikon F3, 600mm lens, 1/8 sec at f4, Fuji Provia 1600.

POLAR PANORAMA

I have met many polar bears in the vast, icy
Arctic landscapes. But this bear was in the
most breathtaking setting I had ever seen.
Our small expedition vessel got as close as
15 metres from its breakfast table. But rather
than a close-up, I wanted to show the bear
within the whole, magnificent scene. I waited
until it lifted its head from its meal of ringed
seal and then took a series of shots as a
panoramic stitch. It's a picture that can
be interpreted in many ways. When it was
made, the timing was perfect to highlight
the latest news about the effects of climate
change in the Arctic: less summer ice forces
the bears to hunt where they find ice – along
the edge of glaciers. But it also illustrates the
interaction between landscape and animal,
as well as the harshness of nature and the
food chain. But maybe I like it because it's
simply telling a story about nature.

Svalbard, Norway, 2005; Canon EOS-1Ds Mk II, 28-300mm
lens, 1/250 sec at f9, ISO 320, two frames stitched.

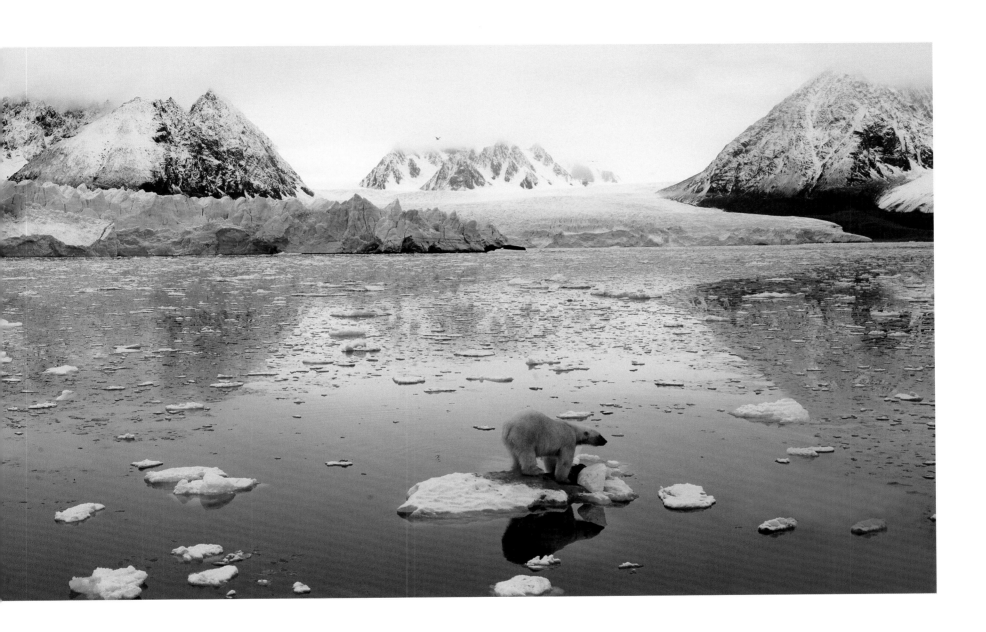

PÅL HERMANSEN

ICE FORMATION

On an icebreaker expedition in the Arctic or
Antarctic, one of the most fascinating visual
experiences you can have is when the ship
forces its way through one-year-old ice.
Standing high on the deck, you are presented
with a treasure-trove of forms and shapes.
Now and then birds fly over the ice,
offering interesting juxtapositions of shapes.
On this passage through melting ice in
Franz Josef Land, in the Russian high Arctic,
I followed the flight of an ivory gull shadowed
by a skua until they presented the perfect
mirror-image arrangement.

Franz Josef Land, Russia, 2004; Canon EOS-1Ds Mk II,
100-400mm lens, 1/640 sec at f6, ISO 100.

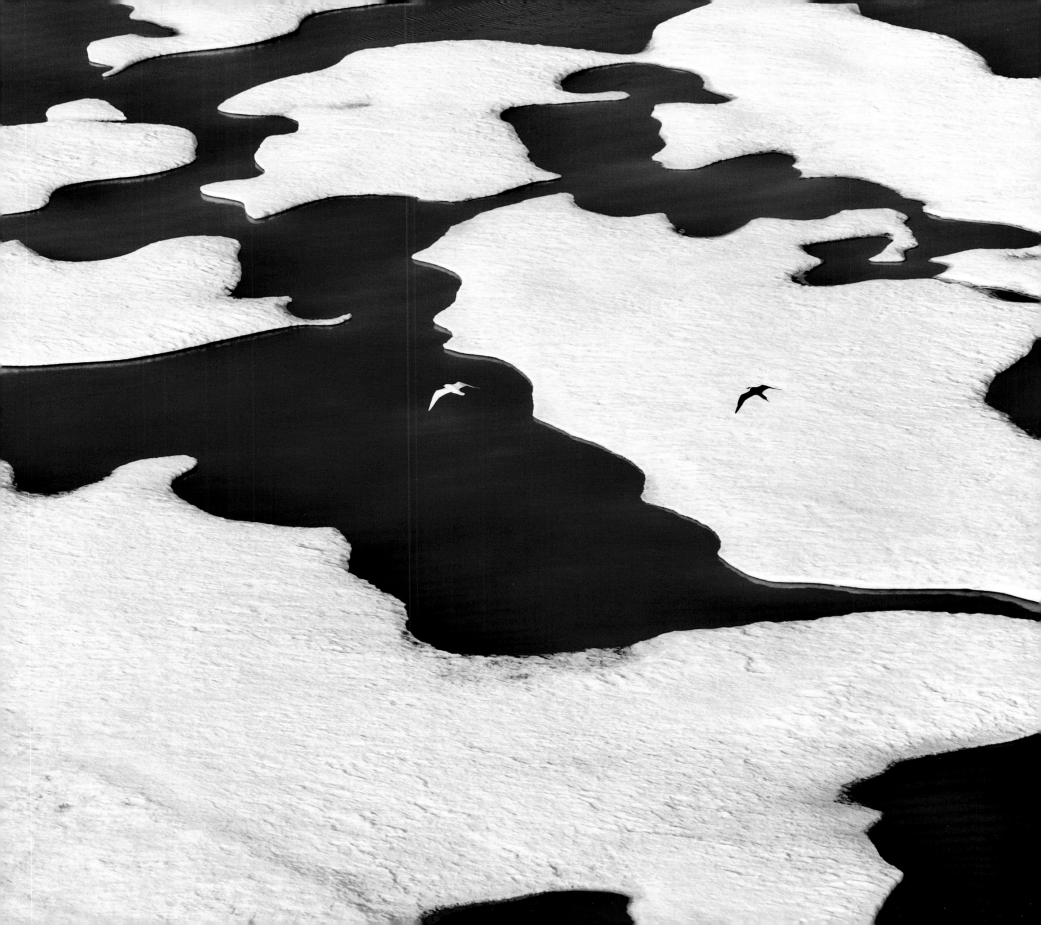

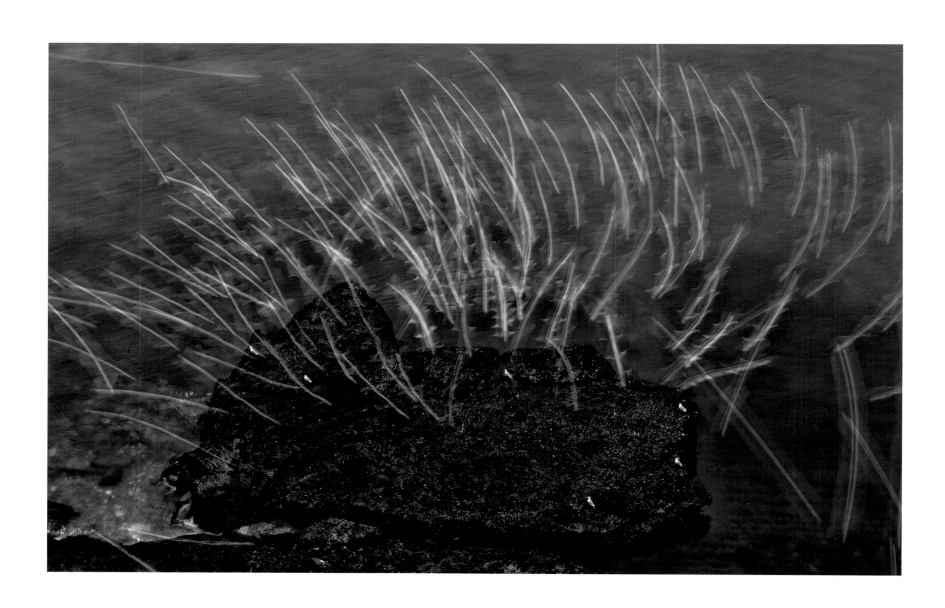

FLIGHT TRACES OPPOSITE

I'm fascinated by how photography can capture phenomena that can't be observed, in particular, the nature of motion. Now short exposure times and fast motor-drives can freeze motion, I'm even more excited by how long exposures compress time and reveal a pattern of motion. A favourite subject is the motion of birds. I don't care what species, as long as they are either white against a dark background or dark against a light one. It then reveals both the spiralling pattern of each bird and the directional pattern of the whole flock.

Kittiwakes, Finnmark, Norway, 2011; Canon EOS 5D Mk II, 70-200mm lens, 1 sec at f16, ISO 50.

LAST SUNBEAM OVERLEAF LEFT

This is a traditional image, but it's the drama of light that makes it special. It reminds me of the chiaroscuro technique of baroque painters, invented by Caravaggio, involving dramatic contrast between light and shadow. This image was taken as the last rays of sun fought with drifting fog banks over the gannet rookery on Great Saltee. During a few exciting minutes, I waited to see what would happen first – the final exit of the sun or a gannet flying into my composition. Luckily the bird arrived first and the light faded a minute later.

Saltee Islands, Ireland, 2009; Canon EOS-1D Mk III, 24-105mm lens, 1/800 sec at f4, ISO 200.

FULMARS IN FLOODLIGHT OVERLEAF RIGHT

The platform for this shot was a fishing vessel off the Lofoten Islands. The catch had been good, and the cleaning of fish lasted till after dark. But the sea was rough, and so I stayed outside on the deck. Suddenly the floodlight was turned on, and I discovered that thousands of fulmars were still following the ship. It was a golden opportunity for motion studies. Hanging over the rail, dodging the huge waves and trying to keep the camera steady, I kept taking shots until, after half an hour, the light was turned off.

Lofoten, Norway, 2008; Canon EOS-1Ds Mk III, 24-105mm lens, 1/2 sec at f6.4, ISO 1250, flash.

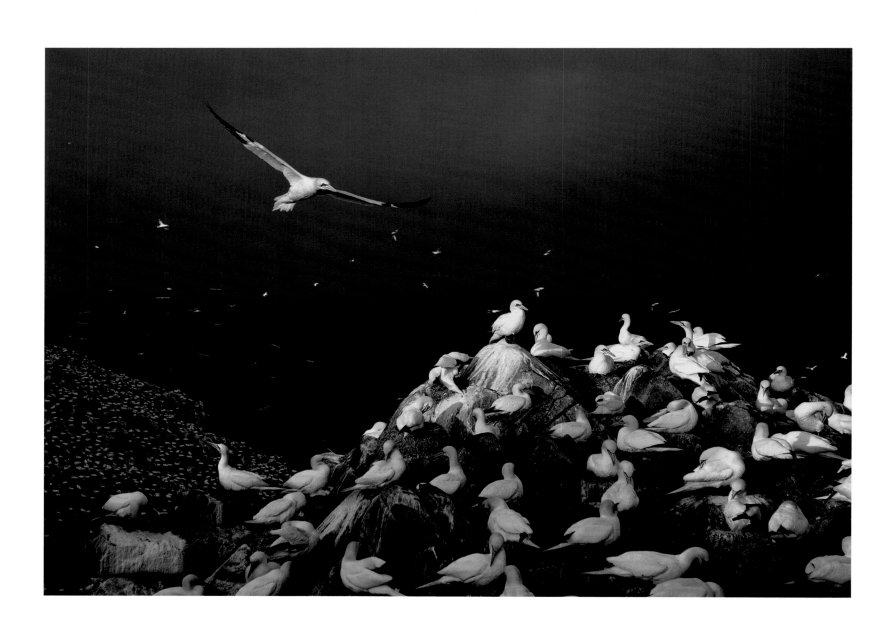

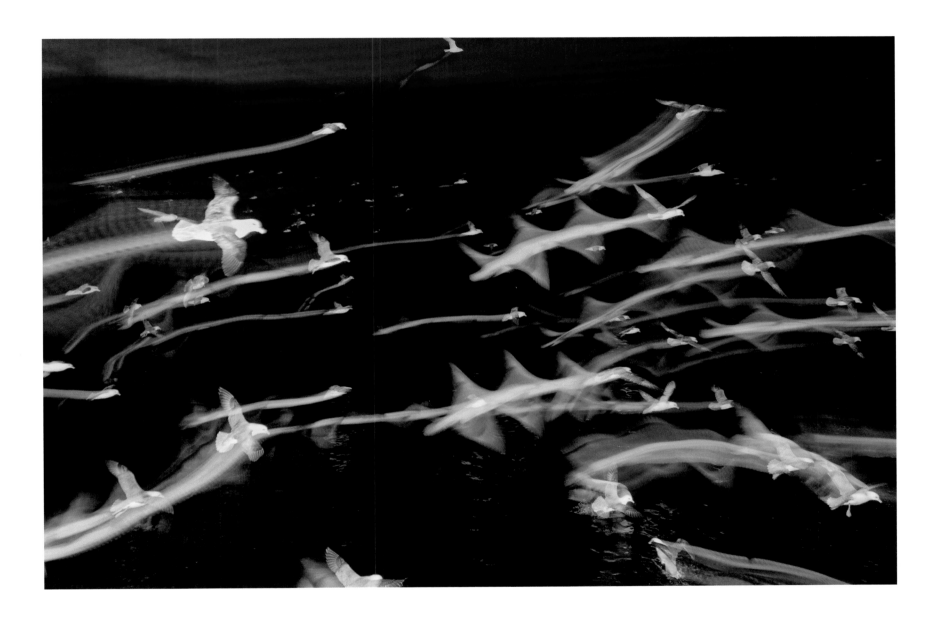

'I prefer images which have a quality of evasiveness – they don't reveal their true selves without a fight – some quality that unnerves the spectator and takes your attention captive. '

CHAOS

So many nature images tend to be 'tidy' and easy to understand. Nice when you see them the first time, but after a while, there is nothing more to find in them. Like cheap chewing gum – after a burst of exotic taste, it becomes an indifferent piece, of no interest. Here the picture shows layers of leaves and branches merging in a natural pattern. Some are reflections mirrored in a lake, some are actually in the water. As the foreground and background merge, the reality is difficult to understand. But then that chaos and confusion is the point of the picture. In Greek mythology, chaos was what existed before the world was created. I try to find chaos in nature and reflect it in my images. Chaotic images invite more interpretation and wonder than the simple, straight, beautiful images. A good quality-control for an image is to put it on the wall and look at it every day. If you are not bored with it after several months, the image is possibly a good one. Your experience may change day by day, relative to your mood – and the weather.

Mullsjö, Sweden, 2010; Hasselblad H3D 39, 50-110mm lens at 90mm, 8 sec at f29, ISO 50.

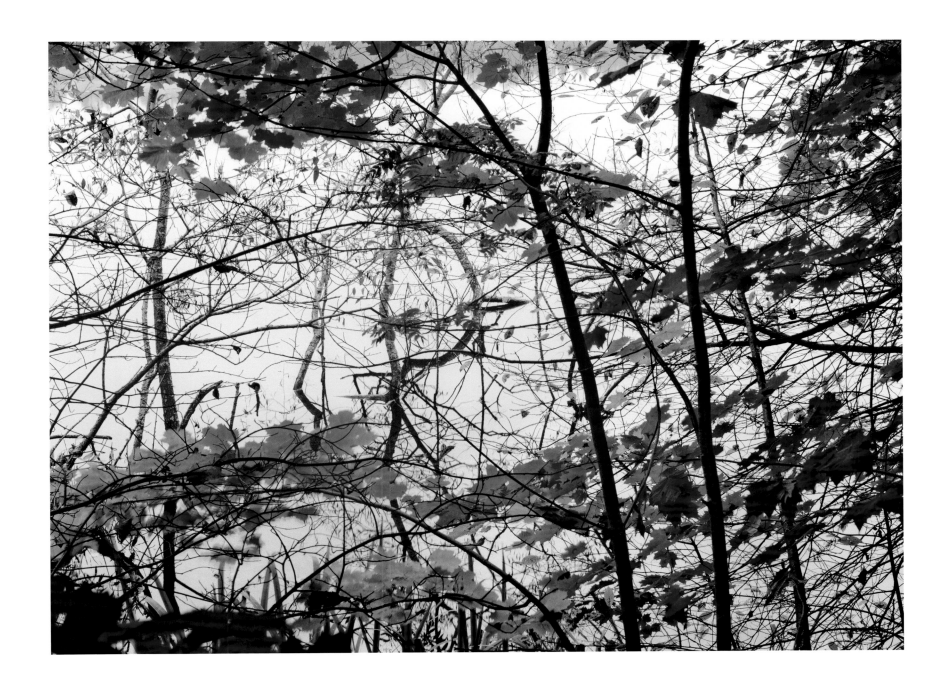

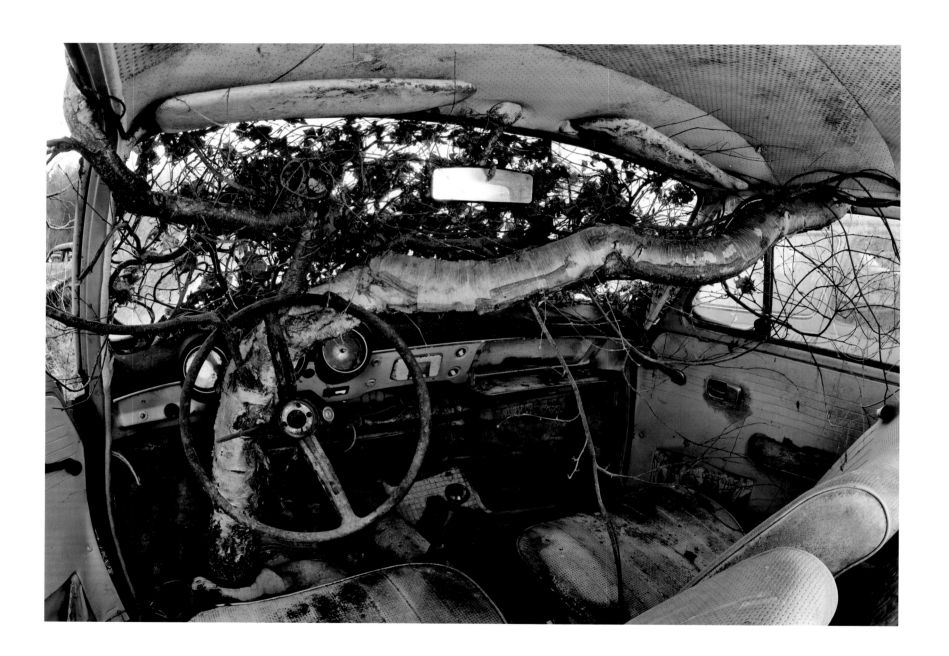

'On rare occasions, a picture has something engaging about it, a detail perhaps, some strange attraction that enables the viewer to make some special connection or association. Such a picture attaches itself to one's consciousness and remains – it somehow emanates a punctum, a certain point. '

TREE-TRUNK CAR

A birch tree forces its way up and out of the skeleton of a car, one of many old wrecks in a Swedish car graveyard being taken over by the forest. The interaction between nature and humans is one of my favourite topics. Rather than taking images that tell a story about overexploitation, pollution and greed, I'm now trying to show how nature takes its revenge, how its power is strong. Even in a static image like this one, I can almost hear the breaking forces of nature. The car, human symbol of engineering and prosperity, is in the end transitory.

Värmland, Sweden, 2011; Hasselblad H3D 39, 30mm fisheye lens, 1 sec at f16, ISO 100.

THE GREAT WALK-OUT

For me, no creatures are as impressive as
emperor penguins. Their adaptation to such
a harsh environment, their size and beauty
and the confidence they show us humans
is extraordinary. A visit to their colony
on the drifting ice is a lifetime memory.
Photographically, however, the stunning
impression they make has been captured
so many times that images of them when
viewed far from Antarctica often appear
too similar and without that special nerve.
This image is the only one I'm left with after
a tough selection from many thousands of
emperor penguin images. What do I see in it?
I guess it's something about the human-like
postures of these creatures in the blizzard,
heading to an uncertain future.

Weddell Sea, Antarctica, 2008; Canon EOS-1Ds Mk III,
28-300mm lens, 1/200 sec at f18, ISO 200.

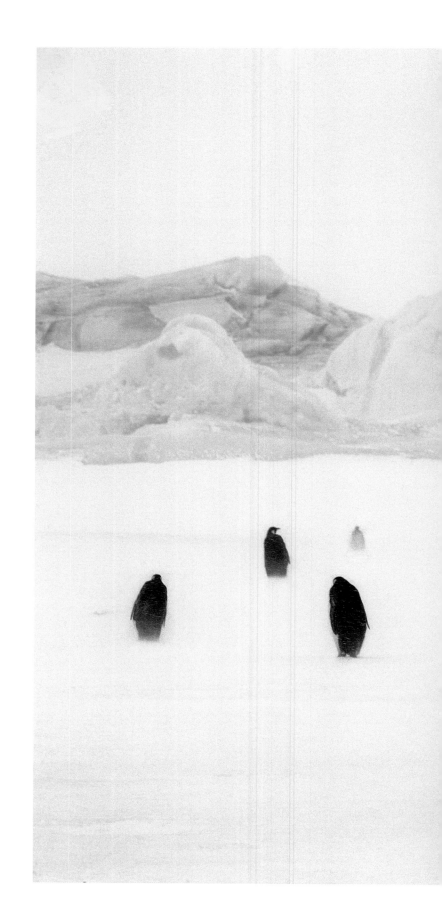

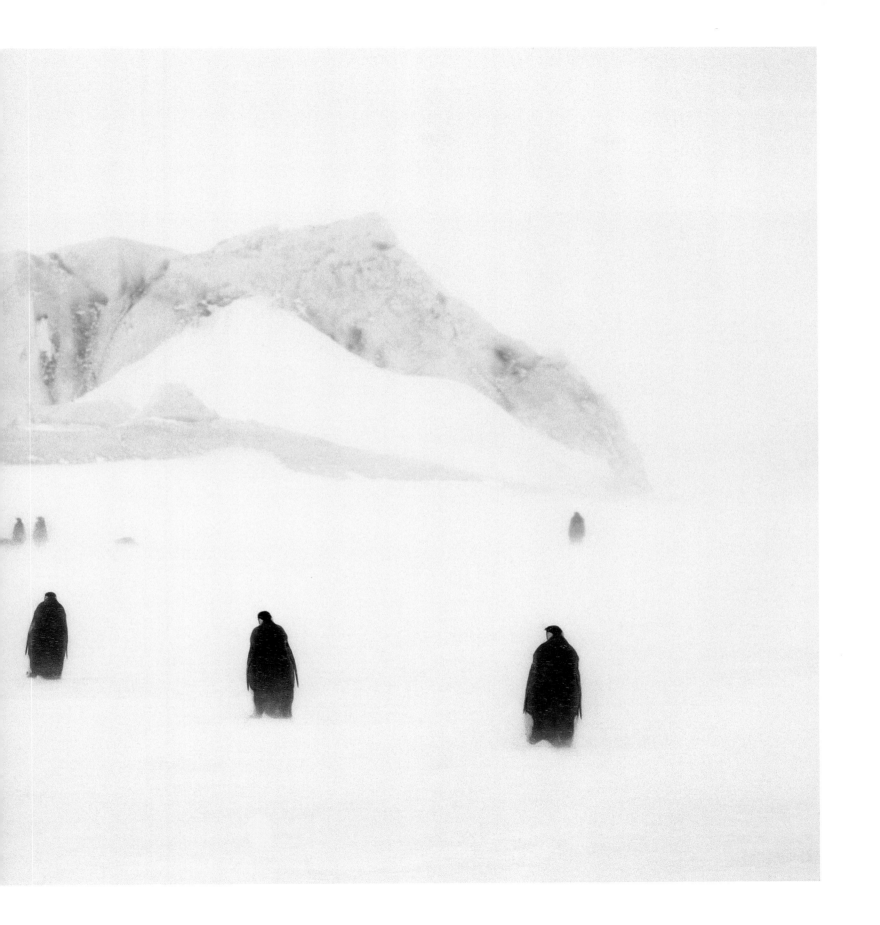

EQUILIBRIUM

In the early twentieth century, Alfred Stieglitz
made a series of images of the sky that
he called Equivalents. The contemporary
Japanese photographer Hiroshi Sugimoto
has created a series he calls Seascapes.
Both sets of images have a timelessness
and lack of place. This shot leaves me with
some of the same sensation. It's a sort of
equilibrium between the sea and the sky –
an image that tells no specific story but is
open to interpretation. It was made in the
Canadian Arctic off Baffin Island, from the
top of an icebreaker. The sea was absolutely
flat, and a thin layer of fog had wiped out the
details of the water. It was August, when the
sun disappears below the horizon for just a
few hours each night. I was on deck at four
o'clock, just after the sun had risen into the
fog – a time of unearthly experience.

Canadian Arctic, 2001; Fuji GX 6x17, 90mm lens, 1/500
sec at f16, Fuji 400 film.

FRANS LANTING

Frans Lanting has probably had more influence on more nature photographers than anyone else.

Getting down on the ground for an eye-to-eye encounter is something that most nature photographers do today as second nature. But it was Frans in the early 1980s who first used such an intimate viewpoint regularly in his work. It was that kind of perspective, his adoption of sophisticated lighting techniques, his careful choice of background and his determination always to be original which have resulted in a catalogue of classic images that have been copied by so many other photographers.

As a boy growing up in the Netherlands, Frans was 'always looking at pictures' in magazines and books, and he was an investigative, self-taught naturalist. But he has had no formal training in photography, art or biology.

'I'd been trained as a social scientist. And the idea that I could become a photographer didn't occur to me until I was in my twenties.' And he says of his originality, 'I didn't know enough about photography to know the rules, and so I could invent my own styles.'

It may be that his social-science training gave him 'a different way of looking at the world – a curiosity to get under the skin of a subject.' Such curiosity also meant that he read widely about European artists and about science. But his biggest inspiration came when, aged 21, he set foot on the West Coast of the US. 'The phenomenal beauty and wilderness of the western United States was a real eye-opener.'

His disappointment with the pictures he took there – his very first, with a 'snapshot camera' borrowed from his mother – was the spur to teaching himself about photography, and experimenting with landscapes back home in the Netherlands. The West Coast, however, was where he wanted to be, attracted 'not just by the grandness of the landscape but also the restless spirit of the place'. In 1978, he moved to California, originally to do academic research on environmental planning, but in 1979, he took the risky decision to become a professional photographer.

'I discovered photography as it had become an artistic tradition and a lifestyle in the US. The great wilderness photographers, such as Ansel Adams and Edward Weston and

Wynn Bullock and Philip Hyde, were among my early heroes. In Europe we didn't have any role models like that. And I thought that perhaps I could become part of this tradition.'

Within a few years, he began to receive international recognition for his work, initially with common subjects such as sanderlings and elephant seals, whose behaviour and characters he revealed as no one had before. And pretty soon he began to do assignments for *Life, Geo* and, from the mid-1980s, *National Geographic*.

Three decades later, Frans still lives in California. But he describes himself as a world citizen, the result of having spent long periods in the field on assignment for *National Geographic* on every continent. The story-telling tradition of the magazine has, he says, been a major influence on his work.

Over more than 25 years, his assignments have included pioneering work in Madagascar and Botswana and a year-long odyssey around the world to assess global biodiversity at the turn of the millennium – a story which filled a whole issue of the magazine.

The aim of telling a story has long been second nature to him, combined with a drive to show his subjects in new and unforgettable ways. Such assignments involved 'huge amounts of work researching a subject, planning expeditions, developing relationships with people on location – understanding the social, economic and cultural context and that there are always environmental issues which cry out to be covered'. The result of those decades of work has also been a number of classic books, including *Okavango: Africa's last Eden* and *Eye to Eye: Intimate encounters with the animal world* – a collection of some of his most memorable portraits.

Not surprisingly, Frans is the recipient of many major honours, including the Wildlife Photographer of the Year Award (1991), the Sierra Club's Ansel Adams Award and repeated top honours from World Press Photo. He has also been inducted by Prince Bernhard as a Knight in the Royal Order of the Golden Ark, the Netherlands' highest conservation honour.

His biggest project so far has been 'LIFE – A journey through time' – his seven-year quest to interpret the story of life on Earth. It was launched in 2006 as a book, a travelling

exhibition and a website. It also resulted in a multimedia symphony, which marries Frans's images with a musical score by Philip Glass – an ambitious work that has been performed by major symphony orchestras around the world.

Frans is now looking with fresh eyes at his own backyard – a wild part of the coast of California – as the inspiration for a new quest.

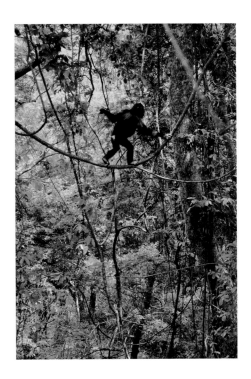

'I like the use of arrangements – mixed perspectives incorporating human elements and not just pure nature – breaking the boundaries of what we conceive of as nature. I suppose I'm restless and keep looking for new ways to make the natural world relevant both artistically and stylistically.'

A WORLD OUT OF TIME

My mission was to visualise ecological tragedy unfolding in Madagascar. It had been isolated from the West, and when it opened up to donors and to WWF in 1985, I was lucky enough to be the first photographer to document its conservation issues and natural history. With nothing photographically on record, it yielded a treasure-trove of discoveries. I even photographed a species of lemur that hadn't yet been named – it doesn't get any more exciting than that. My aim was to create images that not only revealed Madagascar's unique nature but also the conflict between humanity and nature. Nothing is more symbolic of that than the elephant bird – the largest bird that ever walked the Earth, more than 10 feet tall and flightless. Like 80 per cent of the plants and animals found on this island, it lived only on Madagascar. But it went extinct in the wake of human colonisation of the island and was last recorded in the seventeenth century. I set up this picture in the spiny desert, with a backdrop of thorn-covered Malagasy desert plants against the evening sky. An Antandroy tribesman holds the giant egg of an elephant bird. Selective lighting creates the disturbingly surreal effect. It's a picture that for me symbolises Madagascar as an ancient world, running out of time even faster than we feared.

Southern Madagascar, 1985; Nikon camera, 24mm lens, Vivitar 285 flash.

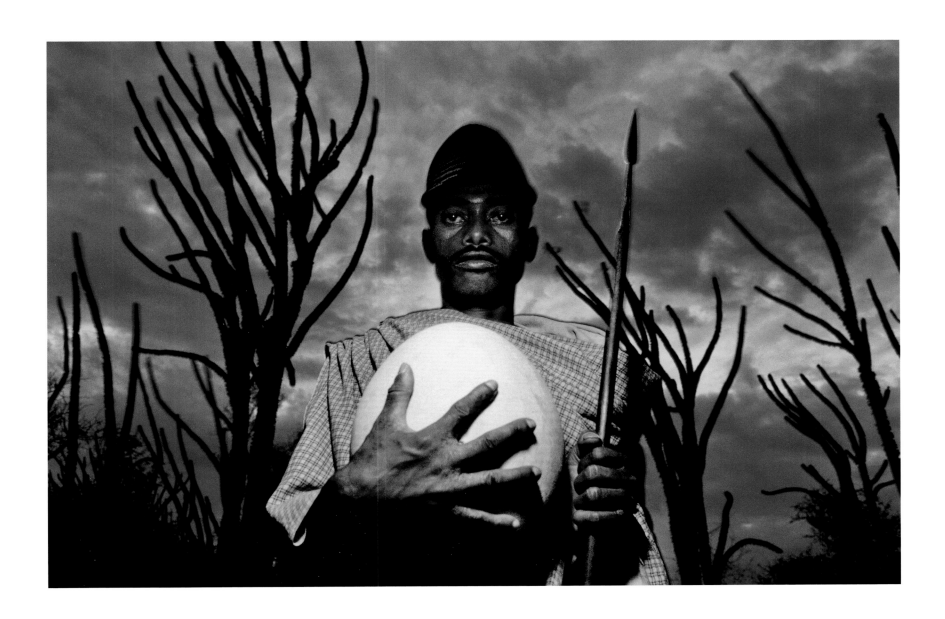

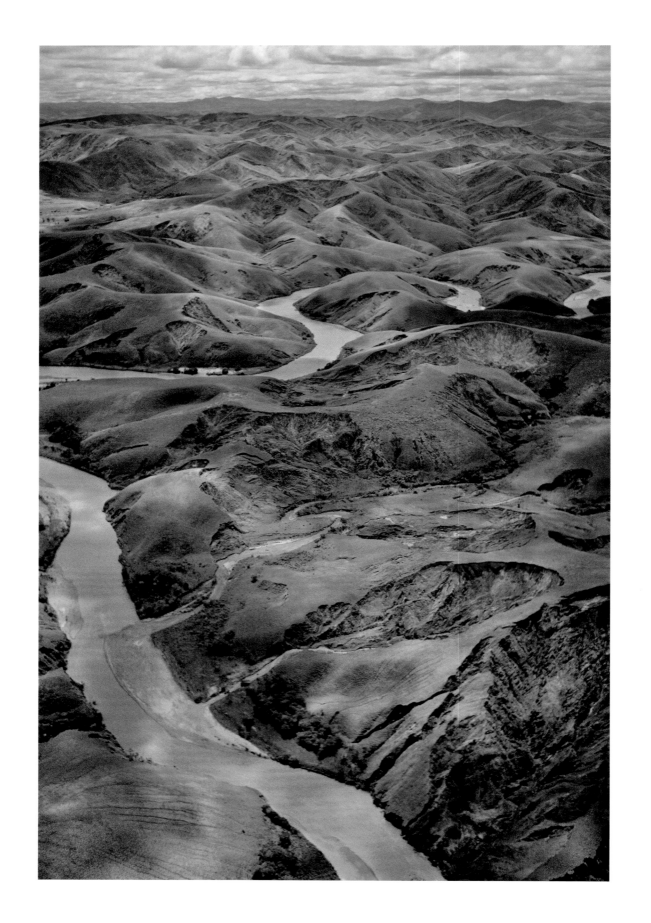

' It's not enough any more to play out
the romantic notion of being an individual
communing with nature. The world is
different from how it was a generation ago. '

A RIVER RUNS RED

This is a simple picture, the result of being in the right place at the right time with the right cause.
It shows the central highlands of Madagascar stripped of vegetation and eroded by rain, the
massive run-off turning the river red. It's also the product of research. I consulted with friends
to find out where the most dramatic effects of deforestation could be seen, chartered a plane
and took the shot out of the window using a wide-angle lens. There's very little artistic about the
picture. But it is evidence in the cause of conservation photography – an explicit encapsulation of
the problem of soil erosion. Its impact was to show how urgent the situation was in Madagascar
and to trigger the first wave of foreign aid.

Central Madagascar, 1985; Nikon camera, 24mm lens.

'Key is not to take nature at face value but to imagine things. In the words of Gauguin, don't spend too much time looking at the way it appears. Dream on.'

ALOE AT SUNSET

There are more than 120 species of aloe in Madagascar. Many are endangered and most are found only on this treasure-house of an island. This amazing specimen, with its candelabras of red flowers, is a Malagasy tree aloe, with a trunk 12 feet tall. I wanted to take a powerful portrait of it as I might take one of a magnificent animal. Kneeling below the aloe, I silhouetted it against the intense glow of sunset – a sunset caused by dust from the eruption of Mount Pinatubo, 5,000 miles away. To enhance the drama, I used a flash to light up the aloe, a technique which in the mid-1980s was not often used by photographers of nature. The photograph has survived time. The species may not.

Southern Madagascar, 1985; Nikon camera, 135mm lens, Vivitar flash.

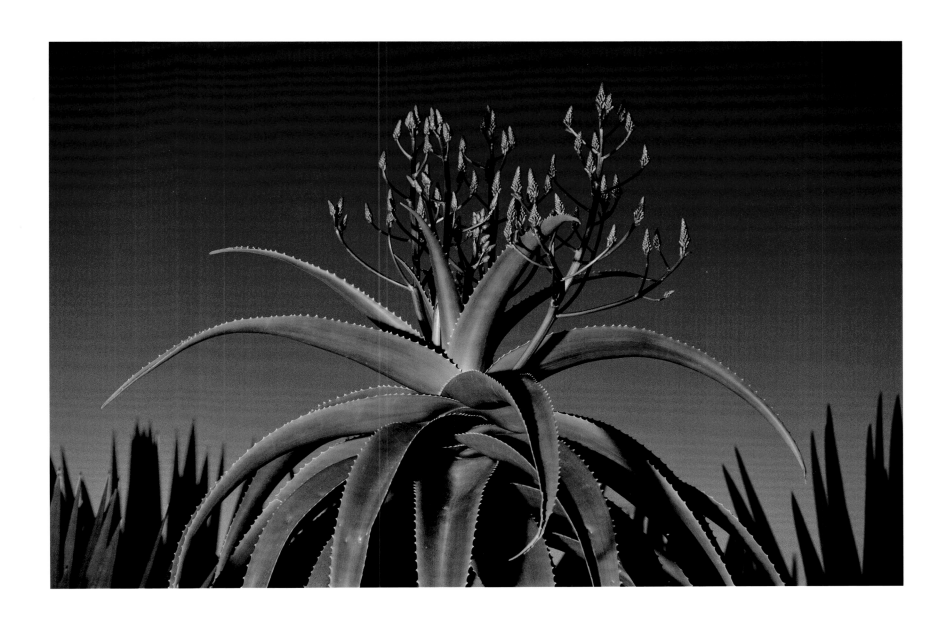

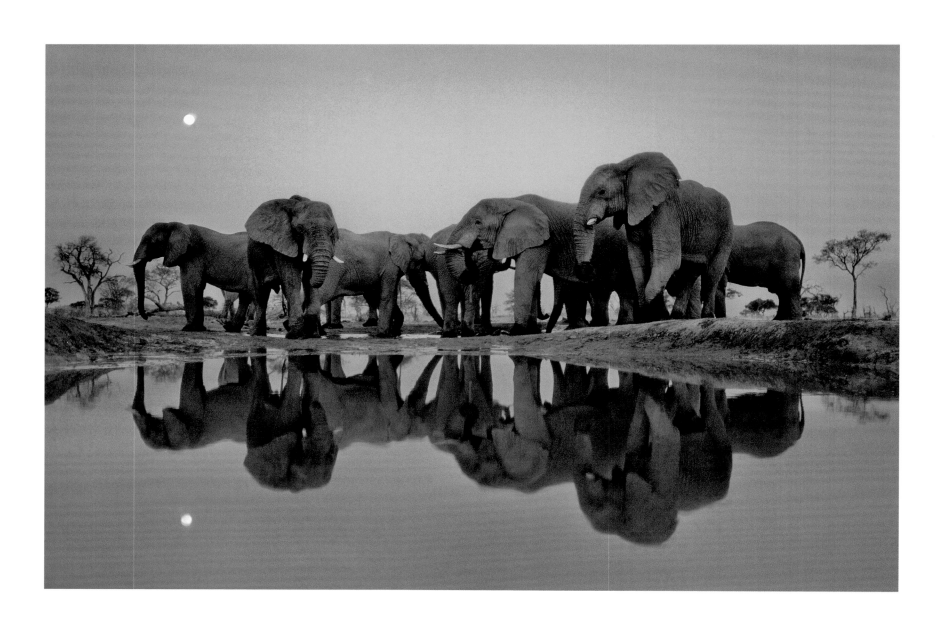

' I always want to get under the skin of the
animals I work with, and I don't achieve that
standing tall with my camera on a tripod.
It's important to get into an animal's world,
mentally, emotionally and physically. '

TWILIGHT OF THE GIANTS

This is an image I'd walked around with in my mind for a while. But in all the weeks I had worked
at this waterhole, this was the only time that the conditions were perfect. I'd come every morning
and afternoon, making myself a fixture in the landscape, sometimes working through the night.
On this particular evening, a herd of bulls came to drink. For a short time, a group gathered
across the water from me, just as the full moon started to rise, with the pink light of the dying
sunset reflecting back onto the landscape and the elephants – a primeval scene of ancient Africa.
To capture the full reflection of the elephants, I had to wade waste-deep into the water. That was
tricky, as a bull coming behind me could have put me in an uncomfortable position. But I'd learnt
a lot about body language from local guides who'd worked with elephants on foot, and these
elephants were relaxed. I used a wide-angle lens and a neutral-density filter to reduce the contrast
between the sky and the landscape. For me, the picture has a monumental message – the last
mega-mammals on Earth, running out of time.

Okavango Delta, Chobe National Park, Botswana, 1988; Nikon camera, 24mm lens.

A GRAND PERSPECTIVE

I wanted to contrast the archaic shape
of an elephant and the modern form of
an impala as they both drank from the
same waterhole. I positioned myself flat
on the sand so that the elephants were
in the foreground and then used a long
lens to compress the distance between
the animals, which had the optical effect
of making the elephants seem larger than
they already were. Juxtaposing big and
small animals this way was a breakthrough.
By choosing a certain perspective and a
certain lens and then cropping the elephants
so dramatically, I could make them look
enormous. It's a concept that's found its
way into the vocabulary of quite a few other
photographers since then.

Chobe National Park, Botswana, 1989; Nikon camera,
400mm lens.

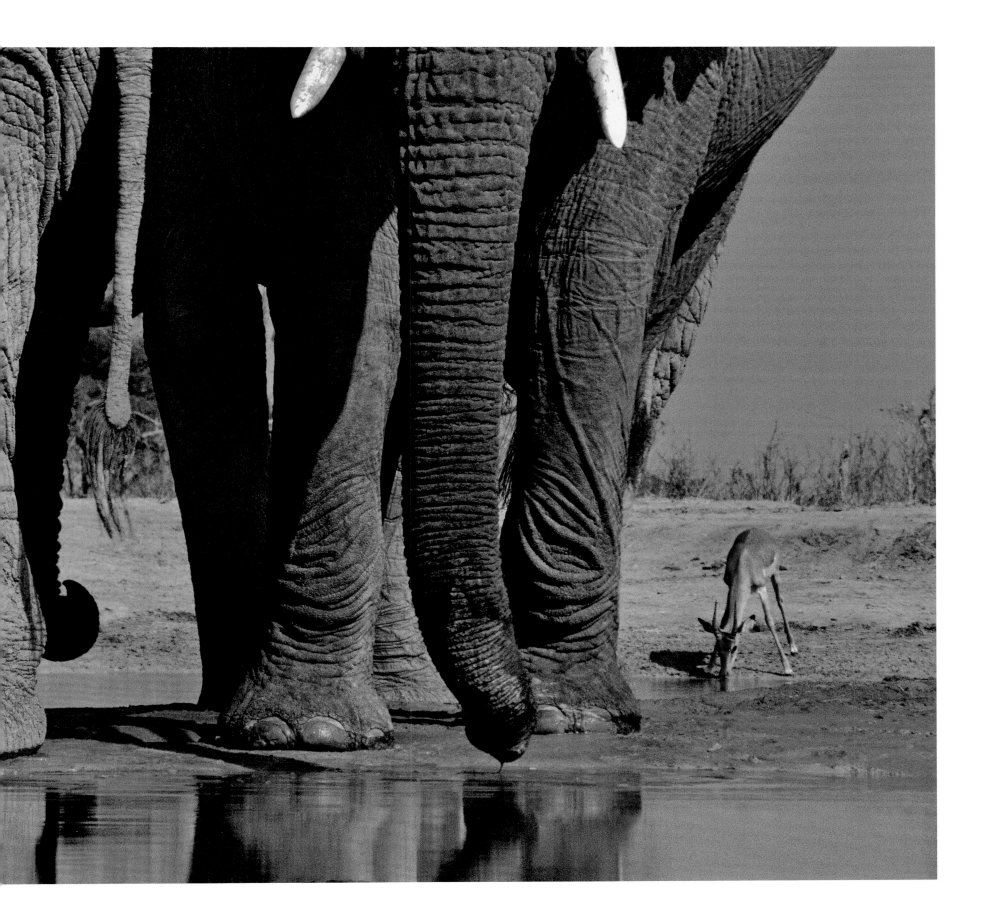

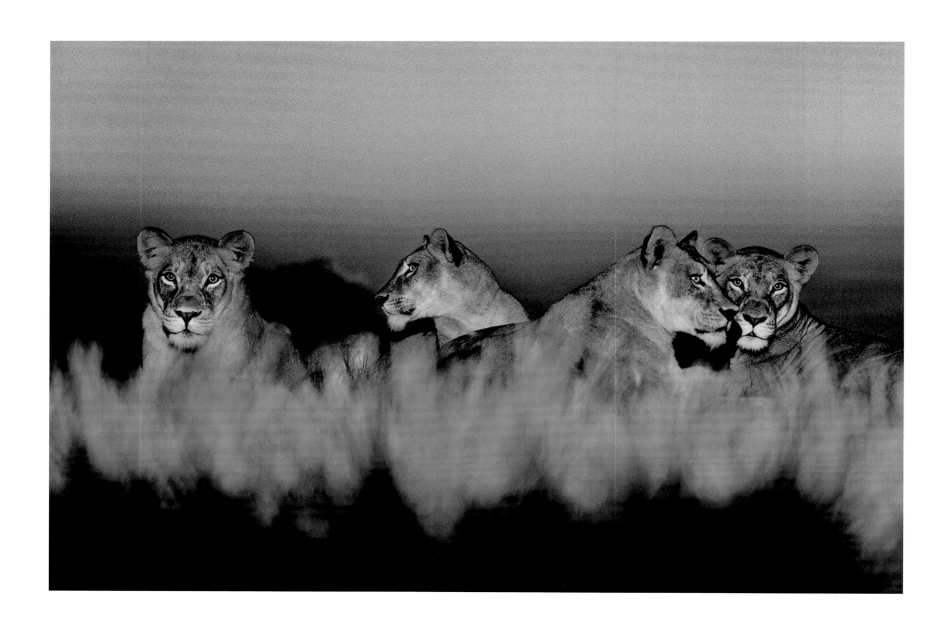

THE FOUR SISTERS

Every night for a month, I followed a pride of eight lionesses. An assistant would keep an eye on them during the day, and I would wake up with the lions and track them at night. I got to know them well, and they got used to me, and when conditions allowed, I would photograph them from down in the grass to get an intimate perspective. I used flash-fill to illuminate the foreground and match the ambient light. Working one-on-one like this with unpredictable predators is tricky, and you can't do it without being really in tune with your subjects and, ideally, with someone watching your back. I needed to pay attention to every bit of body language and back off the moment I sensed anything threatening. But at this encounter the lionesses were alert, yet not alarmed. There's a sense of recognition but not confrontation.

Chobe National Park, Botswana, 1988; Nikon camera, 300mm lens, Metz strobe.

A RAINFOREST LANDSCAPE

One of the hardest photographic challenges
I know is to interpret the grandeur of a
tropical rainforest. There is a gap between
our perception of this biome and the ability
of a camera to capture the nuances. Tropical
forests are an epitome of biodiversity, and so
we expect to see a variety of textures, shapes
and colours. But I have rarely found an
opportunity to express that all in one image.
You need openness to see the architecture
of the forest. A river valley will give you that,
and it can show the forest edges. A river
also creates a channel for the eye to follow.
Landscape painters have known this for
centuries. I was working in the Danum Valley
in Sabah and had come to this overlook a
number of times, but not until that morning,
after a downpour, when mist was rising and
the light was just right, did everything fall
into place. Dappled sunlight filtered through
the mist, spotlighting patches of vegetation,
leaving others in textured shadow. The
resulting variety and lushness corresponds to
the way we would like to imagine a rainforest.

Danum Valley, Sabah, Borneo, 1991; Nikon camera,
200mm lens.

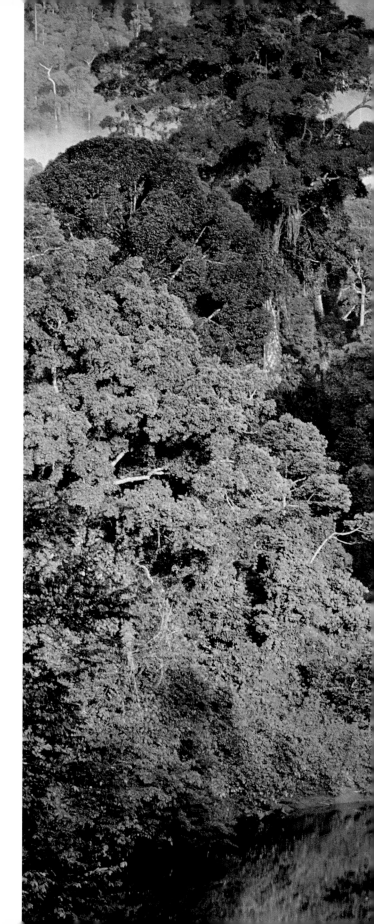

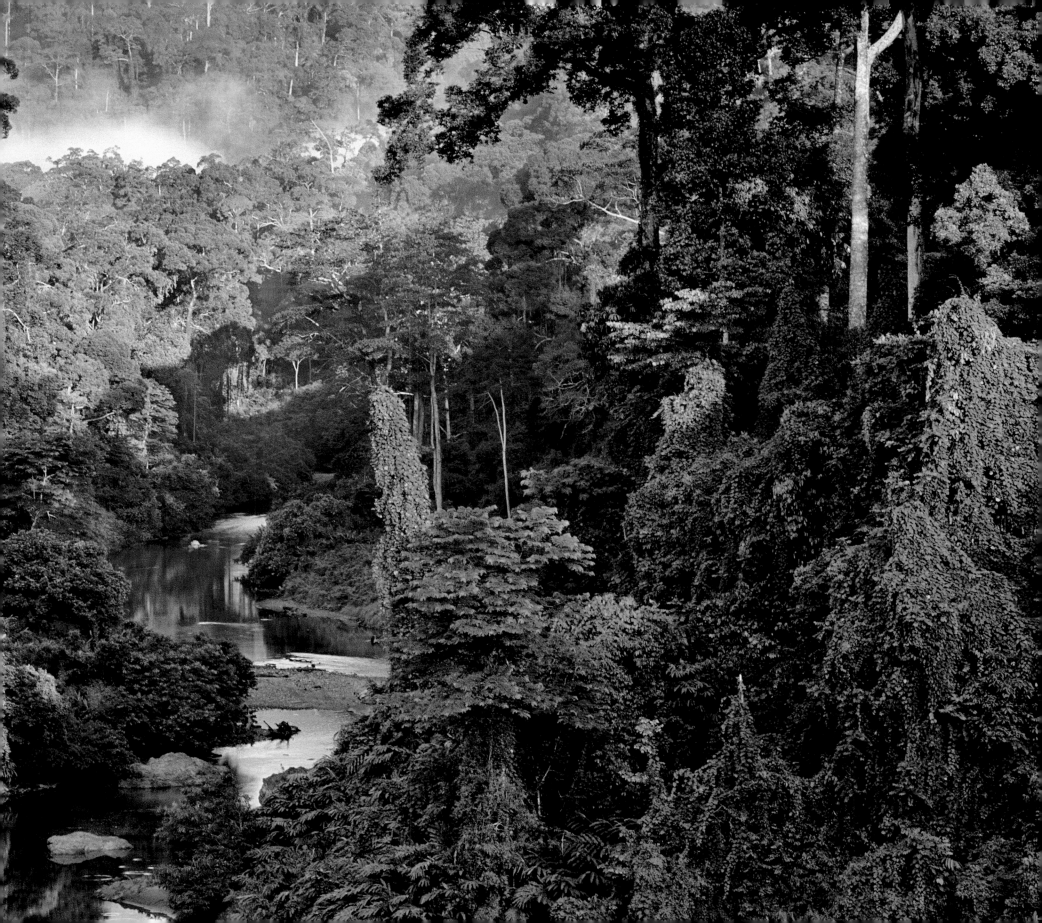

FRANS LANTING

STROMATOLITES AT DAWN

Low tide at sunrise exposes the cracked domes of stromatolites lining the shore of Australia's Shark Bay. These are living structures. The surfaces are the newest layers of sediment formed by communities of cyanobacteria. As early as three billion years ago, the ancestors of these micro-organisms began to release the oxygen that altered the Earth's atmosphere and created conditions favourable for the evolution of complex life, and that includes us. Photographing them under the spreading pink clouds of sunrise hints at that remarkable change in the air. For many years, the only pictures of stromatolites were made by geologists for textbooks. I worked hard to create an image that would transcend that view. I wanted people to be transported back to a primeval time when nothing else was alive. For me, that early morning sky and those clouds full of water vapour and oxygen symbolise the emergence of a new world under a primeval sky.

Shark Bay, Western Australia, 2003; Nikon D1x, 17-35mm lens, 6 sec at f22, ISO 125.

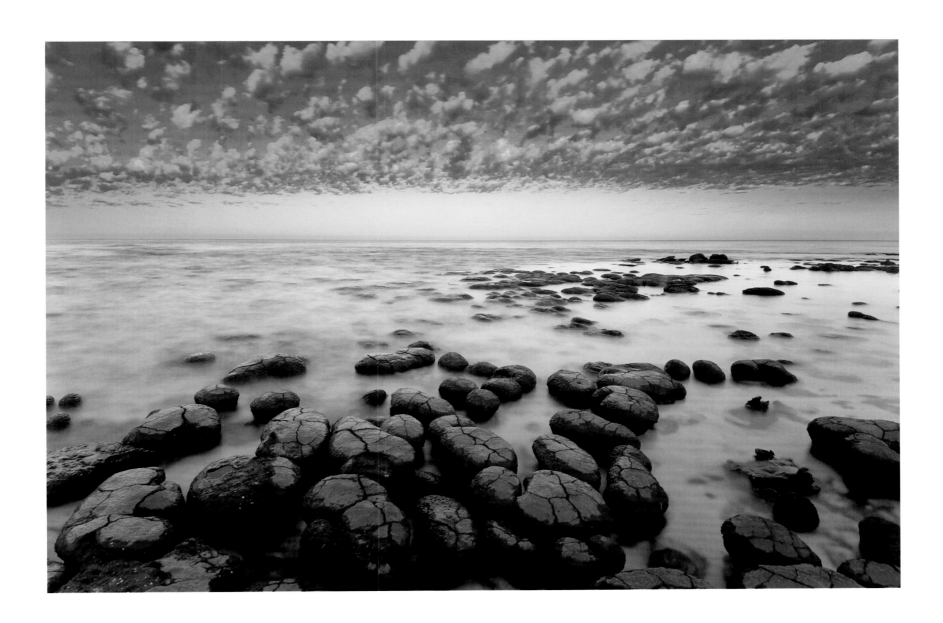

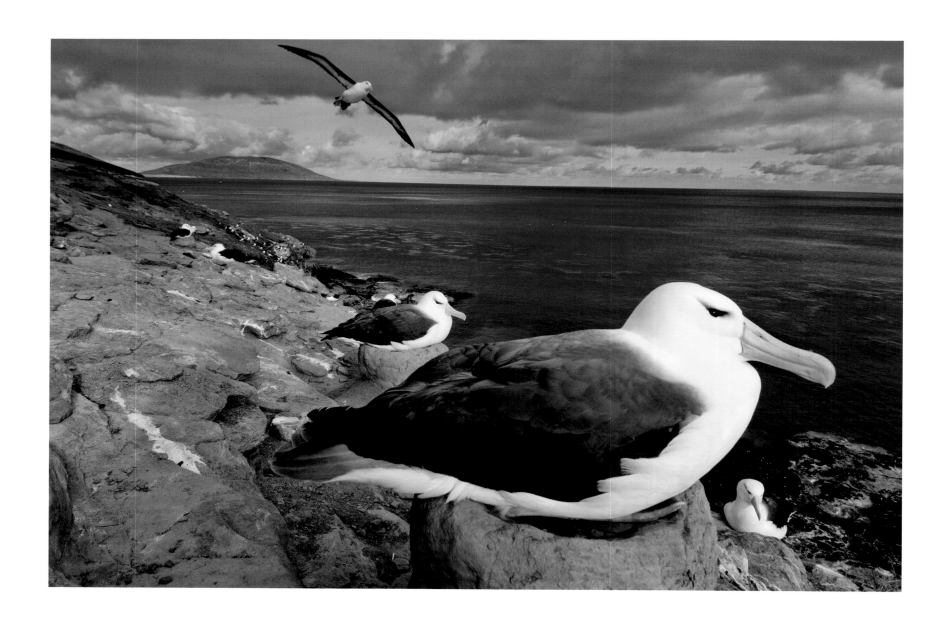

‘ When I started, wildlife photographers
were wedded to long lenses, but for decades
I experimented with wide-angles as a way
to create images that can show the whole
environment and not an animal apart –
a style that's now part of the standard
repertoire of many wildlife photographers. ’

ALBATROSS COLONY

What I wanted to do with this image was to create a relationship between the black-browed
albatross on its nest looking out to the open ocean and another individual in the air. The key to
such an intimate portrait was to find a bird that was photogenically positioned and calm enough
to become my character. I had to come really close to it, but at the same time I was respectful.
I know albatrosses well, understand how to approach them and can tell when they're not happy.
The light unifies this picture, which was composed with the diagonal of land running through
the albatross and with its face highlighted, set against the ocean. The hardest part was to fix
the counterpoint of a flying albatross to give a sense of energy and animation. It defines the
essence of this grand pelagic bird. The partner of a nesting albatross like this one may be a
thousand miles away at sea, but it is bonded for life and will return to its mate.

Saunders Island, Falkland Islands, 2007; Nikon D2x, 17-35mm lens, 1/320 sec at f8, ISO 100.

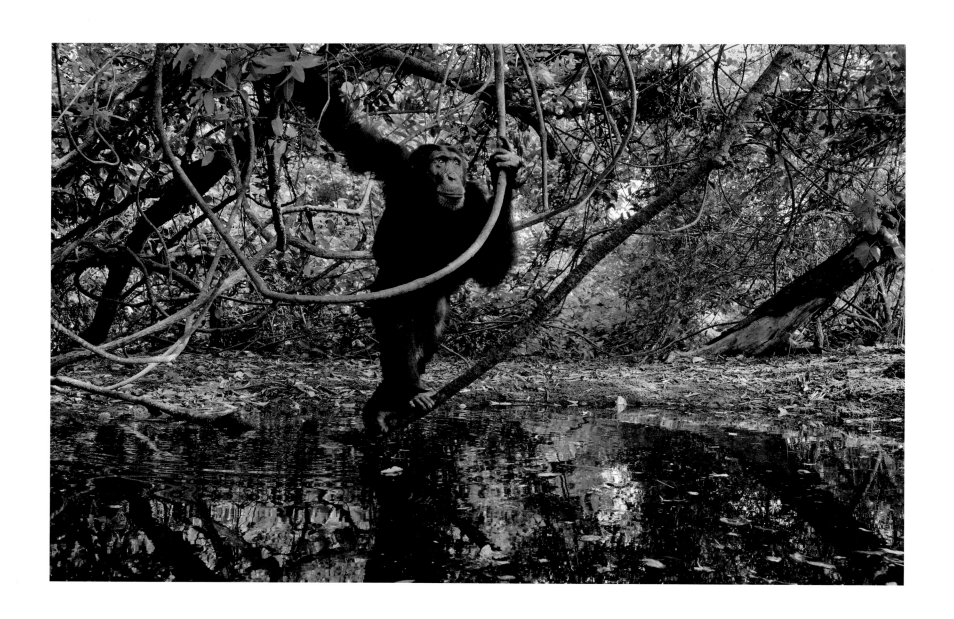

THE BATHING POOL

There are chimps that live not in tropical rainforest but in lightly wooded habitats similar to the environment in which the first hominids lived. I spent two months tracking one such group in Senegal. They were barely used to the one researcher who had gained their trust, and it took weeks before they tolerated me. We would set off at 4am to get to where we'd seen them go to sleep the evening before and then follow them on a gruelling march in 100 per cent humidity, carrying 50lb packs. I lost a lot of weight and call this kind of workout my chimp diet. These chimps love water as it is so beastly hot. At the start of the rainy season, this one pool fills up like a bathtub. To photograph the chimps here, I had to be very cautious. It's difficult to fool them. I put a camera with a remote trigger at the edge of the pool to create an intimate perspective. I then sat at a distance, watching through binoculars, waiting for a key moment to trigger the camera. Chimps are such emotional creatures – some border on neurotic. This male is one of the more relaxed ones, just leaning forward, about to enter the water. It was like peering into his bathroom. Working with these chimps was mentally and physically one of the greatest photographic challenges I've tackled yet.

Fongoli, Senegal, 2008; Nikon D200, 12-24mm lens, 1/250 sec at f8, ISO 800.

THOMAS D MANGELSEN

Thomas Mangelsen never owned a camera, never dreamt of becoming a photographer and didn't take his first picture until he was 22. But he gained a lifelong love of 'the beauty of nature' and an understanding of animal behaviour from a childhood spent out of doors, running wild.

In his early years he roamed the sandhills of western Nebraska, searching for animals or collecting arrowheads and skulls, and when his family moved to a one-room cabin on the Platte River, he virtually lived out of doors, exploring the river, hunting and fishing, always with his old pair of binoculars and a burning curiosity about what he was observing. 'I always wanted to capture the essence of what I saw, but I never knew how.'

The more he became fascinated with wildlife, the less interested he became in hunting. 'Watching the formations of geese crossing the wintry sky against the cottonwoods, I often wished someone would go there to make a painting.' He also observed the dramatic changes in water levels caused by irrigation and dam-building – something his father fought against for 30 years. 'My father was the first environmentalist I ever knew.'

He went on to study biology at the University of Nebraska, where he met Paul Johnsgard, a world authority on waterfowl, an artist and a photographer. Tom became his assistant, travelling to bird refuges around the United States, and Johnsgard taught him not only about bird behaviour but also photography. 'Birds in flight were the most interesting to my developing eye, and the most challenging.' But pictures then were mostly taken 'as you might view an animal or bird through the crosshairs of a rifle scope'. What changed everything for Tom was looking at the work of wildlife art and artists.

First he met Owen Gromme, illustrator of *Birds of Wisconsin*, a master artist and an outspoken conservationist. He was one of the first wildlife artists to do limited-edition prints. 'I naively thought, why can't you do that with photographic prints?' Five years later, he did just that, which led on to his Images of Nature galleries selling prints of his work, now in six US states – something few photographers have achieved. He went on to discover other artists, such as Louis Agassiz Fuertes ('he captured the internal spark of a bird'), Andrew Wyeth ('his compositions still amaze me') and Robert Bateman, who 'once said of one of

my pictures, "that looks like a Bateman," the greatest compliment I could get.'

Around the same time, in the early 1970s, he started shooting 16mm film for a small company, 'believing that films could be a more effective way to tell the story'. This led on to films about the Platte River and the sandhill and whooping cranes, including *Cranes of the Grey Wind* for PBS and the BBC. But he still wanted to 'seize the moment that epitomised an animal in its landscape'. Then in 1985 he discovered the Fuji GX-617 panoramic camera. No one was using it to shoot wildlife, mainly because of the relatively slow lenses, shallow depth of field and the higher shutter speeds required to freeze movement – 'inherently challenging for wildlife photography, but also very rewarding if you get it right'.

He did get it right, winning the Wildlife Photographer of the Year Award in 1994 with one of his first panoramics (see page 100) and going on to publish *The Natural World*, a collection of 120 of his panoramic pictures. Other awards include the North American Nature Photographers Association's Outstanding Nature Photographer Award and

recognition as one of Nikon's Legends Behind the Lens and one of Jane Goodall's *Heroes* on the network Animal Planet. His work has been published widely, including in *Audubon, National Geographic* and *Life,* and his images have been exhibited in museums around North America and Europe.

Tom is also passionate about wanting to help others to discover what he has over the years and to feel as he does about the importance of protecting habitat. In 2001, he co-founded the Cougar Fund to help protect the cougar (or puma or mountain lion) through education and monitoring of hunting policies. He also campaigns against game-farm photography –

'the business of making money by keeping wild species captive for photography, film-making, art and workshops' – and is an advocate for presenting images of nature wild and free in their true form, without computer manipulation.

He still spends up to seven months a year in the field, mainly in the wilderness areas near his home in Wyoming, in Alaska or in Africa, and his passion remains to convince others of the beauty and value of such wild places, 'to capture in one image an animal in its landscape that says this is where the animal lives. This is the mood of moment. This is how it is and how it should remain.'

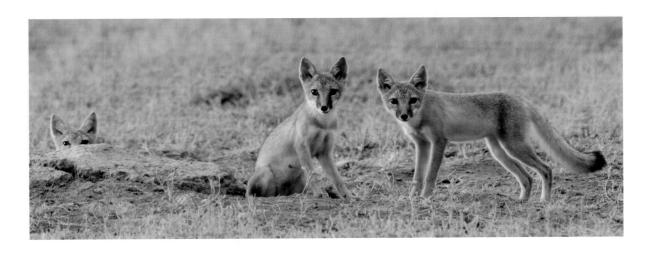

AMERICAN KESTRELS

It's a stark scene, with a wintry, white sky and dead aspen limbs covered with snow. But graphically, it remains my favourite bird image – a contrasting combination of negative space and angled branches, splashes of colour and the soft detail of feathers. It was early May, when Yellowstone was starting to come alive after a long, frozen winter. I was looking for grizzlies – just out of their dens – when I heard the *klee, klee, klee* calls of a pair of kestrels and spotted them landing in a grove of aspens. I watched them for hours. As the female searched for a nest hole, the male caught deer mice for her. He aggressively defended their territory, engaged in combat with red-tailed hawks and attacked another male kestrel, crash-landing into the powdery snow below. As the female called, he released his grasp on the intruder and returned to her on the aspen limb, where they copulated. I made this picture as they rested – the little male's beak opened wide in a yawn. It was a big day in the life of kestrels – and a memorable one for me.

Lamar Valley, Yellowstone National Park, Wyoming, USA, 1984; Nikon F3 camera, 600mm lens, 1/500 sec at f5.6, Kodachrome 64.

THOMAS D MANGELSEN

' Patience usually has its reward but is often not enough. You have to be thoughtful and persistent and previsualise those potentially special images. I've been lucky, but I've had to wait and work for that luck. '

CATCH OF THE DAY

This is my most iconic image, copied more than any other – the split second before the grizzly moved his head and shut his jaws on the sockeye salmon. At the time, no one believed the picture was real. But it was shot on film, the result of planning and luck. I made the image at the now-famous Brook Falls, where the grizzlies congregate annually to feast on salmon coming upriver to spawn. Every day, I'd hike the two miles from my tent to the viewing platform, set up my tripod and focus on a group of bears stationed above the falls. They would stand for hours waiting for salmon to leap near enough to grab with their paws or catch in their mouths. The exposure, speed, depth of field and serendipity would be more critical than usual. The composition would have to be tight enough to make a viewer feel the spray from the cascading water and the rush of sockeye salmon against his legs, to smell the great bear's breath – that was the tension I wanted. I saw the moment several times, which was special enough, but it happened so fast and there were so many variables that it was weeks later, when the film was developed, that I knew I'd caught that millisecond between mouth opened and mouth closed.

Brooks Falls, Katmai National Park, Alaska, USA, 1988; Nikon F3, 600mm lens + 1.4x teleconverter, 1/1000 sec at f9, Fujichrome 50.

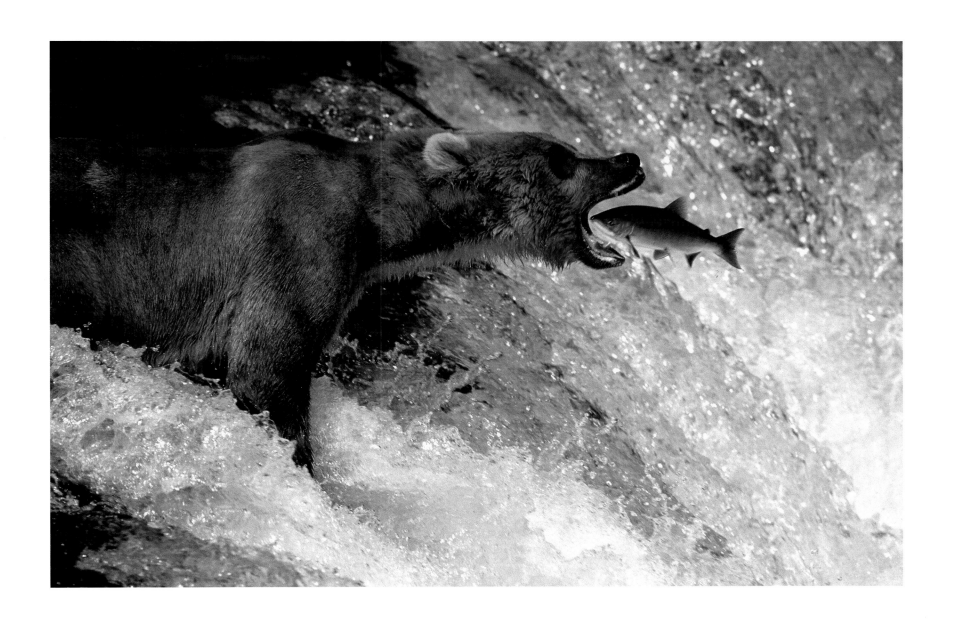

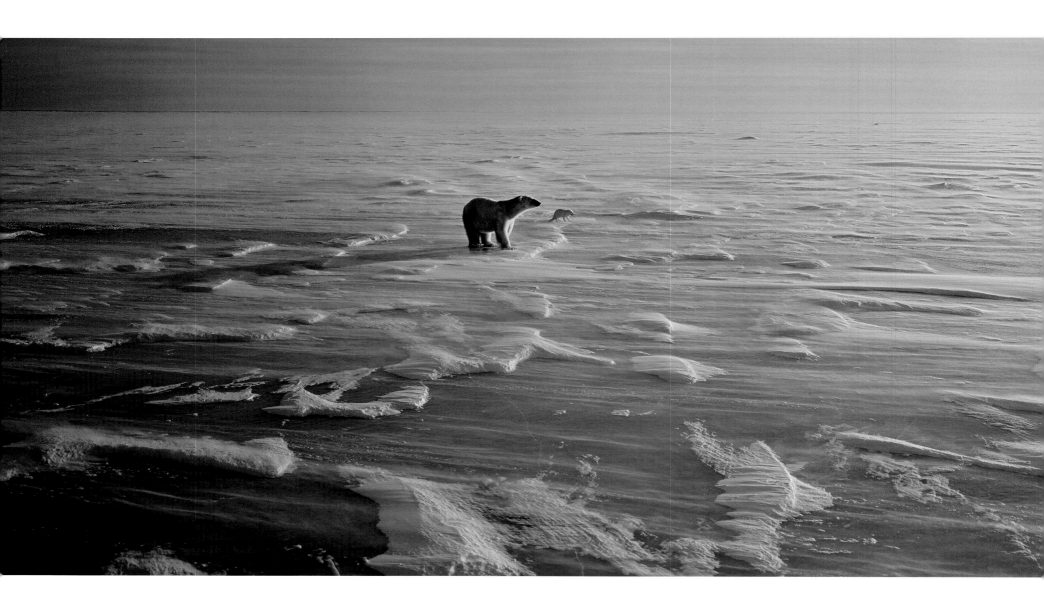

GREAT BEAR, LITTLE FOX

This is one of my most treasured pictures. It was made in mid-November, when the ice of Hudson Bay was starting to freeze and the sun was already low on the horizon. Cape Churchill, the narrow point of land that juts out into Hudson Bay's west side, is a gathering place for polar bears in the fall, keen after months of starvation to get out on the ice to hunt seals. The Arctic foxes are also hungry and follow the bears, hoping to scavenge any scraps they leave behind. After 10 years and some 80,000 frames from photographing polar bears in the far north, I still felt I hadn't captured the image I had in my mind – until this one. It's an image that epitomises the world of the polar bear – the vastness, the blowing snow, the frozen sea, the winter sunset and the ever-present Arctic fox.

Cape Churchill, Hudson Bay, Manitoba, Canada, 1993; Fuji GX-617 panoramic camera, 105mm lens, 1/125 sec at f8, Fujifilm Velvia.

LIGHT IN THE FOREST

It was still dark as we started up the mountain. Though the rocky slope was steep and slippery from wet leaves, our elephant never faltered. An hour later, we found this young tigress lying on a rocky outcrop overlooking the valley. She was relaxed and beautiful in the dim jungle light. I noticed the rising sun striking the top of the opposite mountains and knew it would soon cast light on the scene. But as it moved across the valley, we were radioed to say our time was up – there were visitors in the park waiting for our elephant. Then serendipity saved the day. Bandhavgarh's famous male tiger Charger appeared on the road, and the tourists in their mini-jeeps chased after him. Ten minutes later, the early morning sun penetrated the canopy and gently illuminated the face of the young tigress with an exquisite light. A moment later she got up, yawned, stretched and disappeared into the shadows.

Bandhavgarh National Park, Madhya Pradesh, India, 1998; Nikon F4 camera, 300mm lens, 1/250 sec at f2.8, Fuji Velvia.

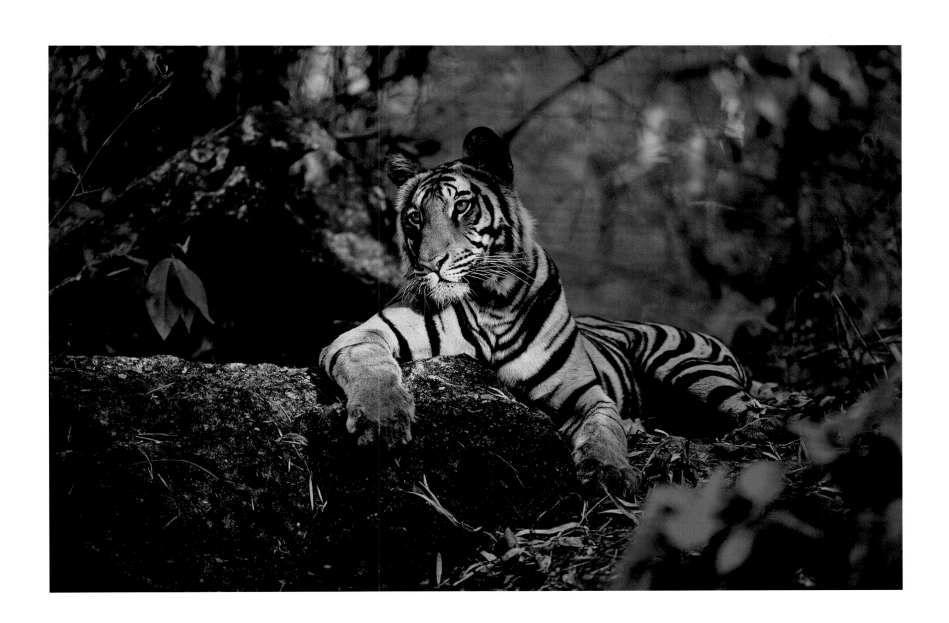

A CHANGE OF SEASONS

This was one of those moments you plan for and push yourself to get but seldom do. I spent three days in Igloo Forest, a magical place, watching this bull moose – one of the biggest in Denali – and his harem of cows. At the end of the third day, most of which he spent sleeping, it started to rain. But I'd spent more than an hour finding the best composition, anticipating the bull standing up, and I hung on, waiting for the light. I knew that the moment his harem moved, the bull would stand up. At the last moment of sunset, the sun poked through, lighting up the distant mountains, scattering through a snow squall and painting the sky and peaks golden – and the bull stood up. I was using fast negative film with the Fuji panoramic camera. But I still needed a slow shutter speed to get the depth of field, and so I bracketed my exposure to two seconds. It meant even the bull's breathing affected the sharpness. But this one shot worked – a portrait of a truly magical moment.

Igloo Forest, Denali National Park, Alaska, USA, 1998; Fuji GX-617 panoramic camera, 180mm lens, 2 sec at f11, Fujicolor NHG II 800.

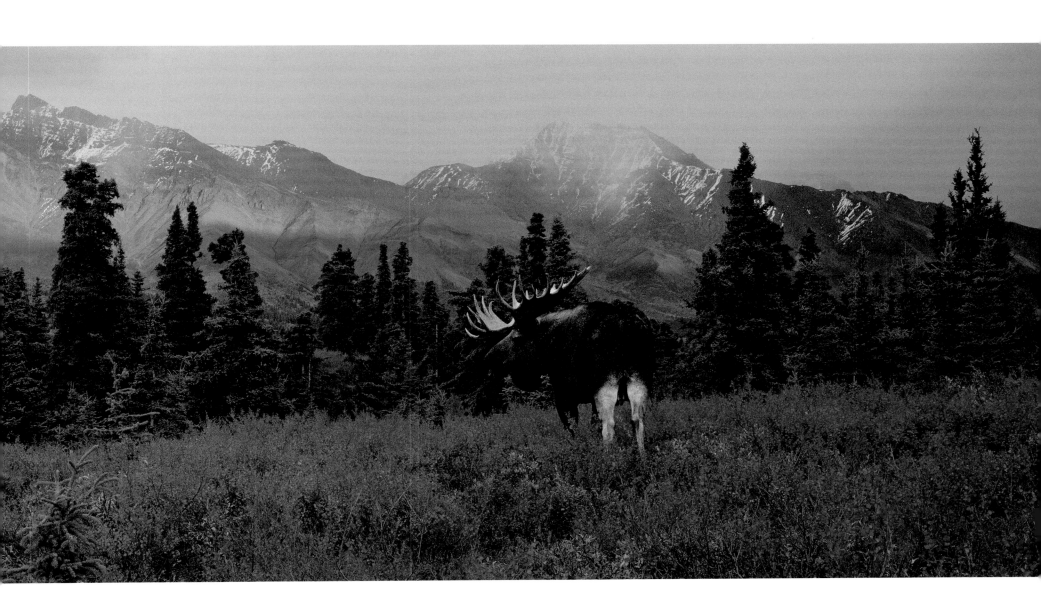

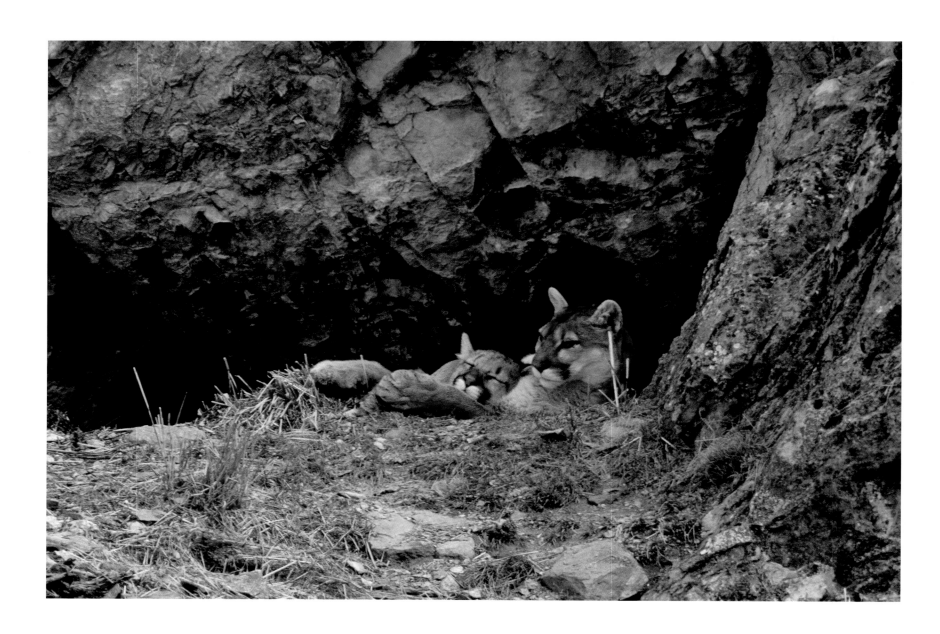

' Anyone who thinks a photograph of an enslaved game-farm animal is helping to educate or to save habitat or endangered species has a curious view of nature, wildness and animal welfare. The only value of such imagery is monetary. Many animals may be very difficult to photograph in the wild, but it is those rare images that are special and valuable. '

THE LOVE OF A MOUNTAIN LION

It was Valentine's Day when I got a call from a friend who works at the National Elk Refuge to say he'd seen a mountain lion with three kittens in a den to the south of the refuge. The location proved to be one of the most technically challenging I'd encountered. Harsh winds, blowing snow, the need to keep my distance and the fact that the cougars were usually only active in early morning and late evening led to a six-week shoot. I used every high-speed film I could find, borrowed a 800mm lens, stacked two teleconverters and used two tripods to steady the lens. Out of 500 rolls of film, I got only a small number of usable photos. But the event was life-changing. These were my first wild cougars, and when I saw one of the kittens peeping out between its mother's legs, I fell in love. The family was seen by hundreds of people from the community and thousands of visitors. I learnt later that, had the mother wandered less than a mile from the den site, she could have been shot by sport hunters, leaving the kittens to starve. It compelled me to co-found the Cougar Fund, to raise awareness of this magnificent creature.

National Elk Refuge, Jackson Hole, Wyoming, USA, 1999; Nikon F5, 800mm lens, 2x teleconverter + 1.4x teleconverter, 1/15 sec at f16, Fuji Provia.

THOMAS D MANGELSEN

LEOPARD PERFECTION

It was late morning in the Serengeti and very hot. The leopard was resting in a sausage tree,
giving her a shady, safe vantage point but posing a photographic challenge because of the high
contrast of the scene. I moved my position several times to exclude anything distracting in the
background, averaged the highlights and shadows on the leopard and the shade on the tree trunk
and overexposed the sky by approximately four stops to render it white. I love the speckled light
and the blue-green of her eyes reflecting the shades of the lichens. The negative space, the
graphic nature of the limbs and especially the repeating patterns make this image compelling –
the mirroring of the shape of an ear in a bump of a branch and a paw in a tree notch. It was the
perfect tree combined with the perfect gesture of a beautiful leopard – a natural moment.

Serengeti National Park, Tanzania, 2002; Nikon F4, 500mm lens + 1.4x teleconverter, 1/250 sec at f11, Fuji Velvia.

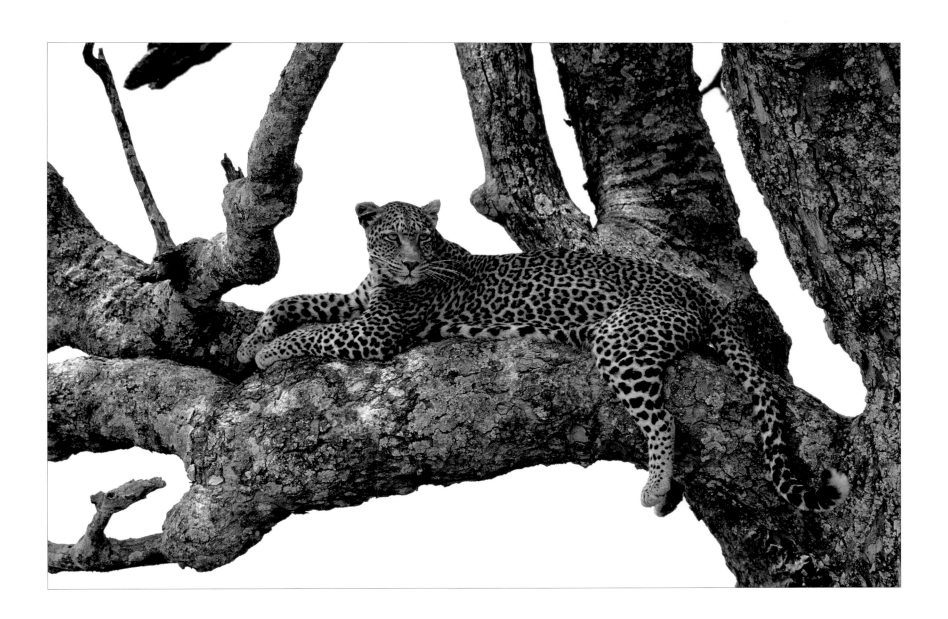

' I think about potential photographs constantly.
Over 35 years in Grand Teton National Park,
I've seen lots of potential images at the wrong
time or in the wrong light. I stash them away
in my mind for the next year. If you put yourself
in the situation, the picture will finally happen.
It's about passion; it's about dreaming. '

FIRST LIGHT, GRIZZLY BEAR

For years I'd been determined to create an image of an elk herd crossing the river in the
morning mist – a scene I'd once witnessed when I didn't have my camera and had been
kicking myself about ever since. In the fall of 2010, I set out to spend as much time as
necessary before the elk rut ended to capture the image I had in my mind. One early morning,
when I got to the spot with the best background and the best chances for an elk crossing, I was
surprised to see a grizzly hunkered over a fresh elk kill on the far side of the river. I watched her
drag the carcass out of the water and then spend the day feeding on her prize and protecting
it from the magpies, ravens, eagles and coyotes. That night, she dragged it further into the
woods, buried it and slept on top of it. At daybreak, as I set up for a potential elk crossing, the
grizzly crossed upriver, just as the first light started to hit Mount Moran. Fortunately, I'd just
changed lenses, intending to catch a bald eagle soaring in front of the mountain. I quickly
repositioned myself to include the curve of the river and the entire scene, and I was able to
shoot half a dozen frames before she reached the far side and returned to her carcass.

Snake River, Grand Teton National Park, Wyoming, USA, 2010; Nikon D3s, 70-300mm lens, 1/500 sec at f11, ISO 6400.

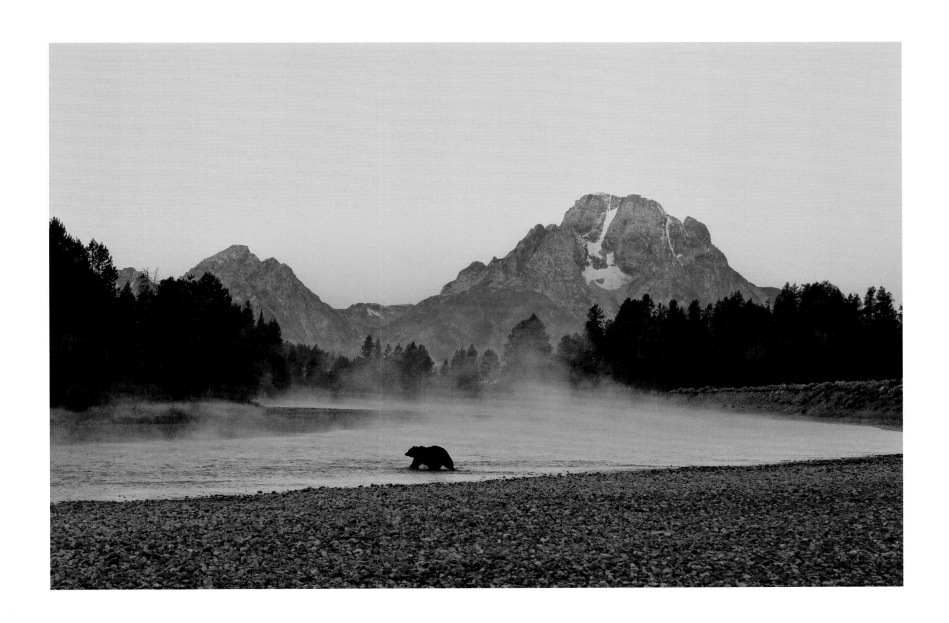

CRANES OF THE GREY WIND

Every spring, I return to my childhood home – the cabin on the Platte River – to witness the annual migration of thousands of sandhill cranes. At sunset, I sit by the river watching as the flocks of cranes darken the sky, their haunting calls permeating the prairie river as they come down to roost. At daybreak, they fly to nearby fields to feed up and gain strength for their long journey north to their nesting grounds. In this stitched picture, taken over two seconds as the first birds start to lift off, a late spring snowstorm blends together the rows of cranes standing in the shallow-water roost.

Platte River, Nebraska, USA, 2011; Nikon D3, 400mm lens, 1/500 sec at f5.6, ISO 4000, stitched.

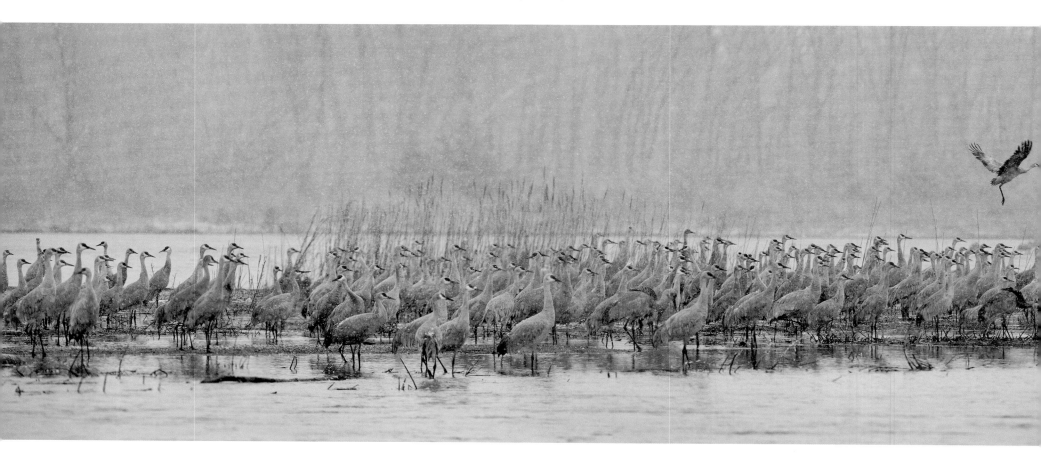

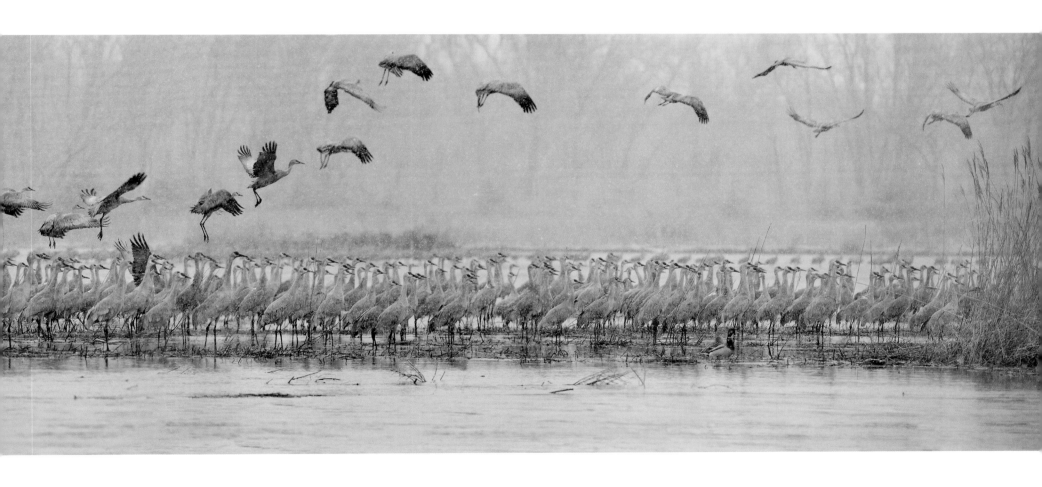

‘ Nature has an incredible power of putting
things in perspective. I hope my pictures remind
people of what is truly beautiful in the world. ’

RESPLENDENT QUETZAL

This is the most amazing bird I've ever seen. Some of the male's tail feathers are longer than
three feet – it's like a little dragon when it flies. I'd always wanted to photograph one. So when
I joined the International League of Conservation Photographers' expedition to get coverage of
Mexico's threatened El Triunfo cloud forest, I was happy to take on the quetzal. A nest was found
and the blind set up a week in advance to get the birds used to it. I'd enter at first light and
come out when it was dark. When a quetzal would land on a branch and call to its mate in the
hole, I couldn't see it. Then, suddenly, the incubating bird would fly out and the other would land
at the hole, just pausing for a second or so to see if all was safe before entering. Most of the time
it was too dark to take pictures, and I wasn't going to use a flash and risk distressing the birds.
But at midday, when the sun was overhead, there would be moments of filtered sunlight, and
with patience, I captured the arrival of the male – a perfect portrait of a resplendent bird.

El Triunfo Biosphere Reserve, Sierra Madre, Chiapas, Mexico, 2007; Nikon D2x, 200-400mm lens, 1/10 sec at f5.6, ISO 400.

VINCENT MUNIER

For Vincent, photography is a means to immerse himself in nature. 'You could say that my career developed as a way to return to nature as often as possible – to see wonderful places, share wonderful experiences and make a living, all at the same time.'

But his nature-photography path has not been a conventional one. He has chosen to avoid the financial underpinning of lectures and workshops and the use of mainstream agencies – 'I don't want my pictures used in hunting magazines or to greenwash polluting companies.' Instead, he has opted for the financially more risky path of 'taking pictures to please myself'. His lifestyle is a simple one, and his base is a smallholding in a small village in the Lorraine region of France, near his family home.

Of his style, he says, 'It's quite involuntary. I photograph what I feel.' But his pictures are nearly always recognisably his, always with the animals totally as one with their surroundings, always taken in northern wild places. Often there is an echo of the minimalism of the Japanese photography and art that he loves. Vincent regards his spiritual father as the twentieth-century Swiss

nature artist and ecologist Robert Hainard, who immersed himself in nature and whose motto was to let the animals come to you. His true artistic vision is, however, very much rooted in the environment in which he grew up, the mountainous Vosges region of France.

He considers himself lucky to have been raised by parents 'who opened my eyes very early on to the beauty of our world and its wildlife'. His father taught him to 'respect the quietness of the wilderness', and aged 12, Vincent was given his first 35mm camera and his 'precious' Novoflex 400mm. Even more valuable, his parents let him take off on his bicycle to photograph in the forest and in the mountains, day or night. The result: he learnt a lot about wildlife but failed all his exams.

Leaving school at 18 – 'not so easy when you are the son of teachers' – he had a series of manual jobs. This, though, gave him an outdoor life, free time and money to buy his first 600mm lens. Military service followed, which led to a role as regimental photographer. Then, at 24, he got a job as a regional press photographer. 'It was good experience for a

rather shy man like me, and it gave me money to start travelling.' In the same year, 2000, he entered the Wildlife Photographer of the Year competition and won his first Eric Hosking Award (for photographers aged 26 or under, to help them early in their careers). He would win it again in 2001 and then again in 2002, with pictures taken on his first trip to Japan. He had begun to follow his dream.

The publicity that followed his awards and the approaches from editors and international magazines gave him the confidence to give up his job and turn full-time professional. For the first few years it was a struggle, and he was forced to do 'survival photography' (commissions) on the side. But 'if it had come to it, I would have been happy surviving as a peasant, tending to my animals (he has sheep, goats and chickens) and my vegetable patch.'

Vincent constantly describes himself as 'a very lucky man'. And as a non-conformist, he probably is. The quality and originality of his pictures were recognised relatively early. His first book, *Tancho*, a homage to the beauty of the red-crowned crane, was published in 2004 and sold out quickly.

White Nature (2006) was a gallery of images from snow and ice locations, including Kamchatka, the Canadian Arctic and Japan, and most of his subsequent art books, produced with lavish attention to the paper and printing rather than profit, have become collectors' items. Three – described as 'odes to the beauty of nature' – display pictures taken in his home region, including *Au fil des songes*, with poetry by French avant-garde musician and artist CharlElie Couture.

Sensations ('a silhouette in the mist, a quick movement on the snow, a shadow between trees') and strong emotions ('the violence of the wind, blinding snow, cold that freezes everything') are what he looks for and relishes. His most recent expeditions have been to Antarctica and to Tibet – the most extreme and gruelling of all. Perseverance and patience, and the ability to relish the experience, even when the perfect picture doesn't happen, are what he says makes such endurance trips worthwhile – 'to enjoy the process as much as the result'.

Vincent is humble and has stayed constant to his art. His luck, if it is luck, is to have pulled it off.

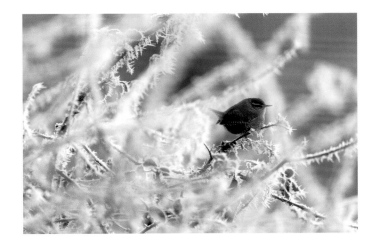

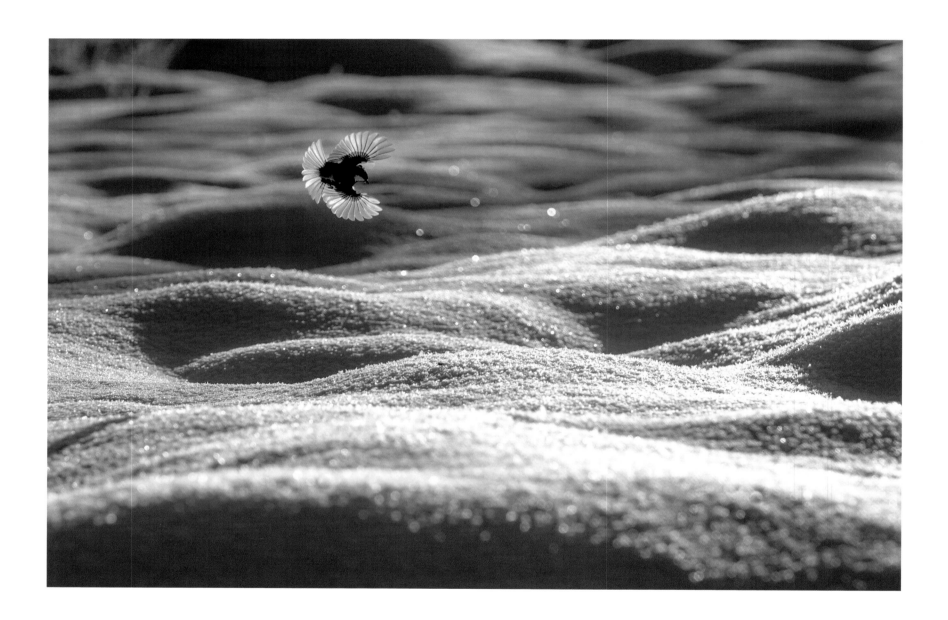

A SUNBURST OF FEATHERS

Every winter, for 15 years, I have gone to the same place in the mountains, just an hour from my
home – a boggy glade in the forest where I put out seeds for the birds. They hear me coming.
And now the tits will take sunflower seeds from my hand. It is such fun. And in the deep snow, it's
such a beautiful place. The snow hollows and hillocks are so graceful. Visiting here is like a ritual.
I just sit down, and the birds accept me. I try to find a nice angle of light and start taking pictures.
This image is one that captures for me the magic of the place and the moment.

Fossard Forest, Vosges, France, 2006; Nikon D2x, 300mm lens, 1/2000 sec at f2.8, ISO 200.

' I'm a fan of minimalist art, of haikus, and
of course cold and snow – that's something
that's always been in me. White has been
a constant fascination. There is every colour
in white. I smile when the first snow arrives.
It covers everything that is superfluous. '

A STUDY OF SWANS

This is one of my favourite pictures. It's like a screen-painting, so Japanese. It was taken on my
first trip to Hokkaido and my first trip as a professional. There had been a heavy snowfall, and
the wind had driven the snow onto the side of the branch, which makes the edges appear painted.
Lake Kussharo is famous for its whooper swans. It's volcanic, and part of it never freezes. So the
swans stay there in winter. Here it's veiled in mist, and the swans materialise as if in a dream.

Lake Kussharo, Hokkaido, Japan, 2001; Nikon F5, 80-200mm lens, 1/250 sec at f5.6, Fuji Sensia 100.

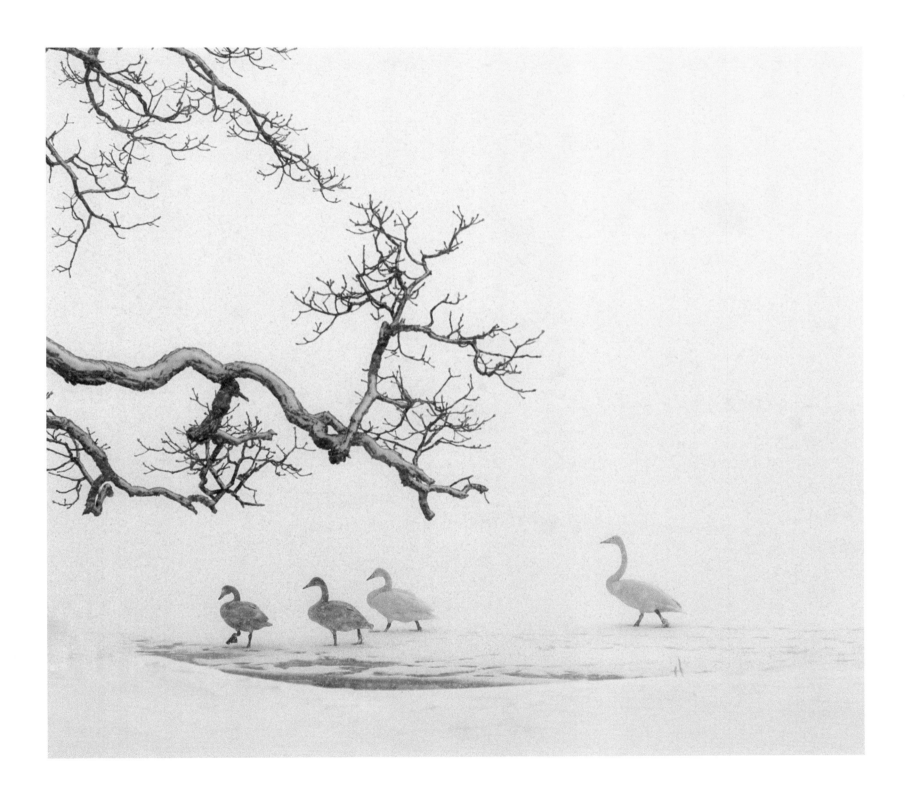

' For the perfect image, I wait for a storm. The violence of the wind, blinding snow, cold that freezes everything so the landscape becomes naked and everything is wiped out – until you discover, far off, an animal, very still but quite composed. The experience becomes then a lesson of humility in front of these creatures at home in the elements. '

SNOW OWL

In the winter of 2006, a harsh winter, I finally realised one of my dreams, to see snowy owls – for me a symbol of the beauty and fragility of the Arctic. I spent two weeks with several owls that had stopped off beside the St Lawrence River on their way south across Canada. This female had taken shelter behind a hill, but it was still bitterly cold, and a fine, powdery blizzard was blowing. It was perfect for my photography. I lay on the snow for several hours watching her. Everything was white except for the branches, like brush strokes, and the owl, who sat as still as a sculpture. The picture shows exactly how it was – a perfect still life in snow. I was so fascinated by the scene that I forgot to cover my face. That evening my friend told me my nose was black. I had to go to the emergency department, and I lost a bit of my nose. But I still have good memories when I look at this picture.

Belle Chasse, Quebec, Canada 2006; Nikon D2x, 200mm lens, 1/1000 sec at f6.3, ISO 125.

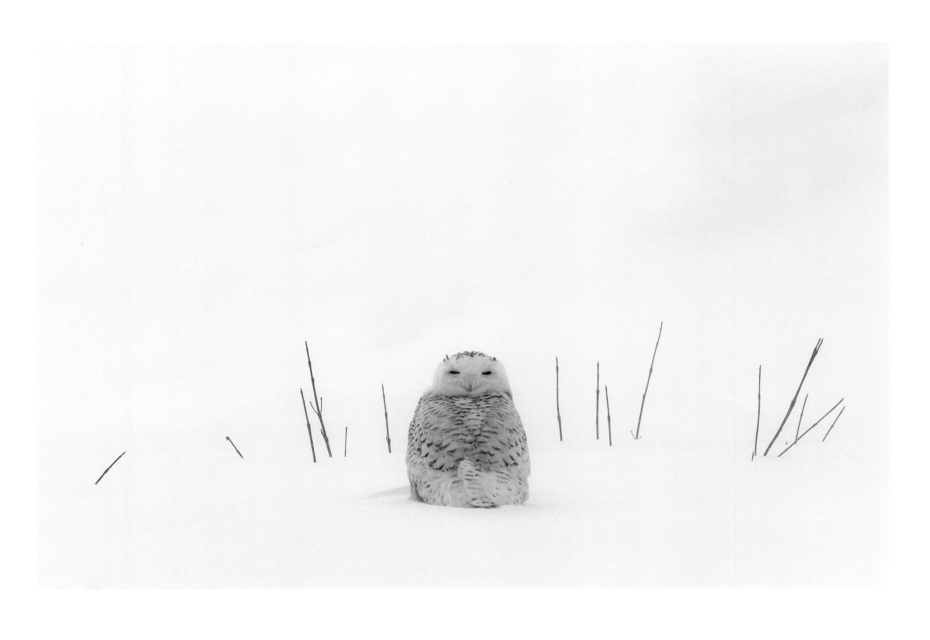

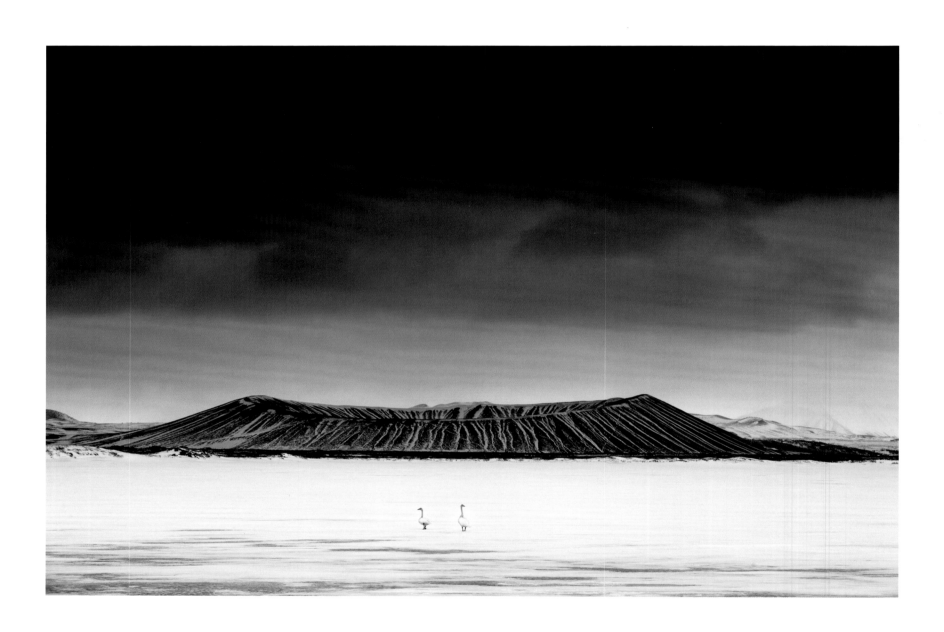

VOLCANO SWANS

This picture looks surreal, but the scene is exactly as it was on that April day – the grey snow cloud, the white ice and the black volcanic crater. I'd travelled to Mývatn in northern Iceland to photograph the waterfowl, but especially the whooper swans at the start of their mating season. For several days I camped by Lake Mývatn, looking across to the Hverfjall Crater. I was lucky. It suddenly turned very cold, the lake froze and it started to snow. It's so graphic when snow falls on this volcanic landscape. When I saw a pair of swans landing on the snow-covered ice, I was so excited. I moved around until I found a good angle and then waited a few hours until the swans had finished resting and stood up to walk across the ice, ready to fly off. It was such a lovely moment.

Mývatn, Iceland, 2008; Nikon D3, 110mm lens, 1/500 sec at f10, ISO 250.

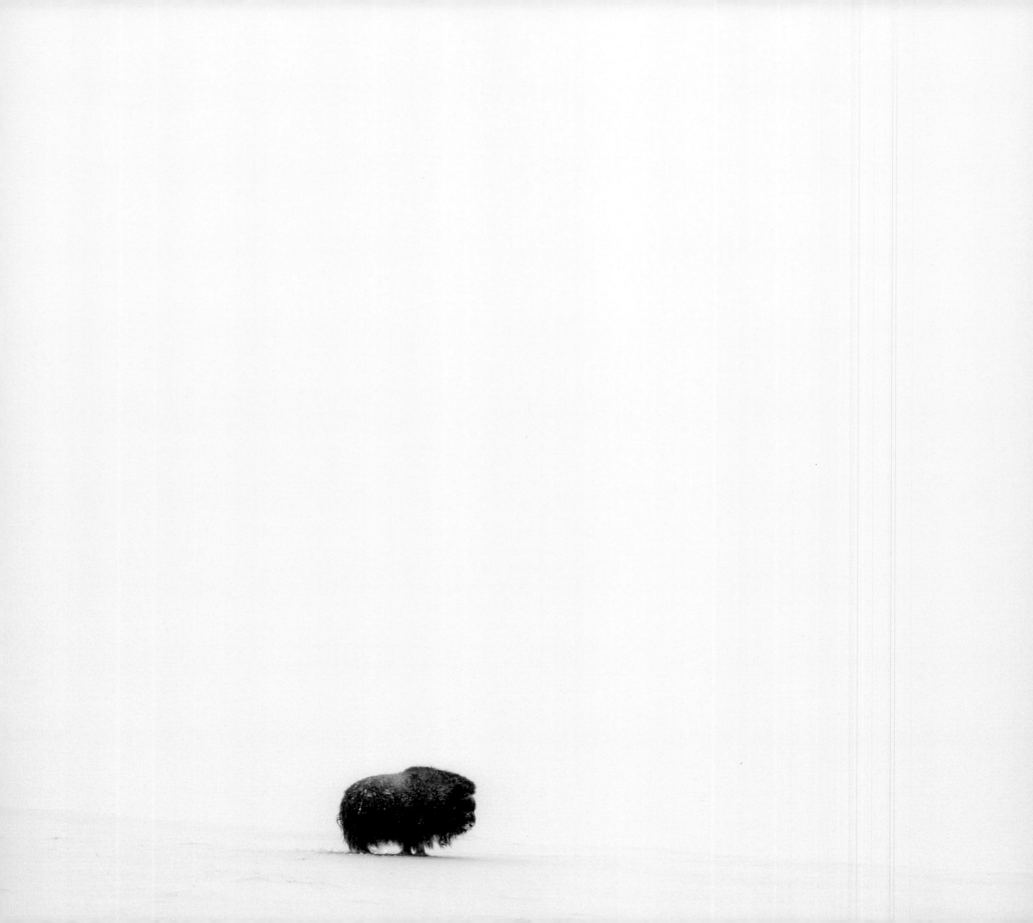

LONE MUSKOX

The muskox stood like this for hours,
like a black prince in a white desert.
The picture represents how I see these
animals. Sometimes I need silence. That is
what I imagine this one is doing, standing
in silence, just slightly away from her herd.
Though she is facing away from the wind,
it was comparatively calm that day, with
only a little snow. I have good memories of
the afternoon I spent with her, just waiting.
Once she got curious and walked towards
me, then turned and went back. Muskoxen
are crazy animals – when they start
running, they don't stop. So I prefer to stay
at a distance. This picture was taken with
a 600mm lens from a couple of hundred
metres away. The light was wonderful, the
mist creating this rare silky white colour.
White is such a difficult colour. Sometimes
it is too grey or too dirty. But at this
moment the colour was perfect, as if we
were in an Arctic studio.

Dovrefjell, Norway, 2006; Nikon D200, 600mm lens,
1/1600 sec at f5, ISO 200.

VINCENT MUNIER

MUSKOXEN IN A SNOWSTORM

These are such wonderful animals, so prehistoric. I wanted to picture them in a blizzard, to show how they live in such harsh and difficult conditions. I love it when the snow blows. It's a sea with waves of snow. It also creates a grainy picture and a strange light. The sky was grey, and suddenly, for a minute, the sun tried to come out. The muskoxen also started to move, which was unusual. It was a magical moment, when every element came together.

Dovrefjell, Norway, 2009; Nikon D3, 200mm lens, 1/1600 sec at f13, ISO 200.

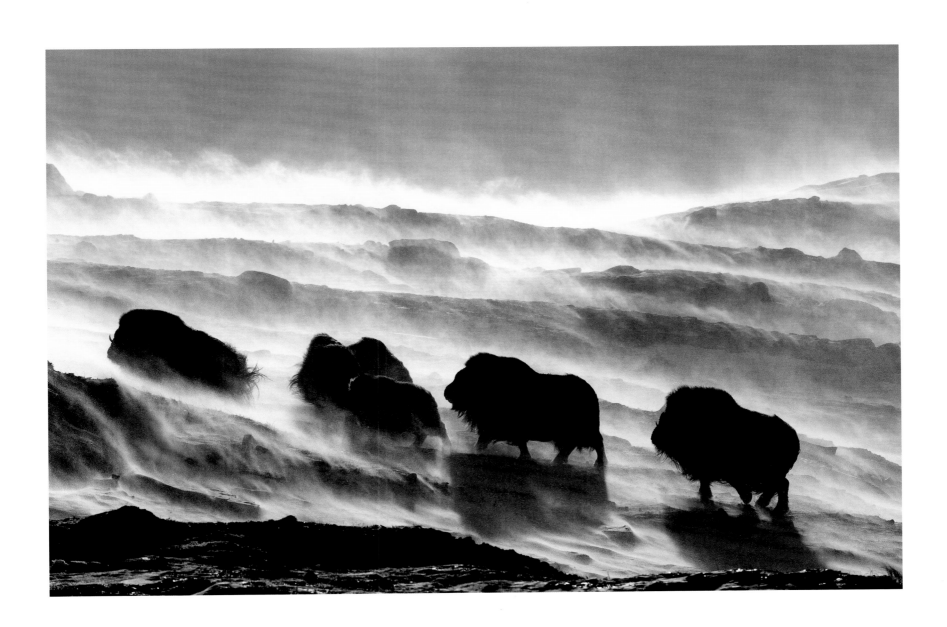

VINCENT MUNIER

' When I'm in the field, it's not work, it's
pleasure. When I see nothing, it's not serious.
Sometimes, it's even what pleases me –
the difficulty of it. I search for simple images
that allow you to breathe, and I long for
great wide-open spaces where you are free
from civilisation. '

FOX ON HIS ROCK

I got to know this fox. He wasn't so shy and accepted me without the need for a hide.
I photographed him for a whole week, several times on this rock. It was his place. I love the colour
of the stone and the lichens peppering its cracks and crevices, and the smooth curves of its
sculpted profile. Here the fox is looking past me, watching for prey and listening for mice.
His family would sometimes shelter on the other side of the rock.

Cape Merry, Manitoba, Canada, 2009; Nikon D3s, 200mm lens, 1/320 sec at f5, ISO 2500.

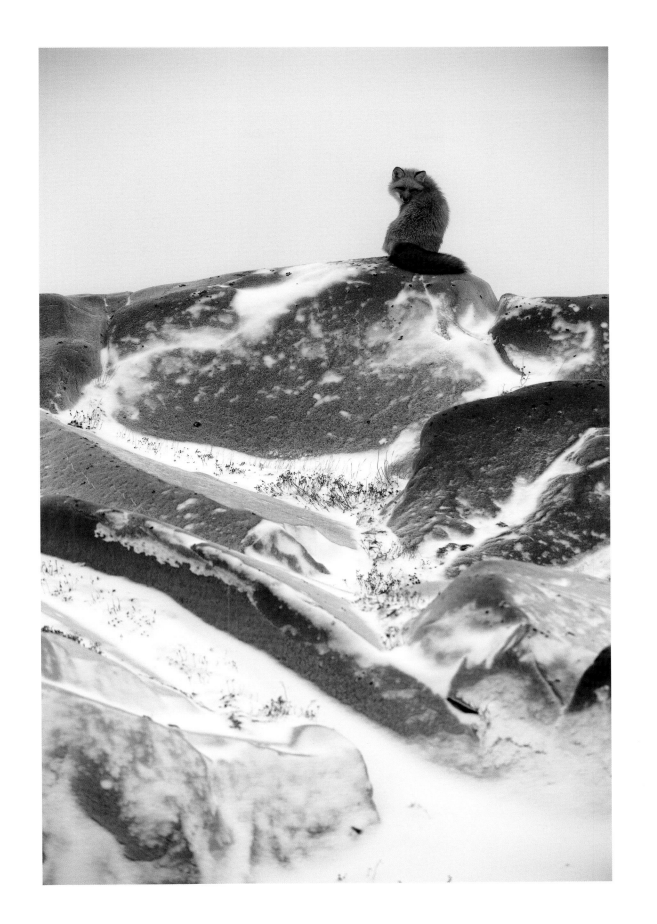

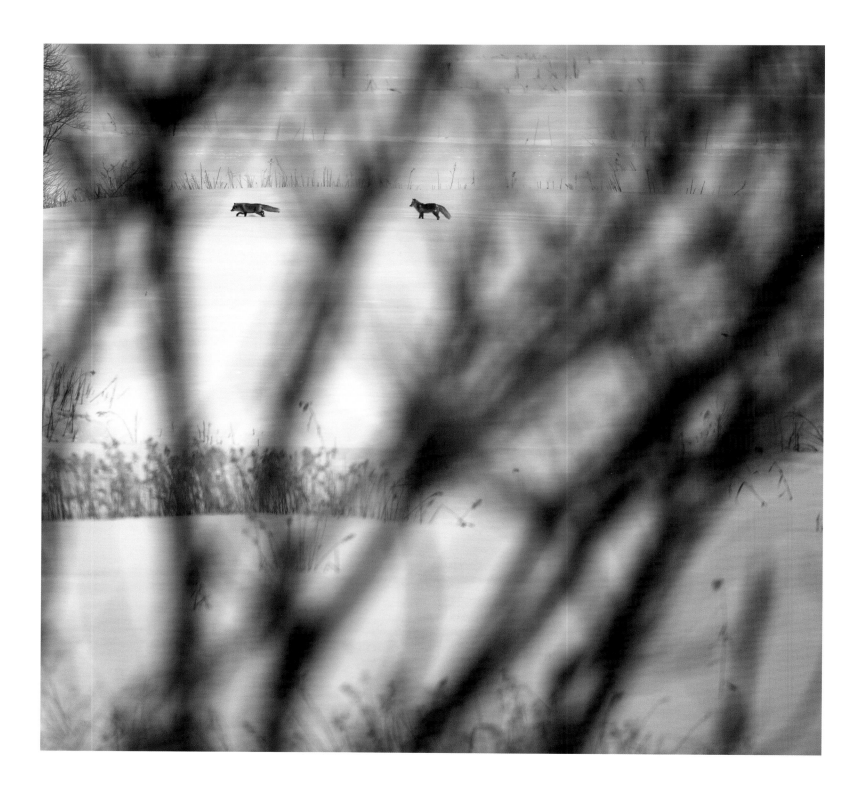

THE LOVE SEASON

In winter, it's rare to see foxes in France in the daytime, except in the love season. Here a male is courting a female, following her closely. I deliberately shot the picture with branches in the foreground so the viewer becomes the invisible watcher. It's how we see animals normally, from a distance, looking through vegetation. I love the way they appear as actors on a stage – giving us a glimpse of a tiny moment in their lives. The photograph was taken in January, close to my home. I worry for the foxes as every winter they are hunted for sport. There is a tradition here to kill all predators, including birds. Now there are so many mice everywhere that they destroy the crops. So people put down poison, which kills more predators, especially the foxes and badgers. You can understand why foxes are so shy and why it's only possible to spy on them.

Champagne, Vosges, France, 2010; Nikon D3s, 400mm lens, 1/3000 sec at f4, ISO 200.

DANCING CRANES

Cranes are among my favourite birds. They led me to go on my first trip away from home, following the common cranes as they migrated across Europe. My next dream was to see the red-crowned cranes – their plumage so very white, their landscape so snowy. When it's very snowy, I'm smiling, and it is the same with the cranes. They dance. When the flakes of snow are very big, the couples sing and dance even more, each mirroring the other's move. You can tell they're excited because the flash of red on their crowns becomes more red. On this trip, 10 years after I first photographed cranes in Japan, I managed to catch an impression of the perfect symphony of their courtship dance, with snow falling like confetti. I was so happy to see that their numbers had increased. But they are still endangered, and their survival still depends on humans putting out food in winter.

Tsuiri, Hokkaido, Japan, 2011; Nikon D3s, 600mm lens, 1/5000 sec at f4, ISO 320.

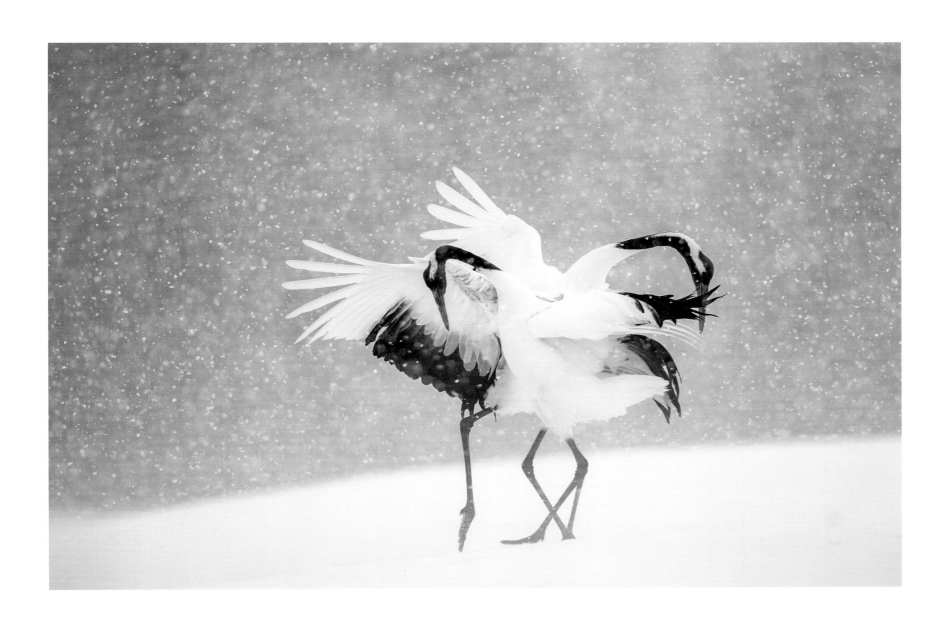

' There is nothing more magical than suggestion. When you reveal everything, you kill imagination. I live in a world of imagination. And that's where I want to stay. '

SPIRIT OF TIBET

It was a hard trip – a remote place, a very high altitude, some of the most extreme conditions I've ever experienced and very shy animals. But this is a landscape like no other and one I long to visit again. Woolly mammoths once lived here, but now the wild yak is the spirit and guardian of the place. I'd found the valley on Google Earth and could even make out the dots of the yaks. But getting there was a different matter. When we finally reached the plateau, we had altitude sickness for the first five days, and the snow was so thick that walking was exhausting and we were blinded by the blizzards. But it was the rutting season, and we could hear the yaks. Then finally we had our close encounter. I heard the belching first. It was so exciting, but also a little worrying, as a male will charge if he's angry or surprised. Then his great form appeared through the blizzard. I was shivering with cold, excitement and fear, and so most of my pictures were unsharp. The bull was there for a few minutes and then just melted away, like a mirage. But I had this image – and the memory.

Arjin Shan, Tibetan Plateau, Tibet, 2011; Nikon D7000, 600mm lens + 1.7x teleconverter, 1/50 sec at f16, ISO 320.

MICHAEL 'NICK' NICHOLS

For Nick Nichols, it's all about passion – finding a powerful way to document or glorify something you care about. He is also driven – by the work ethic born of a tough upbringing, and by a need to express himself, but later by the injustices he saw in the way we treat nature. 'I found the vehicle in photography, I found the cause in the environment, and I found the patron in *National Geographic*.'

Born into a poor family in Alabama, USA, his first chance to use a camera came when he was drafted into the army at 19. But through books and magazines he had already discovered the power of imagery. By signing up for an extra year's national service, he achieved a posting to a photo unit. There he learnt both the art of black-and-white photography and the photojournalist's philosophy of 'f8 and be there'.

Eager for challenges, he started taking pictures in caves, mastering the use of stage-lighting that would become a hallmark of later work. On his release from the army, he studied photography at university. Here he met his first mentor, the former *Life* magazine and famous civil-rights photographer Charles Moore, who fostered his interest in photojournalism.

His first assignment was a cave shoot for *Geo* magazine in 1979, which led to a series of adventure stories. But it was his coverage of the Mountain Gorilla Project's innovative education and eco-tourism work that led him to discover how 'images of nature can do more than entertain – they can help save a whole ecosystem. I knew then this was going to be my life, that I could give a voice to those who can't speak.' This and his adventure work led to him being nominated in 1982 as a member of the famous Magnum Photos photojournalist collective, founded by Henri Cartier-Bresson and Robert Capa.

Here he found inspiration. 'Being around social-documentary photographers made me see what I could do.' The primatologist and conservationist Jane Goodall also saw what he could do, and the two worked together on *Brutal Kinship*, a book featuring our relationship with chimpanzees. 'Jane taught me that chimps are a metaphor for how we look at the rest of the world. When their usefulness in entertainment or research is over, they either die or live out the rest of their lives in captivity – many times in unbelievably horrible conditions. Jane's advocacy showed there is an alternative.' Knowing that his work

could also make a difference was empowering. He started shooting for *National Geographic* in the knowledge that 'when the *Geographic* does a story, it reaches so many people that you really can effect change'. Since 1989, he's had more than 30 stories published, becoming a staff photographer in 1996 and later the magazine's editor-at-large for photography.

Many of the stories have been transformational, for the places and animals as well as for Nick himself. Greatest was the coverage of Central Africa, accompanying conservationist and biologist J Michael Fay. Their expedition to the 'last place on Earth' – the remote and untouched heart of Ndoki Forest, discovered by Fay in the Congo – led to its protection. There Nick developed camera-trapping, with the aim of achieving shots of totally relaxed animals in truly wild places, a technique he perfected with his coverage of tigers in India, determined to show that the best way to conserve them is not by fundraising for captive-breeding in zoos but by enabling wild tigers to rear wild young. There followed the epic megatransect project, a 15-month, 2,000-mile trek across the Congo and Gabon with Fay, resulting in a series of articles and *The Last Place on Earth* book. But the key

outcome was Gabon's creation of 13 national parks protecting forest that had been earmarked for logging.

The project introduced Nick to wild elephants and led to four more stories on elephants, 'from the fearful and hunted, to the safe, happy and loving, to the heartbroken and orphaned'. That collected work has now been published as *Earth to Sky*, a major homage to elephants and a plea for more wild places to be left wild and for ways to be found for humans and elephants to coexist – 'the wealthy world has to help Africa.'

Through Fay, Nick also discovered the plight of California's remaining old-growth redwoods. Two more major stories followed and – in reverence to the largest and most ancient living things on Earth – two extraordinary composite pictures of a coast redwood and a giant sequoia, reproduced as five-page pull-outs.

Nick's recent mission has been a two-year assignment on lions, using Craig Packer's long-term study of the Serengeti lions and all the current technology to show lions in their world, by moonlight, by infrared and even with a hovering camera, the MikroKopter, but

in a world dominated by humans. 'Lions are headed the same way as tigers and all the other great predators. I know now that photography can effect change – influence legislation, affect fundraising. That's what I hope this coverage might achieve.'

Nick is now talking about simplifying his life. 'My body doesn't do everything I want it to. I can't do the travel any more and drag around all the stuff I need to do my big pictures.' But then that drive is still there. 'I still want to be a voice for the greater good – there are seven billion humans but very few wild places left. The wild has to be protected, because if we lose it, that's it, we can't get it back.'

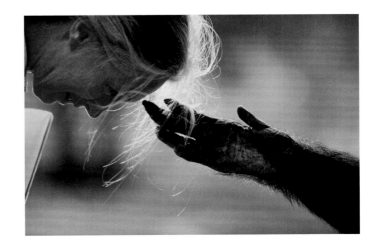

MICHAEL 'NICK' NICHOLS

THE TOUCH

Getting to know and photograph Jane Goodall changed my life. She taught me to pay attention to the individual – showed me that converting just one person to a cause can make a difference. Here Jane draws on her understanding of chimpanzees to comfort La Vielle, an old female, half-crazed from spending years alone in a Congolese zoo. The Jane Goodall Institute had moved her to a sanctuary in Pointe Noire, so she could recover through contact with young chimps. I used a tight frame and natural light to convey the intimacy of the moment. And, yes, I wanted these pictures to be used for advocacy. Once I saw the plight of chimpanzees at the hands of humans, I was driven to make strong statements in the hope of effecting change.

Tchimpounga Sanctuary, Pointe Noire, Congo, 1995; Canon EOS DCS, 35mm lens, 1/60 sec at f5.6, Kodak 100.

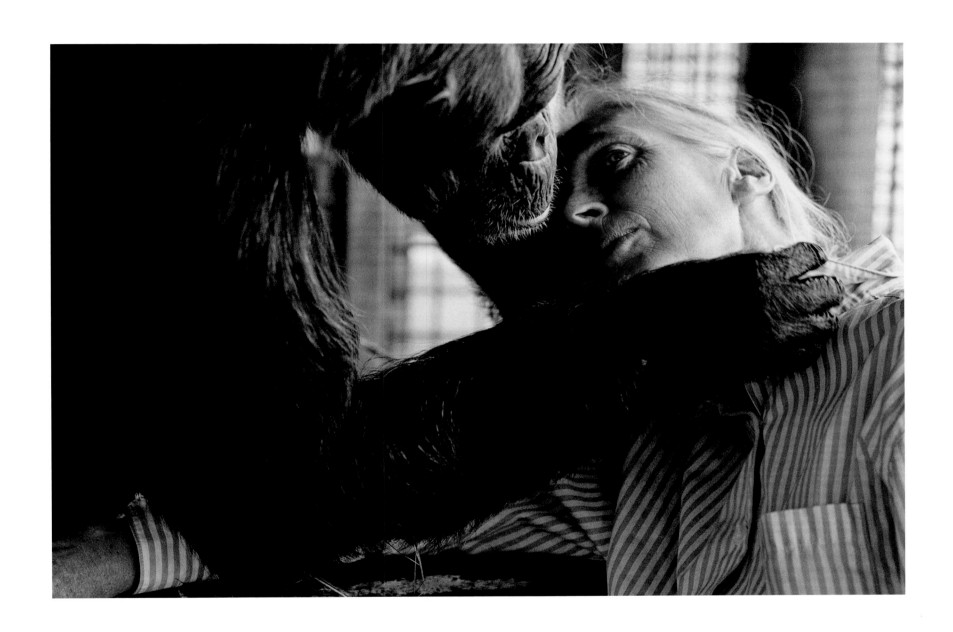

' One of the things I see is that there is too
much political correctness in the selection of
photographs. People can cope with reality.
They don't want a sanitised view of everything.
It's also very important to keep a picture real
and edgy – far more effective than a set-up.
You then get photos that create emotion. '

WHISKEY

Whiskey was named after the drink his owner gave him. When he stopped being a cute pet,
he was chained by his neck in a dark, wet, disused lavatory behind an auto-repair garage. I used
a little flash mixed with a slow shutter speed to bring out the horror of his solitary confinement,
the walls smeared with excreta where he had managed to hit them as he twirled around in his
dance of madness. He was a tortured creature, a metaphor for what we do to these animals.
Release came through the Burundi Chimpanzee Conservation Program, affiliated with the
Jane Goodall Institute, but it was too late. He already had liver disease.

Bujumbura, Burundi, 1989; Canon T90, 35mm lens, ¼ sec at f2.8, Kodachrome 64.

' I don't quietly consider the scene. I'm like
a vacuum cleaner. But I'm not randomly
photographing. I'm going for the moment.
The real art and authorship is in the choice
of the shots that transcend, that are quirky
and challenging and say something for me. '

THE GELADA GANG

I was still shooting film at the time I went to Ethiopia to photograph geladas. It was a break after
12 years of assignments in the rainforests of Central Africa. Here I found myself averaging 50 rolls
per day. In the forest, 50 rolls was a good month's work. The geladas were wild but used to the
researcher studying them. So I could get really close. But I wanted to move in still closer to catch
an intimate, street-scene moment. So I set up a radio-triggered wide-angle camera on the ground
under the giant heath trees in the favourite resting spot of this gang of bachelors. I love the energy
of the composition, one gelada flashing his eyelids and baring his teeth and red chest patch at
a rival male who was provoking the group, another lunging forward. Here the strobes were
all-important to fully light the scene and emphasise the drama.

Simien Mountains National Park, Ethiopia, 2002; Nikon N90, 24mm lens, 1/125 sec at f8, radio trigger, three strobes, Kodak 100.

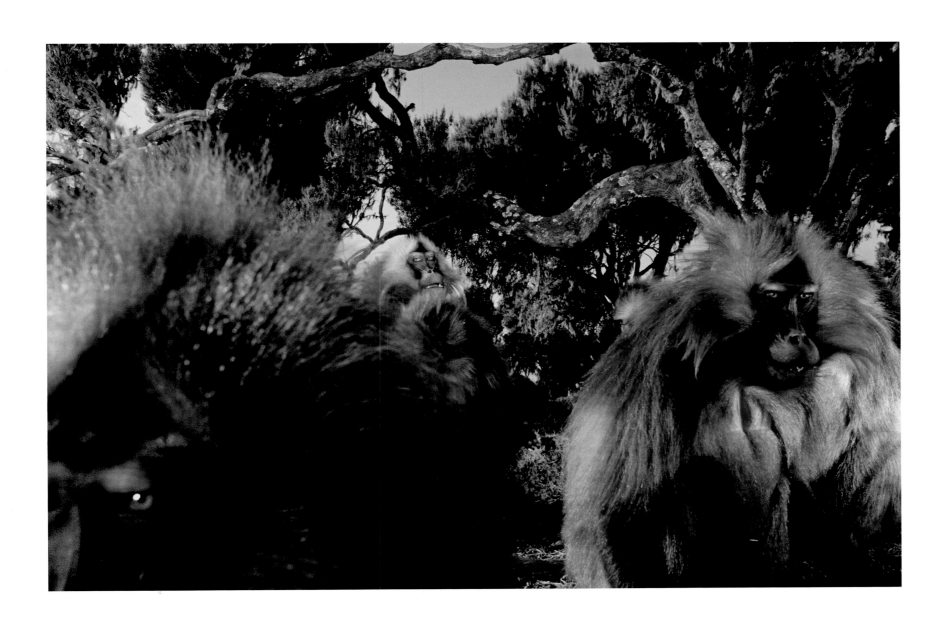

MICHAEL 'NICK' NICHOLS

' I can't have an even view when it comes to people killing elephants for ivory. There is no middle ground for that. I want photography to have a scream, a loud voice. And when you see elephants taking care of their young...
At the end of the day I want people to see that we are arrogant in our treatment of the world. '

FOREST GLIMPSE

This is a rare picture – an old forest elephant bull, deep in the rainforest in one of the last truly wild places on Earth, Loango in Gabon. It's one of my favourite pictures from a 15-year-long assignment in Central Africa, resulting in 10 stories. It's also a miracle. I'd seen elephants crossing the Echira River, but I knew there was little chance of getting near enough for a portrait. They are terrified of human scent. Gabon and northern Republic of Congo represent the last frontier for forest elephants, but organised criminals have penetrated deep into the region, slaughtering the elephants to supply ivory to China. After weeks of scouting, we finally found a spot where an elephant highway crossed the river and set up an infrared camera trap where a wading elephant might break the beam and trigger the shutter. The forest setting and the water were vital elements of the picture, which made the position of the lights as well as the camera crucial. The camera flooded, and this was the one frame I selected from four months of work. It couldn't have been more perfect. There is no sense of human presence. There is mystery, and there's that something extra – the magic.

Loango National Park, Gabon, 2003; Canon EOS-1Ds, 28mm lens, 1/15 sec at f5.6, Kodachrome 64.

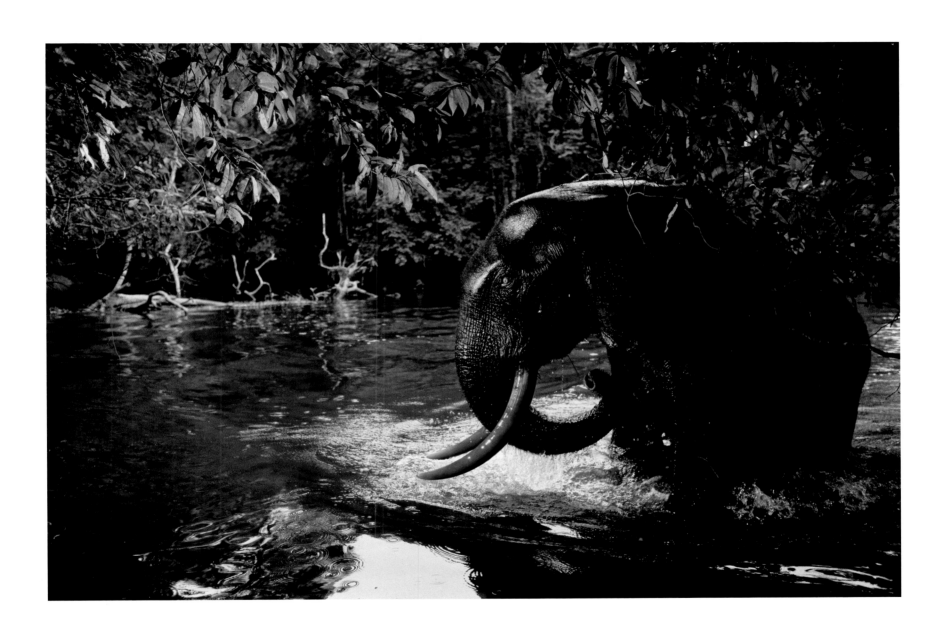

MICHAEL 'NICK' NICHOLS

THE LOST MIGRATION

It was Mike Fay who enticed me to Chad
with tales of giant herds of elephants in a
little-known paradise. I had this picture of a
huge herd in my mind, and we plugged away
at it, flying over the park day after day. When
we found this 800-strong herd, being led by
a single matriarch, we could see that it was
heading out of the sanctuary of the park,
presumably to find fresh forage. The magic
of digital showed me that I'd got the shot.
But that night, the elephants were ambushed,
and 20 were slaughtered for their ivory. We
realised then that the giant herd was in fact
lots of terrified family groups, moving together
for security. In black and white the picture
is simpler and stronger, and I knew people
would react differently to it. When the story of
Chad's elephant massacre was published in
National Geographic, funding was raised for
an anti-poaching airplane, and the president,
shamed by all the killing, bought two trucks
with machine guns. But today, Zakouma
probably has fewer than 300 elephants.
In 1970, there were 200,000.

Zakouma National Park, Chad, 2006; Canon EOS 5D,
110mm lens, 1/100 sec at f2.8, ISO 500.

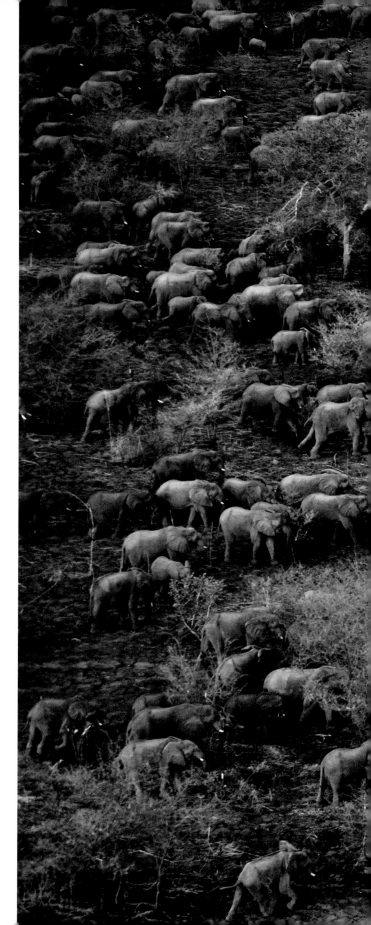

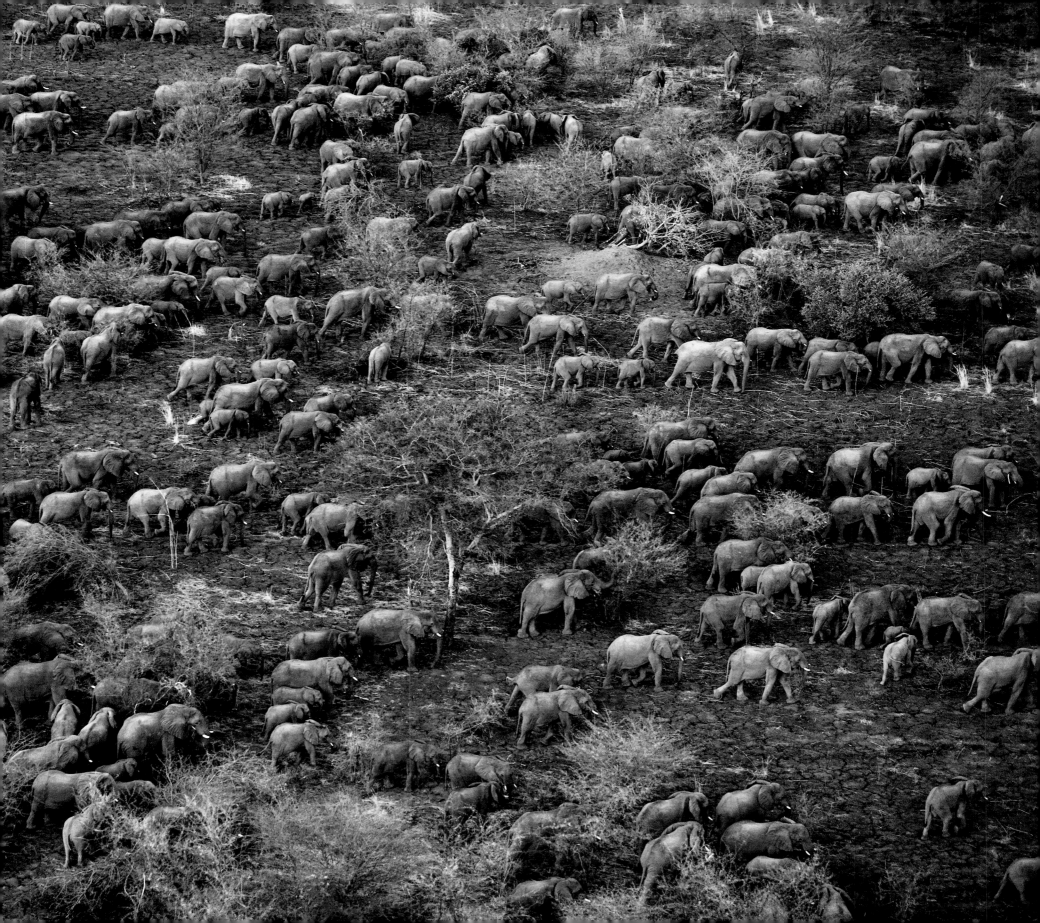

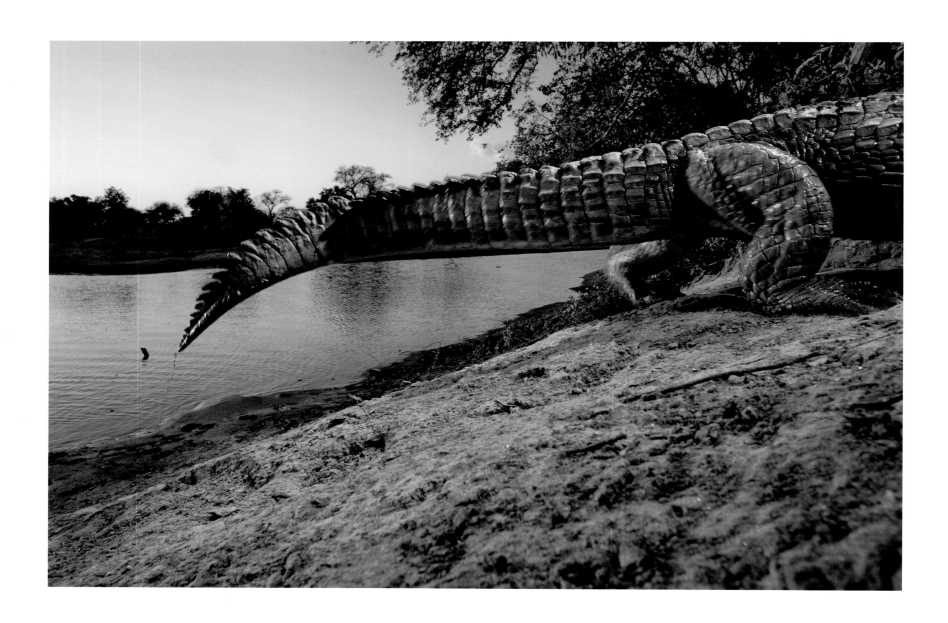

VANISHING MONSTERS

What I visualised was an eye-level view that would create a sense of the size and power of these prehistoric reptiles. The crocodiles along the Salamat River can be very big, but they are also very shy, the result of being hunted for an illegal export trade in skins – a trade that has reduced the population of crocodiles in Chad by more than 90 per cent. I found the drag path of a large crocodile leading up from the river to its den. We then set up the camera a few feet away, an infrared sensor to trigger it, and linked lights. The result was plenty of pictures of the full crocodile, looking like a crocodile. But when I saw this one, with the great hind-quarters frozen mid-step and the powerful tail held high – an eye-level view no human would want to see for real – I knew I had it. Here was the dinosaur; the Earth was still bubbling. That's the whole thing about photographic serendipity – it's not the pictures you make, it's the pictures you choose.

Salamat River, Zakouma National Park, Chad, 2006; Canon EOS Digital Rebel XT, 15mm lens, 1/60 sec at f9.5, ISO 100.

THE ELEPHANT EATER

With a bounty created by rains and flooding
followed by the famine of dryness and
drought, Zakouma National Park was the
most dynamic ecosystem I've ever seen.
In the dry season, elephants concentrate
around the waterholes. So do lions. It's when
young elephants are especially vulnerable.
Normally, the families fiercely defend their
own and lions have little chance. But now
poachers kill so many adults, the herd
structure is completely destroyed, and
orphans become easy prey for lions. Here
a lion feeds on a three-year-old female, still
tuskless. He's not a Serengeti lion used to
people, he's a Chadian lion, surprised by the
intrusion of humans. The lighting is a mix of
ambient light from the car headlights and a
flash from a different direction. It gives the
sense of surprise and rawness to the shot –
a late-night scene at a dining hole. There is
also a feel of something illegal about it –
for me, the massacre that preceded the kill.

Zakouma National Park, Chad, 2006; Canon EOS-1Ds
Mark II, 800mm lens, 1 sec at f8, ISO 400.

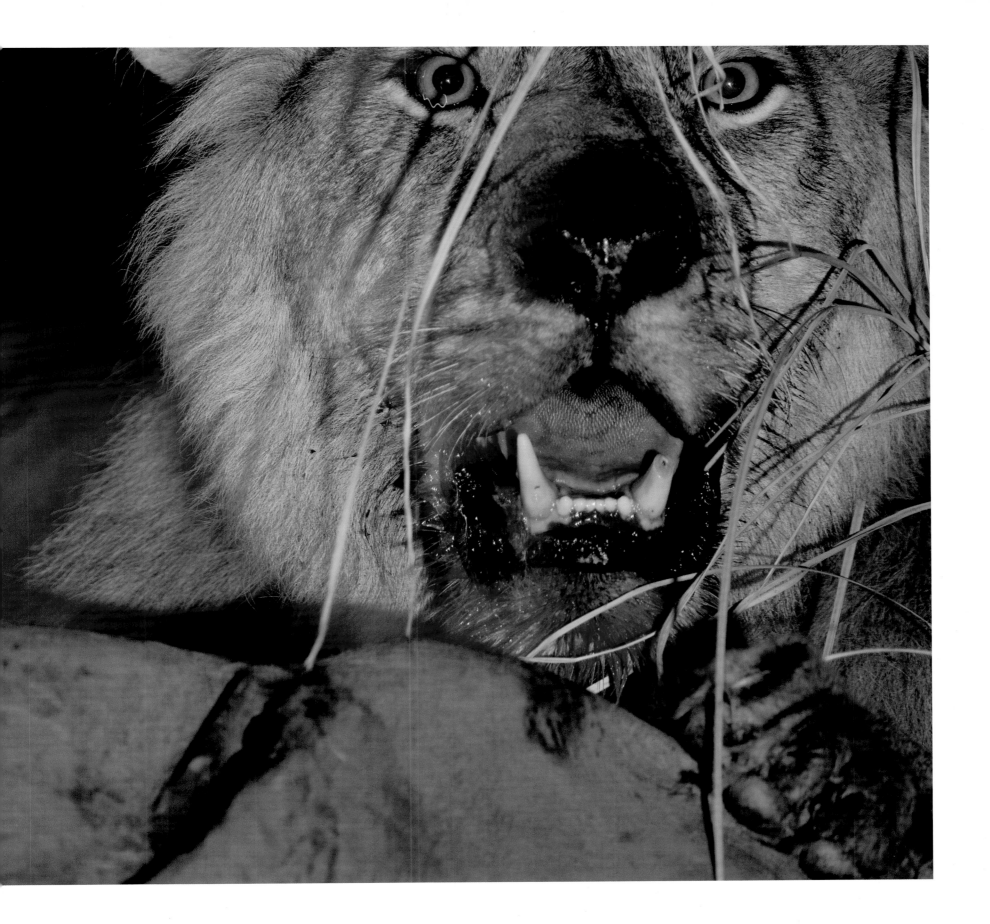

MICHAEL 'NICK' NICHOLS

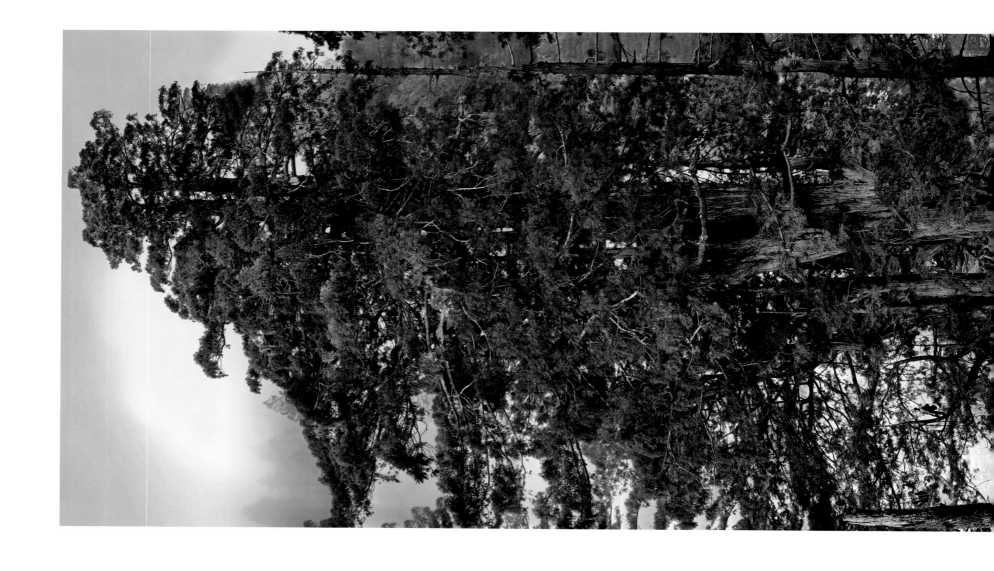

THE TITAN

I wanted to create an image to show to the world the total magnificence of a redwood tree. The only way to get across the scale was to recreate the tree, picture by picture. But it had to be complete, not a bunch of fragments, which required teamwork and the precision of the latest computer software to sew it together. To shoot this 300-foot, 1,600-year-old titan, arguably the most beautiful of the giant coast redwoods, required a year of planning, three weeks of rigging, and weeks to stitch together the 84 pictures. The technical breakthrough was the use of a filming dolly, on which were hung three gyroscope-balanced, super-focused cameras that we lowered slowly down on rigging lines on a tree opposite the titan. We rigged up every day at dawn for 19 days. The pictures were taken at six-foot intervals, shifting the exposure to match the changing light. But the final image required more than just technology. When I was in the forest, I felt as if I was in a church. But I couldn't feel any of that spirituality in the pictures, until on the thirteenth day nature provided the magic touch – a 30-minute sunrise glow. A tree like this is one of the most special living things on the planet – truly something to worship.

Prairie Creek Redwoods State Park, California, USA, 2008: 84 images, Canon EOS-1D Mark III x3, 35mm lens x3.

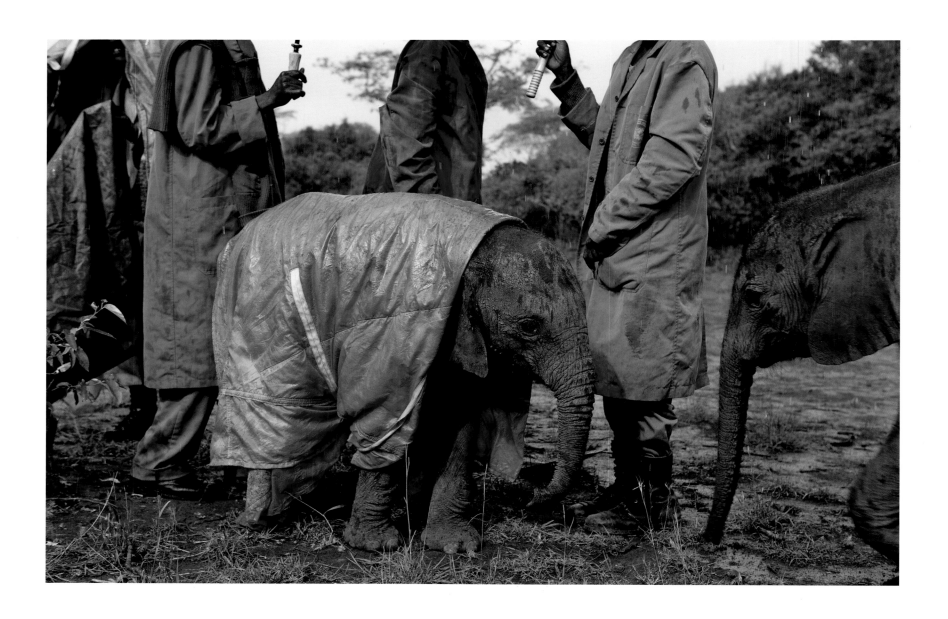

' You have to have a complete mastery of the technique so you can move beyond automatic mediocrity. Take chances. Take pictures all the time, rain or shine. You have your bag of tools. So try them. You want to keep trying different combinations because then you will find that surprise. The pictures I care about most are the real moments, not cropped, not set up, the ones with a kind of surreal energy. '

KENYA'S LITTLE ORPHANS

The coverage of Kenya's orphaned elephants was the last piece I did in my 20 years of elephant work. I wanted to show the connection between humans and elephants – that we can take an elephant that has been destroyed by having its mother killed and save it with love. In most cases Africans are the enemy of elephants. But these Kenyans very much care for them. Almost all asked to become keepers because they love animals and take naturally to being shown how to nurture these traumatised infants. When I first visited the David Sheldrick Wildlife Trust's nursery, it was the rainy season, and the keepers were constantly having to protect the youngest orphans from the cold and wet, sheltering them, as if they were under their mothers' legs. The raincoat adds to the impression of vulnerability. But I don't think about that when I am shooting. I have this overall idea and I just shoot everything I see. It's the editing that defines the work. But of course your mind is always looking for the images that express the emotion you are looking for.

David Sheldrick Wildlife Trust Elephant Nursery, Nairobi National Park, Kenya, 2010; Canon EOS-1Ds, 51mm lens, 1/180 sec at f5.7, ISO 100.

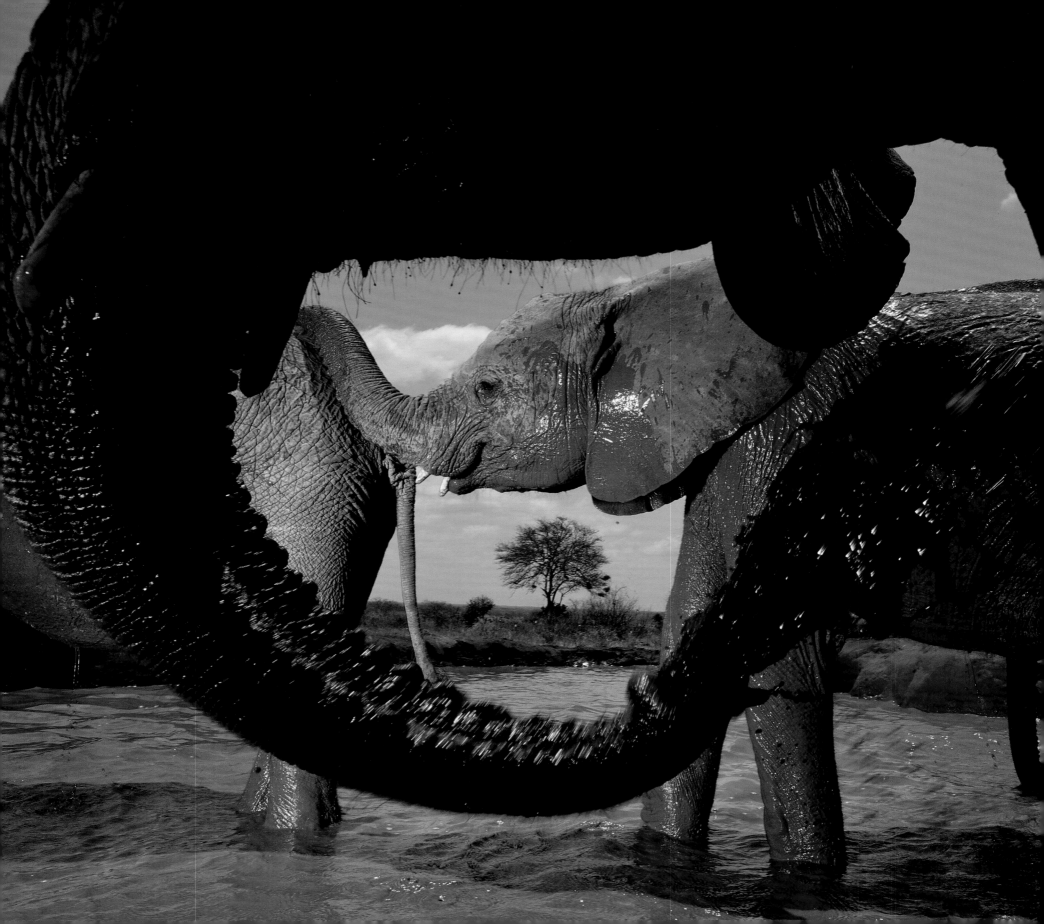

MUD-BATH TIME

I set out to shoot the exuberance of
the mud bath. It's a midday ritual for
the orphans, which use the mud as a
sunscreen and for insect-control, but also
for play. So I had to shoot at noon, which
meant matching the overhead sun with a
strong light – a flashlight hooked up to the
car. It's almost like a studio picture. That
doesn't matter – it's what comes out of it
that does. I was looking for the exuberance
of play and shot the picture in chaos.
There was mud everywhere. The elephants
were knocking me down. My assistant was
preoccupied with a video. I couldn't see
through the camera, which was low down
on a stick, just shapes on a tiny computer
screen. But I did compose it to catch the
tree in the background, and I was hoping
that the mud would make a beautiful curve.
Out of that chaos came this formal picture –
an accident, like all my best pictures. But
I also love it as an example of my subjects
and me working together to create it.

Voi Rehabilitation Centre, Tsavo East National Park,
Kenya, 2010; Canon EOS-1Ds, 24mm lens, 1/256 sec
at f16, ISO 160.

PAUL NICKLEN

Being both a photojournalist and a polar specialist requires extreme resilience as well as determination. Paul is among the most obsessive of such photographers, obsessive about getting the shot and telling the story. With 24-hour polar daylight, he will typically work 18 hours a day in the field, and he won't give up until he achieves his photographic goal, which in the case of some pictures has taken years.

That he works mainly under water is in one sense a natural result of his upbringing in the Arctic, where most of the wildlife lives in the sea or on the sea ice and depends on it, as do the people.

Paul really is a child of the frozen north. From four years old, he lived on Baffin Island, Nunavut (Canada), in a tiny Inuit community. There was no TV or radio, and the only entertainment was outside. In this almost permanently frozen land, extreme cold was normal and hunting was part of life. He saw his first polar bear when five years old, had his own snowmobile at ten, got his thrills from blizzards and ice and had baby seals and gulls for pets. As part of an Inuit community, he learnt all the skills necessary to survive in a polar region where, if you can't read the weather or don't know the difference between one type of ice or another, you die.

He was brought up listening to the traditional stories of the Inuit, which most probably instilled in him an appreciation of the power of storytelling. As for pictures, there was no TV then on Baffin and few illustrated books, but his mother, a teacher, loved to take black-and-white photos, and Paul would watch her print them.

But wildlife was his passion, and at 18 he left the Arctic to take a degree in biology at the University of Victoria in British Columbia, dreaming of future adventures with animals in the polar wilds. It was in the desk-bound years of study and exams that the idea of becoming a photographer, shooting stories for magazines, started to take hold.

He got his dream job as a biologist, studying polar bears, grizzly bears and lynx in the far north. But hours of data collection and scientific-paper writing rather than communication of what he saw with a wider audience began to frustrate him.

'On one polar bear tagging expedition, we had travelled over 10,000 kilometres by snowmobile, saw polar bears catching seals and white wolves eating bearded seals, and all I had to show for a trip of a lifetime was a bunch of data points on sheets of paper.' So at 26, he resigned, undertook a three-month solo hike with his camera into the high Arctic, shot rolls of average pictures and went slightly crazy but came out convinced that he had to become a full-time photographer.

Like most nature photographers starting out, he went through many years of living on the breadline and out of his car, building up his experience and pitching to magazines. Finally, after nine years of trying, he got his first *National Geographic* assignment.

Polar-ocean shoots have since been his trademark, with more than a dozen major stories in the magazine and an award-winning book of his work, *Polar Obsession*. He has also received more than 25 international awards for his photography, including five awards with World Press Photo and, in 2012, the Wildlife Photographer of the Year award.

'The photo opportunities in the polar regions are endless,' he says, 'and the ocean is hidden from view, vast, vulnerable and completely underrepresented in story coverage.' Yes, the poles are risky areas to work in, but, he maintains, 'if you know how to eat, how to stay warm, if you're comfortable in that habitat, you can spend 90 per cent of your time there. Cold is just pain management, though of course you have to know the difference between cold and frostbite, know what stage of hypothermia you're at.'

Now his real ambition is to get the audience for his images not just to see his pictures as beautiful but as a reminder of what is at stake as we lose the glacial and sea ice.

'At *National Geographic* they refer to me as a street-photographer under water. And I like that. My job as a journalist is not just to show viewers a picture of a polar bear. It's to bring them through the page and into the world of that animal, to get them to care. With an ultrawide lens and a full frame, I know I can do that.'

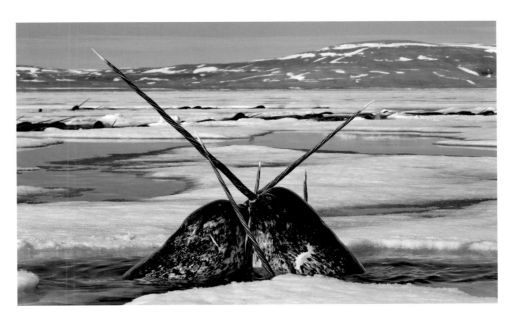

> ' The ideal for me is that combination of storytelling and art. No matter how important an image is, how hard it is to get, it still has to be artistic, informative, beautiful, powerful. '

POLAR REFLECTION

In one way, this picture was a fluke. I had always visualised photographing a polar bear under water. It's the perfect image to illustrate climate change. A bear standing on solid sea ice doesn't do it – it needs to look vulnerable. This big male was at his most vulnerable, swimming out in the ocean. You're never in control of the elements, and so the luck is when everything comes together, as it did here. The bear's reflection against the glassy surface is what makes the picture, the floating ice framing it. I took the shot from the boat. I could have swum with him, but that would have disturbed the water and scared the bear, risking him as well as me – if he'd attacked me, he would have been shot. So I took the picture blind, with my arms in the water. I was sure I'd got the frame and that it was sharp. But it was on film, and so I had to wait more than a month, after I got home, to find out how good it was. I knew the film had gone through X-ray on the way to the shoot and was damaged, and so when I saw the shot, I got the biggest surprise. I love it when I have a vision, I pursue it and the image comes out better than the vision.

Admiralty Inlet, Nunavut, Canada, 2004; Nikon F4, 20mm lens, Nexus housing, 1/125 sec at f2.8, Fuji 100.

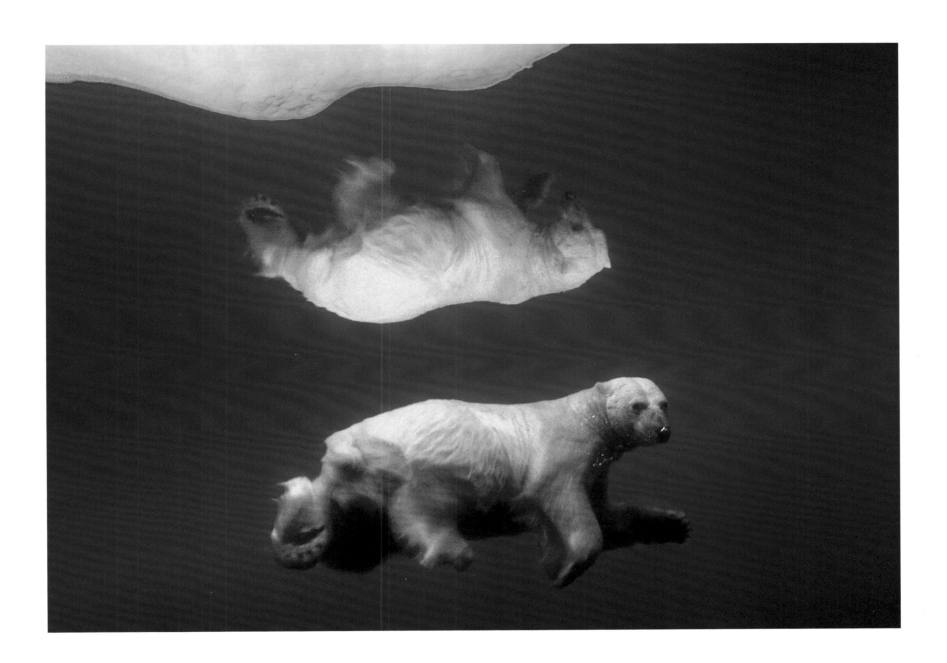

‘ I feel at home in this landscape. I'm intimate with it, and getting my camera to see it is second nature. It's the world I'm passionate about. It's where my art unfolds, and the opportunities are endless. ’

WINDOW INTO THE ICE

Ringed seals are among the most shy of Arctic animals. So to be sitting by a breathing hole and all of a sudden have a seal come up and take no notice of me was extraordinary. He was so relaxed that he fell asleep against my camera housing, and I had to gently push him away. He let me into his world, and I wanted to find a way to make a portrait that would capture his spirit. As he came up to the hole, he would stop an inch under the water, checking for polar bears. So when his nose was just below the surface, I laid my lens on the water, and by shooting ultra-wide, allowed the surface to unfold, the ice and clouds reflecting in the water. The result was a dreamy, ethereal view of an animal you seldom get to see close-up – an artistic way of showing it in its ice environment. If we lose the Arctic ice, we'll lose not just ringed seals, the main prey of polar bears, we'll lose a whole ecosystem.

Admiralty Inlet, Nunavut, Canada, 2004; Canon EOS IV, 16-35mm lens, 1/125 sec at f16, Fuji 100.

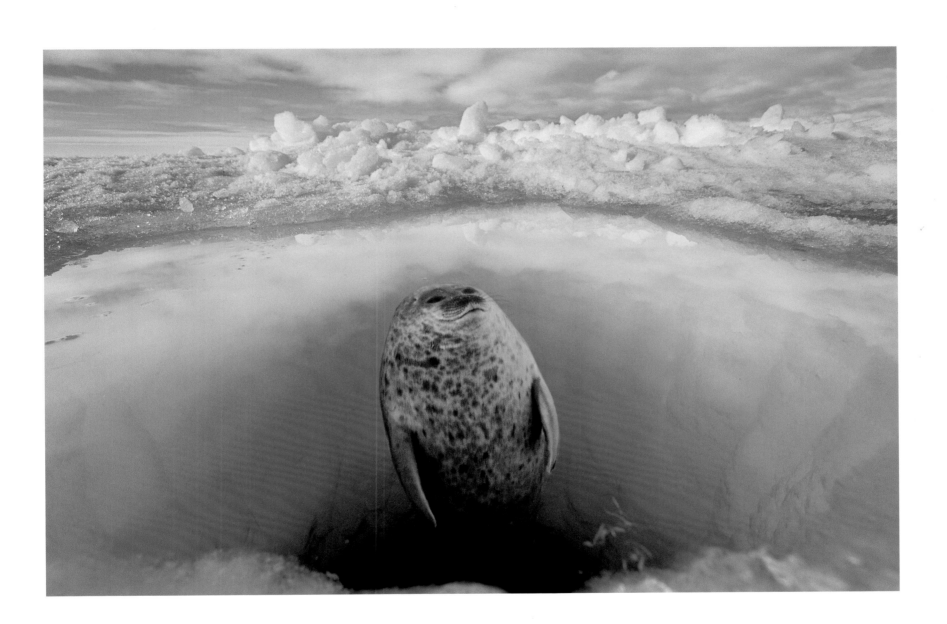

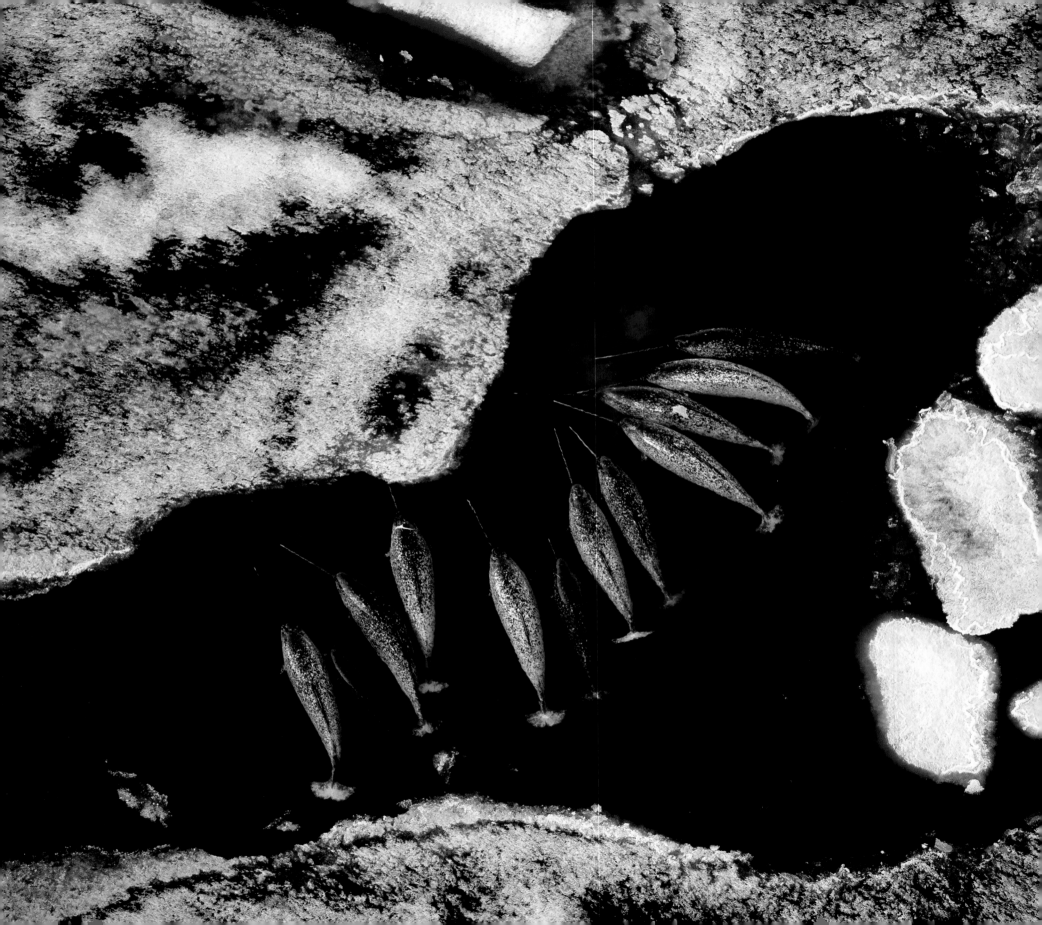

BREATH TAKING

It had been a 10-year pursuit – a lifelong
dream to photograph narwhals. I bought an
ultralight plane on floats. I trained on it.
I convinced my friend to pilot it. I had it
shipped to Arctic Bay – a huge operation.
On the first night, we froze up, lost the
engine, blew a crankshaft and barely landed
on the ice. It took a new engine and six
weeks of hauling this plane around before
finally, on the second-to-last day, we got in
the air. Flying over the sea ice, we could see
groups of narwhals in pockets in the ice.
I wanted to fly in and get close, but then
I saw this group of males in a teardrop
opening in the ice, and we had time to draw
back so I could get the beautiful pattern of
ice and frame the subject. As soon as I took
the shot, I knew I had something special.
It's a picture that you can look at as art or you
can look closer and see the bullet scars on
the whales – a combination in one picture
of storytelling, journalism and art. And that's
what I try to do with my photography.

Admiralty Inlet, Nunavut, Canada, 2006; Canon EOS-1Ds
Mark II, 70-200mm lens, 1/2000 sec at f5.6, ISO 400.

PAUL NICKLEN

‘ When working in this environment, you are
always thinking safety, like a pilot, checking
everything out. The most dangerous part is
when you are willing to step over the line in
order to get the picture, when you won't let go.
But you have to know when to walk away.
You can't take pictures when you're dead. ’

DAY OF THE NARWHALS

The Inuit once told me that when narwhals come up in the rotting ice, you can get close enough
to grab their tusks as they surface for air. They also said it was too dangerous to try. But when
an image burns into my consciousness, I can't let it go. So I bought a float plane, planned and
trained and finally set off for a narwhal feeding area off Baffin Island. Flight after flight we saw
nothing. Then on the last flight day of the trip, far out over the drifting pack ice, our luck changed.
We spotted hundreds, then thousands of narwhals. I convinced my friend we could land the
little plane on the rotting ice. When we stepped out, the whales were coming up all around us.
The sound was almost deafening – the squeals and groans and the whales blowing. Just as
I walked up to this one hole, the narwhals started to surface. I was 1.5 metres away with a 16mm
lens. They didn't care I was there. They were in a feeding frenzy, catching polar cod under the ice.
At that moment, I lived the dream – I was in arm's reach of a large tusked narwhal. That's when
the tears started to flow. I just wished I had a mask and snorkel and could jump in with them. It's
one of the highlights of my career. If there had been nice light, it could have been a better picture.
But it's one of those pictures that you remember for the moment – one I'll never forget.

Admiralty Inlet, Nunavut, Canada, 2006; Canon EOS-1D Mark II, 16mm lens, 1/250 sec at f11, ISO 160.

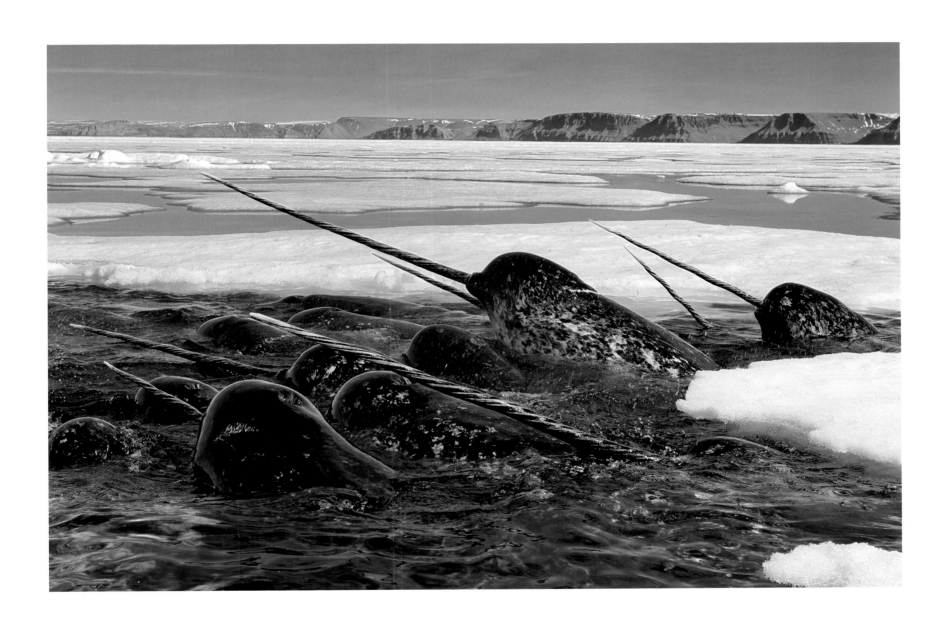

' I started out photographing ice. It's my subject.
When I'm on sea ice, I feel I'm walking
through a painting. Ice isn't just white –
there are blues and greens and turquoise. '

ICE-COOL LEOPARD SEAL

I wanted to show that leopard seals are not the vicious animals they are so often portrayed as,
that they are often misjudged because people don't understand their behaviour. This female was
resting on floating ice in the Lamaire Channel. Though I was a stranger in her world, she didn't
even raise her head when I swam up, revealing just how confident these intelligent predators are.
I used a split-level shot to show her in her environment and the beauty of the ice on which she
depends – her world without ice would be like a garden without soil. But it was a dangerous
situation. There was a three-knot current down the channel, and the ice was swirling around.
The seal was fine, but I'm in the water, with my face up against the ice, and great pieces are
smashing around me and pushing me under water. In the end, I got squeezed out and had to dive
down and swim under the ice to find a breathing space, which is when I abandoned the shoot.

Lamaire Channel, Antarctica, 2006; Canon EOS-1D Mark II, 17-40mm lens, Seacam housing, 1/250 sec at f8, ISO 100.

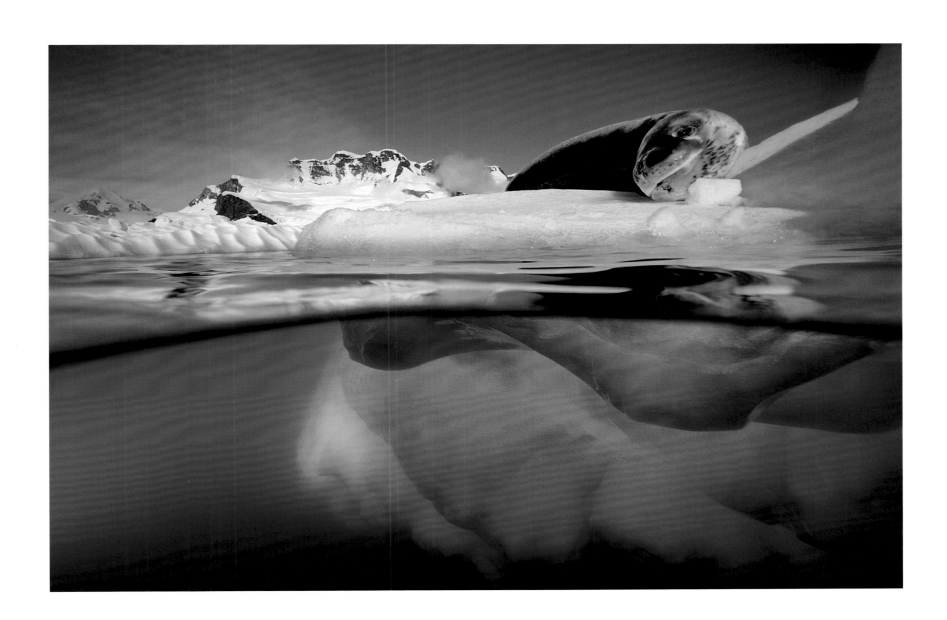

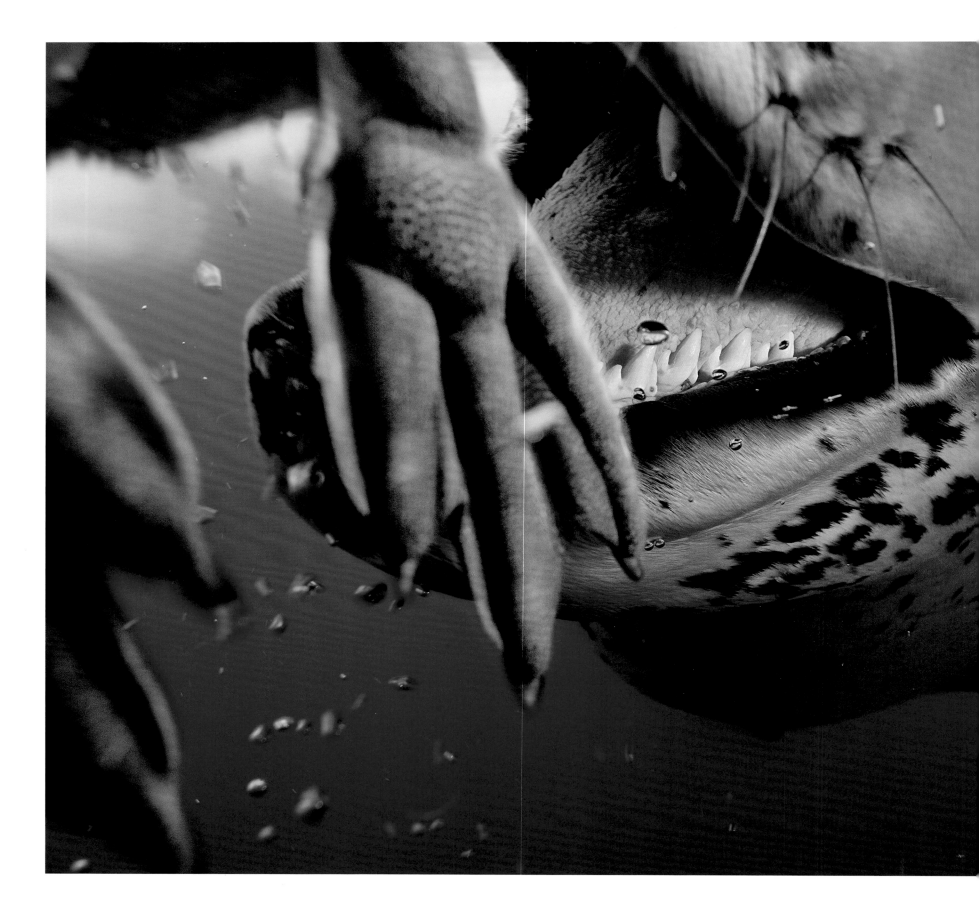

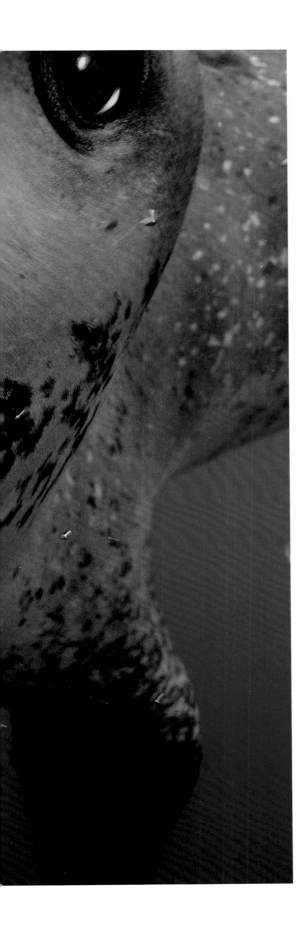

THE GIFT

Under water, this 12-foot leopard seal seemed unbelievably huge. Coming right up to me, she opened her huge mouth and lunged, her upper teeth above my head, the bottom ones close to my chin. She repeated the threat several times, then swam off. It was the start of a four-day encounter. Back she came with a live penguin. She released it, let it swim towards me, chased it, brought it back and then released it again. She did this several times and then ate it right in front of me. She caught another, offered it to me and then ate that one. Finally, realising I was a useless hunter, she brought me a dead penguin and left it floating in front of me. I was laughing so much that I flooded my mask. Never did I feel threatened. This agile, beautifully designed, highly functional killing machine was communicating with me. Locking into the moment, I kept shooting, something that would have been impossible with film. It was an extraordinary encounter – an astonishing gift from the sea.

Anvers Island, Antarctica, 2006; Canon EOS-1Ds Mark II, 17-40mm lens, Seacam housing, 1/100 sec at f9, ISO 500.

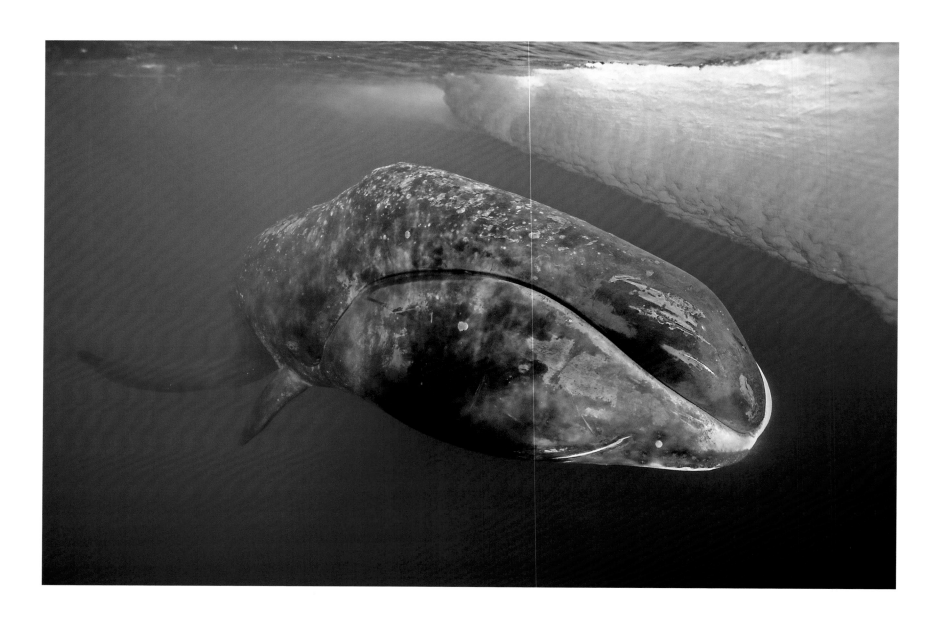

BOWHEAD DREAM

This was one of those moments when you have to make your own luck. You have to be ready.
I'd been snorkelling for four hours in -1°C water trying to photograph narwhals. Slushy fresh water
mixing with the salt water had made visibility almost zero, and I'd got so cold that I was borderline
hypothermic. So I was just lying on the edge of the ice, numb, when suddenly this huge 50-foot
bowhead whale surfaced only six feet away. My Inuit assistant knew I'd been trying for years
to get a shot of a bowhead under water. He came running over, put the snorkel in my mouth,
put my housing in my hands and just rolled me into the water. I didn't even have my flippers on.
I found myself in a swimming pool of clear visibility. As the whale had come up, he'd brought a
large volume of sea water with him and displaced all the fresh water. So here I was with one of the
most beautiful, ancient beasts on the planet, a foot away from his chin with an ultra-wide lens,
my hand so frozen that I couldn't even feel if I was hitting the shutter. He looked at me and
then slowly, very slowly, rolled over and sank under the ice. I had to ask myself, did that really
happen? Was it a dream? But I was shooting digital, and so I could see the composition – the
bowhead in crystal-clear water and the floe edge in the frame, connecting him to this icy world.

Lancaster Sound, Nunavut, Canada, 2007; Canon 1Ds Mark II, 16-35mm lens, Seacam housing, 1/160 sec at f4, ISO 400.

PAUL NICKLEN

BLAST-OFF

On the second day of the shoot, standing on
the ice, I was knocked flying by a leopard
seal that came hurtling out of the water and
realised too late I wasn't a penguin. At that
moment, I knew first hand why emperor
penguins rocket out onto the ice. To double
or triple their speed, they use a lubrication of
micro-bubbles released from their feathers
that cut down the friction of feathers against
water. The challenge was to catch this in a
single, clean moment and with artistry. The
water was crystal clear but with hundreds
of penguins exiting the hole, the scene was
chaos. Diving an hour at a time in the -1.8°C
water, trying to maintain perfect buoyancy
so as to not to move a muscle, I waited, with
the scene framed in the viewfinder. Finally a
single penguin in full-on bubble-release mode
came shooting by, air coming out of its lungs,
bubbles pouring out of its feathers. Shooting
at 10 frames a second, I just caught it.

Ross Sea, Antarctica, 2012; Canon EOS-1D Mark IV, 16-
35mm lens, Seacam housing, 1/1250 sec at f5, ISO 400.

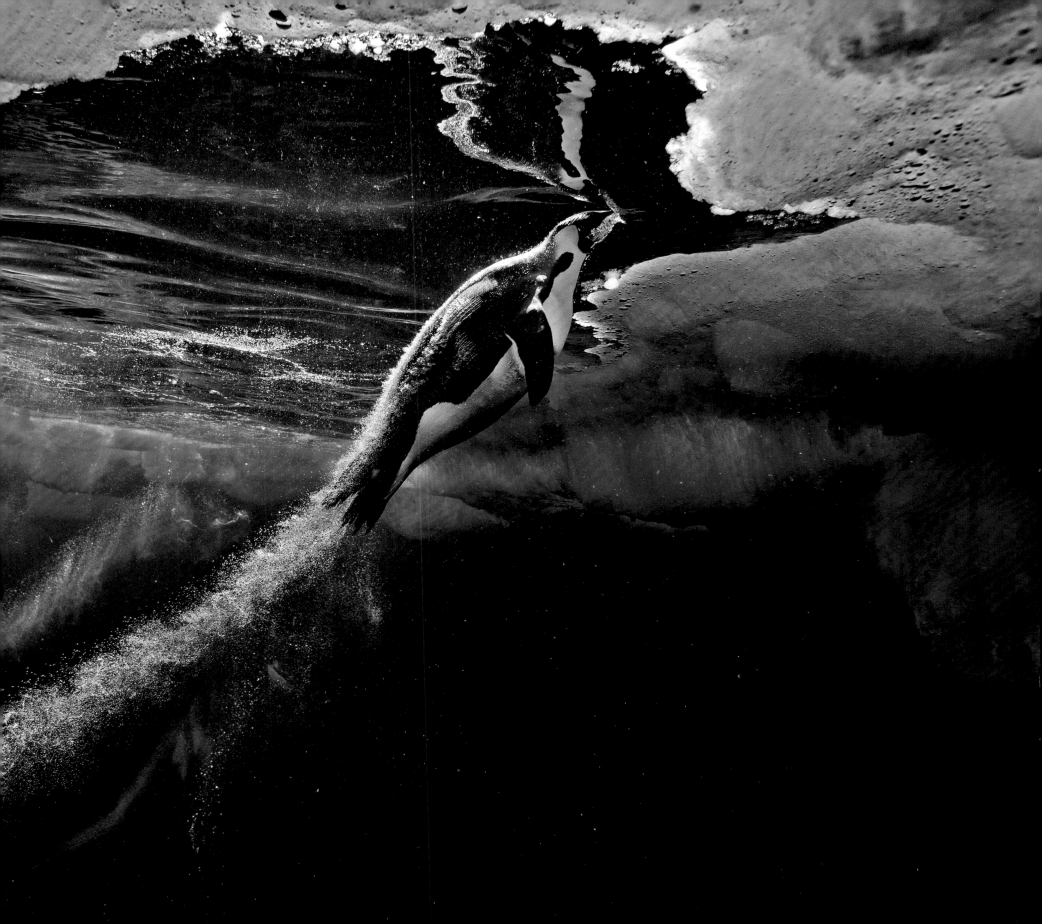

'I felt so empty as a biologist, turning beauty into data and not art. Now I can turn data into art and hang it on my wall.'

BUBBLE-JETTING EMPERORS

The light under water in the Antarctic is unbelievable. The ice throws it around. But here it was nearly impossible to get the exposure right, and the slush and bubbles meant I couldn't use strobes. Under the ice holes, it's total chaos. The emperors come in waves, 200 to 300 every hour or two. The chaos is what I wanted to capture, so viewers would feel they were among the penguins shooting to the surface. I love how layered and chaotic the picture is. The left-hand penguin was against my head – these are huge birds. I also love the one perfect penguin, its back arched. I wanted to be in their world. They perform with such speed and grace and can dive to depths of more than 1,600 feet. I'm inept by comparison, but for that short underwater time I did feel at one with them.

Ross Sea, Antarctica, 2012; Canon EOS-1D Mark IV, 8-15mm lens, Seacam housing, 1/1000 sec at f7.1, ISO 500.

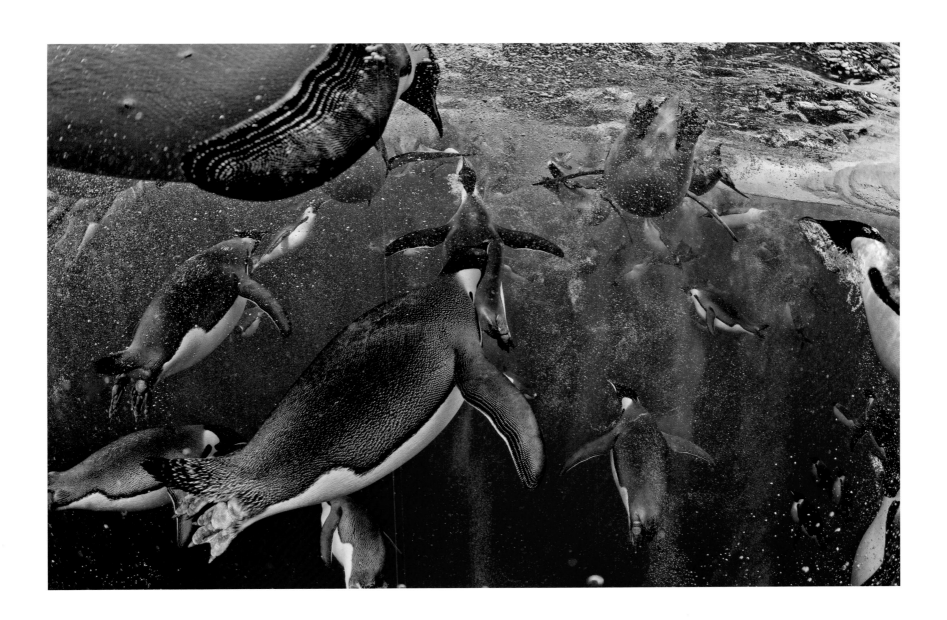

PAUL NICKLEN

SPIRIT BEAR AT REST

For three days, I followed this spirit bear. He completely accepted me. I respectfully watched and photographed as he meandered through the moss-draped rainforest, his stomach full of salmon. At one point he fell asleep in a mossy day-bed at the foot of an ancient red cedar, the largest in the forest. I also lay down, just a few feet from the bear. I smelt his rich, damp fur, and I heard him breathing and watched his chest heaving slowly as his body began to relax into rest. This was to be one of the most incredible experiences I've had, both as a photographer and as a human. Now the spirit bear's home, the Great Bear Rainforest, faces the threat of a massive oil pipeline running through it, taking oil from Alberta to the coast of British Columbia, so oil can be loaded onto supertankers for shipping to China. The only way we'll protect this rainforest is if people feel some connection with it. I want others to look into the eyes of this bear and feel moved. That's what I want my photographs to achieve.

Princess Royal Island, British Columbia, Canada, 2010; Canon EOS-1Ds Mark III, 35mm lens, 1/60 sec at f8, ISO 400.

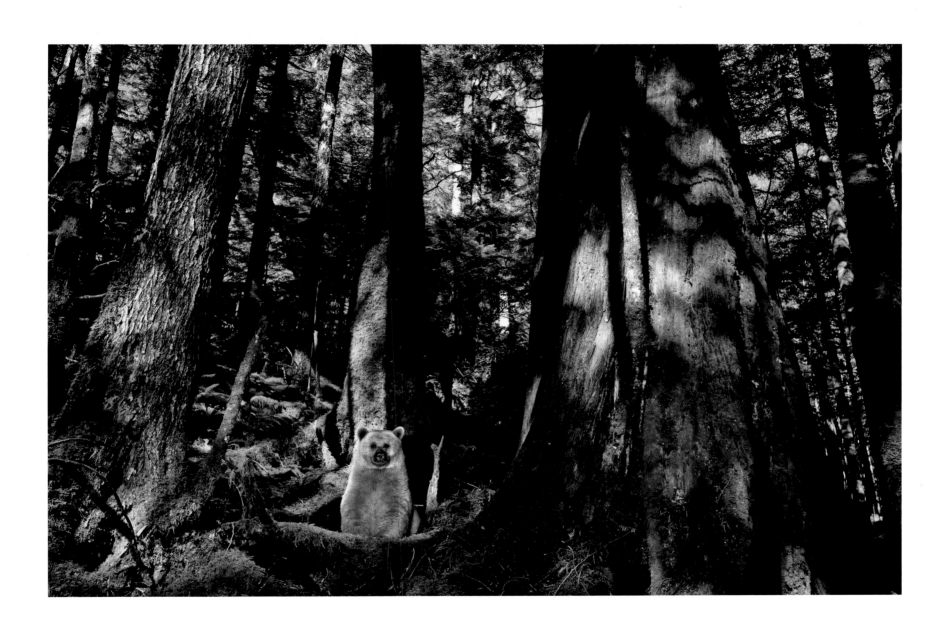

ANUP SHAH

It's not surprising that a childhood spent in Kenya would lead to a love of wild places. But the heart and soul of Anup Shah's work lies in his upbringing – 'a family tradition of love and respect for all living creatures' and the belief that 'kindness to animals is paramount'.

His photographic ethics are always to put an animal's welfare before the desire to get the shot and to ensure that his photography is respectful of the individual. Such sensitivities, combined with an analytical mind, have given him a fascination for the nuances of behaviour.

Anup's evolution as a wildlife photographer came later in life. He has a doctorate in mathematical economics from the London School of Economics and began his career as a university researcher and lecturer, specialising in ecological economics. But the pull of the wild was irresistible, and at every opportunity he would return to Africa.

The 'first click of the shutter' and that first step towards life as a wildlife photographer was, however, made on a trip to India, and born of 'an encounter with a tigress and

her two cubs in the dappled light of Ranthambore's beautiful forest'. It led to his first book, *A Tiger's Tale*, and his departure from academic life. It was, however, in the Serengeti-Mara ecosystem where his evolution as a photographer took place.

Rather than taking a documentary approach, Anup started to work with concepts, which gave rise to a series of books. The first was an evocative illustration of cycles in nature based around the Serengeti ecosystem – *The Circle of Life*. This led on to a visual narrative of the great migration, and the cyclic process alongside it, *African Odyssey – 365 days*. And his fascination with that cradle of humankind, the East African Rift Valley, and the story of human evolution, linked to his love of the great apes, gave rise to *The Great Rift Valley of East Africa*.

What he is particularly known for is capturing the subtle communication or connection between one animal and another. More recently he has also become fascinated with the idea of trying to make pictures that view animals totally on their level, 'what it feels like to enter the private space of a wild animal without impinging on it, free of all

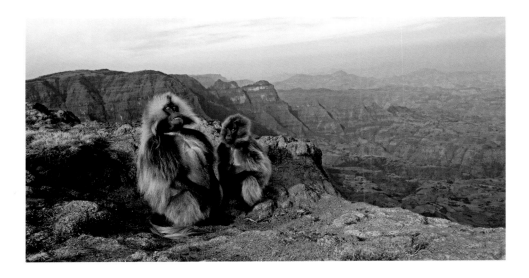

man-made intrusions, of even the space between the animal and the camera itself'. These 'immersive' pictures don't involve eye-to-eye contact – often quite the reverse. The pictures are taken using a remote bespoke camera and kit linked by radio control to a TV screen inside his car, so he can adjust the camera settings and trip the shutter at the chosen moment.

'The hardest part was camera placement – selecting where I thought the animals might move to' – which is when 15 years' worth of knowledge of animal behaviour became important. The resulting collection of work was published as *Serengeti Spy: Views from a hidden camera on the plains of East Africa*.

What Anup is obviously drawn back to time and time again is a fascination with non-human primates, especially the great apes. They cannot help but 'strike an emotional chord in us', and so often 'it is they who choose' to communicate with us.

'I suppose I am trying to make a connection between myself and the natural world,' he says, 'not consciously trying to convey the essence of the animals, rather trying to appreciate for myself their innocence and vulnerability. It's what we have lost, along with being vulnerable to the weather, the environment, the wilderness.'

What amazes Anup most is the trust that so many animals give him: 'the wonder of an animal trusting you' – a view that links back to ancient eastern philosophy. 'We are in a partnership with the Earth – and the animals have something of value to say to us.'

ANUP SHAH

' Imagine rising early in the morning.
The forest is beautiful and the light amazing,
and a tiger walks by. You feel joy.
What a wonderful world. Some people cry,
some people write music, I just express it
through the photographic possibilities. '

LAST LOOK

Noor Jahan was named after the famous Mogul empress and lived in Ranthambhore in the
golden days of the park. She is pictured here with her young son Bhinsen, walking along a track
just after dawn. They have paused to wait for Bhinsen's two siblings to catch up. It's a moment of
intimacy – one of those special moments when everything has fallen into place: the light, the look,
the pose. In the six years of working in the park, it's the moment I remember most vividly.
Noor Jahan is looking straight at me, calm and confident, perhaps too trusting of humans.
Bhinsen seems more anxious. That same year, Noor Jahan and her entire family were killed.

Ranthambhore National Park, India, 1991; Canon EOS-1V, 500mm lens.

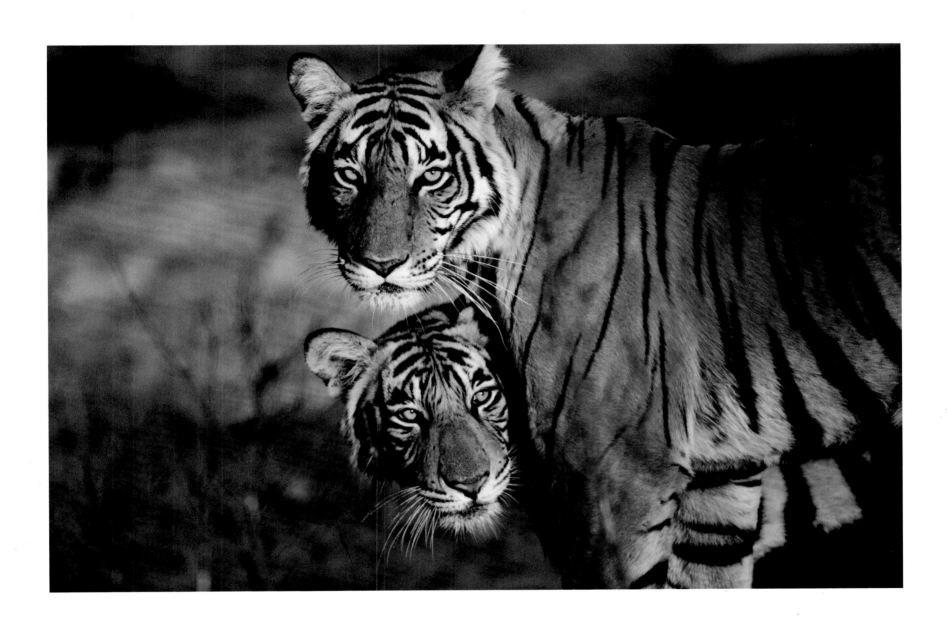

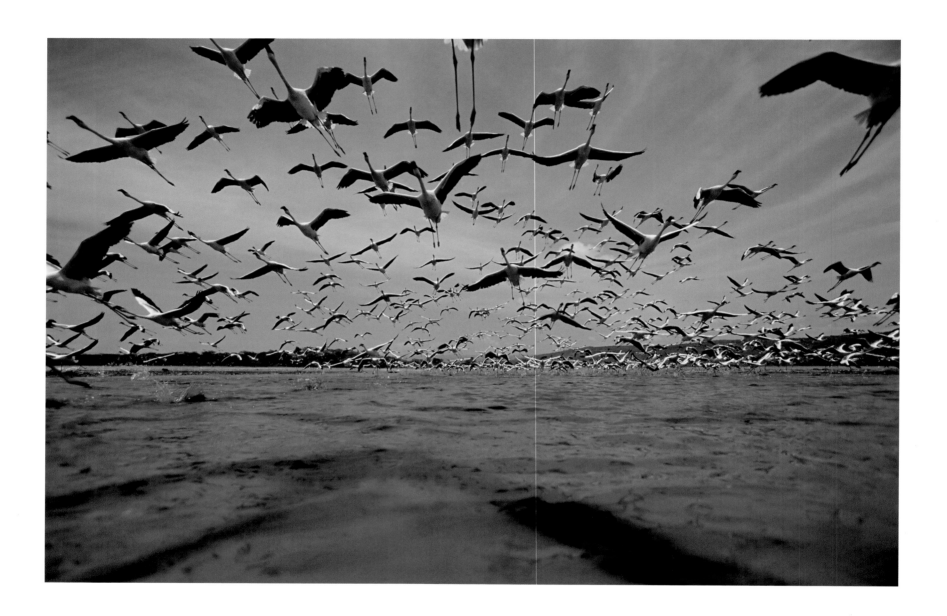

FLAMINGO FLIGHT

I've always been fascinated by flamingos. They are crazy birds – their looks, their rituals and their strange behaviour. More than a million congregate at Lake Nakuru to feed. In the morning, they often move to the river at the far end of the lake to drink and wash – to clean the soda from their feathers. It's when they feel most vulnerable to predators. I wanted to get a shot right in among them, to convey the panic. The camera was camouflaged on a platform just level with the river surface, remotely controlled by radio. I placed it in anticipation of the direction they would fly in, but it took five days to get the picture. The flamingos were panicked by a hyaena charging at them. Those in the air were the ones further upriver who had the space to take off, but the ones in the congestion near the river mouth were still running. I like the dimension of panic that the close wide-angle gives and the way the pattern of escaping birds mirrors the clouds.

Lake Nakuru, Kenya, 2007; Canon EOS-1V, 16-35mm lens.

ANUP SHAH

A MOMENT OF HESITATION

I like the slight hesitation in the pose, the hint
of vulnerability – the duality of magnificent
power and uncertainty. The brothers are
confident territory-holders, part of the
Paradise Plain pride. They seldom hunt,
feasting instead on kills made by the pride
females. Their habit was to rest together
and move into the shade once the sun was
up. The only shade in the area was a single
bush, which is where I had placed the
camera. I'd park my car at a distance and
get into position before dawn. I'd designed
the camera system to give me as much
remote control as possible over the camera
and lens movement, and in this case I went
for the widest possible angle so I could
include the brothers in the background.
The aim was to bring out the personality of
a lion going about his daily life. A radio-control
trigger made such a low-level shot possible –
without it, I'd have been breakfast.

Masai Mara National Reserve, Kenya, 2008;
Canon EOS 5D, 16mm lens, 1/1250 sec at f8, ISO 400.

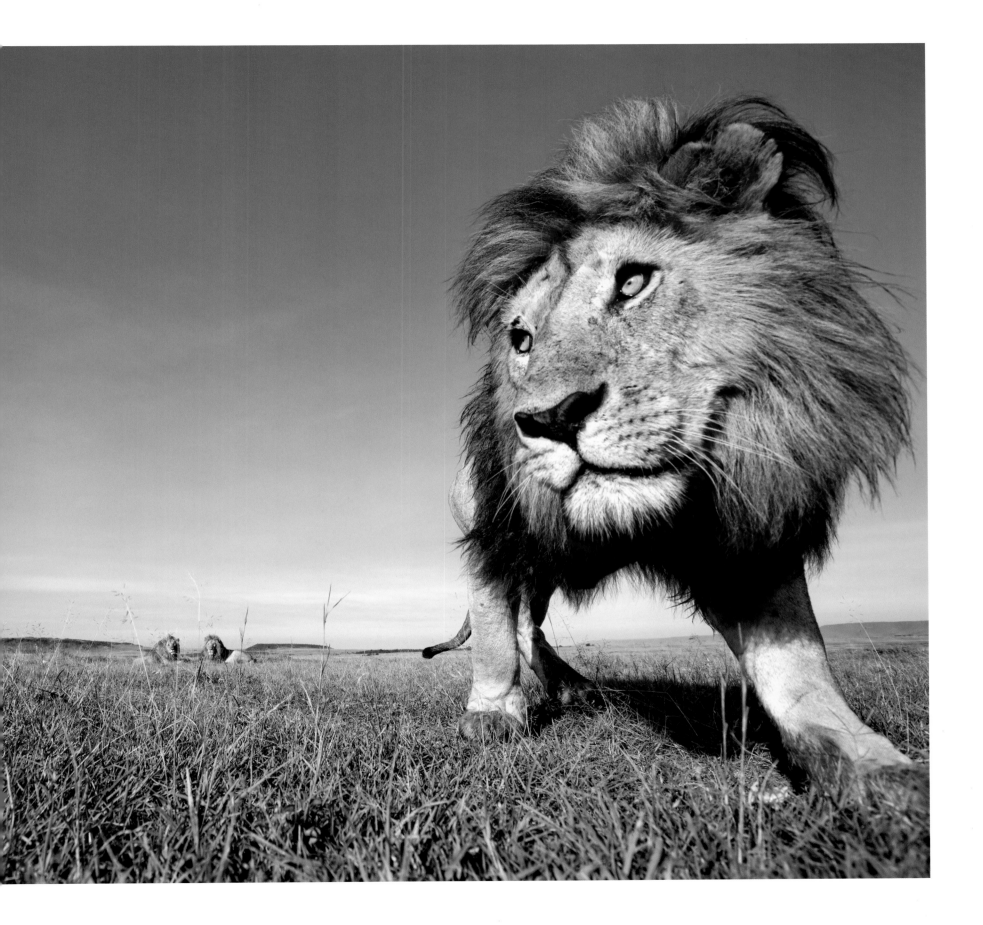

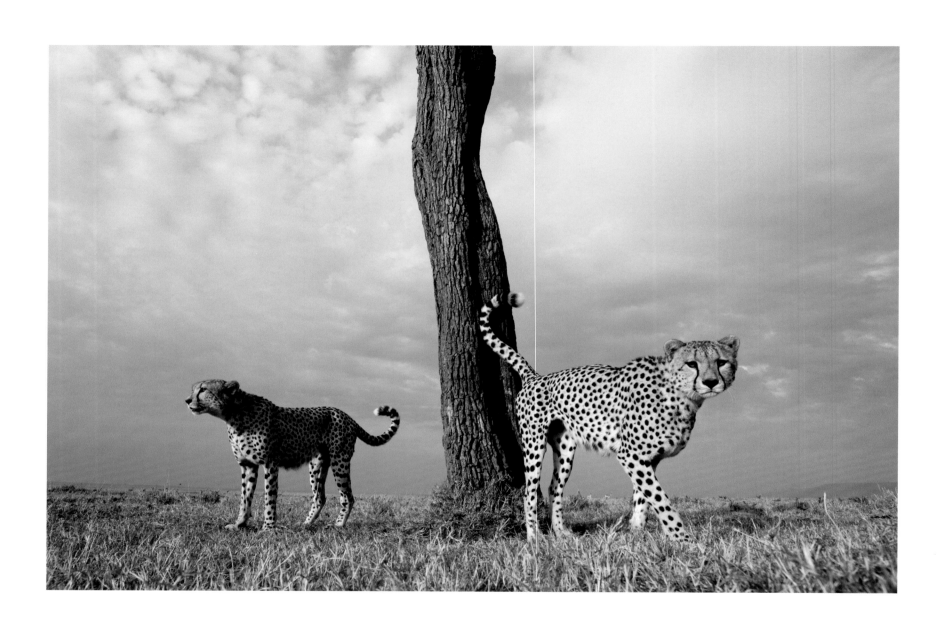

BROTHERS ON PATROL OPPOSITE

This composition was in my mind for a long time. A remote camera on the ground gives you a ringside view. Here, the cheetah brothers are at a regular marking post. One has done his work and one is in the act of spraying. The composition is satisfying, with one cheetah pointing one way and his brother the other, each doing his thing. Once they had remarked their message post, they moved on, ignoring my car at a distance.

Masai Mara National Reserve, Kenya, 2009; Canon EOS 5D Mark II, 19mm lens, 1/1000 sec at f8, ISO 800.

GAZELLE FORMATION OVERLEAF LEFT

It's early morning, and the Thomson's gazelles are lining up at a regular spot to drink at the river's edge. At this distance from the water, they are relatively relaxed – there is no vegetation to hide big cats – and they are just trotting back and forth, making up their minds when to go down to drink. Their fear is crocodiles. I love the sense of movement, row against row, in line with the river, and how the bands on their flanks link them together.

Mara River, Masai Mara National Reserve, Kenya, 2010; Canon EOS Rebel T, 10mm lens, 1/4000 sec at f4, ISO 400.

THE GREAT MIGRATION OVERLEAF RIGHT

It took a couple of weeks before I found the right spot for this shot, near a river crossing in the Mara. Thousands of wildebeest were moving south in search of new grazing, and I wanted a picture that would capture the feeling of being right in the herd. It took 50 shots to get this one. No cameras were lost in the making. Mine was disguised as a stone and well protected. It sums up what I feel about the great phenomenon of migration.

Masai Mara National Reserve, Kenya, 2011; Canon EOS Rebel T1, 10mm lens, 1/250 at f5.6, ISO 400.

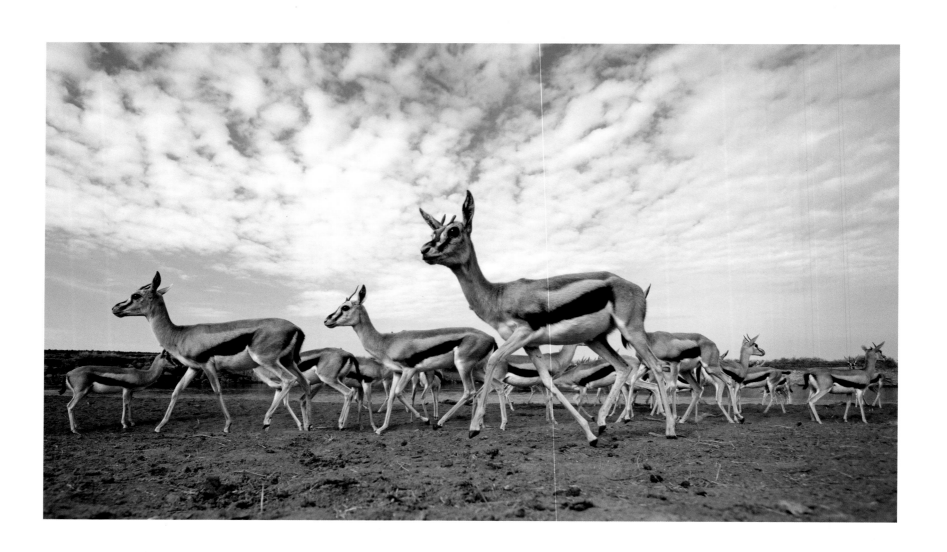

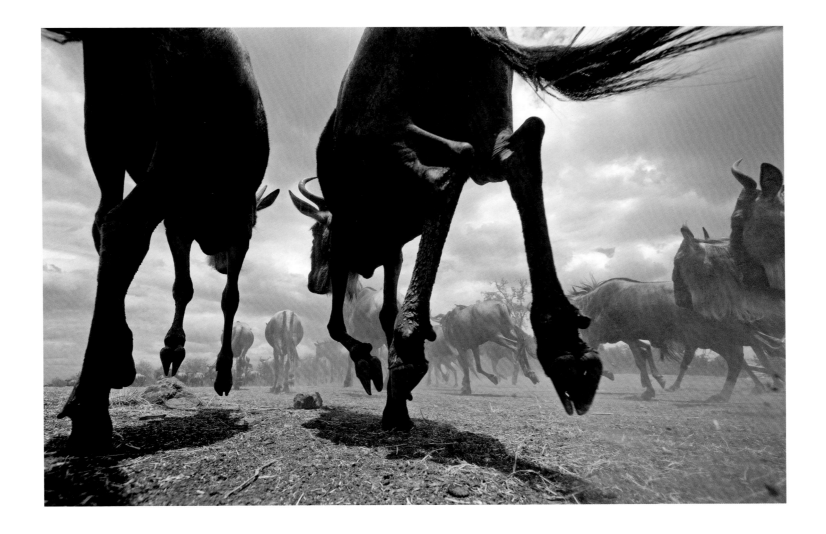

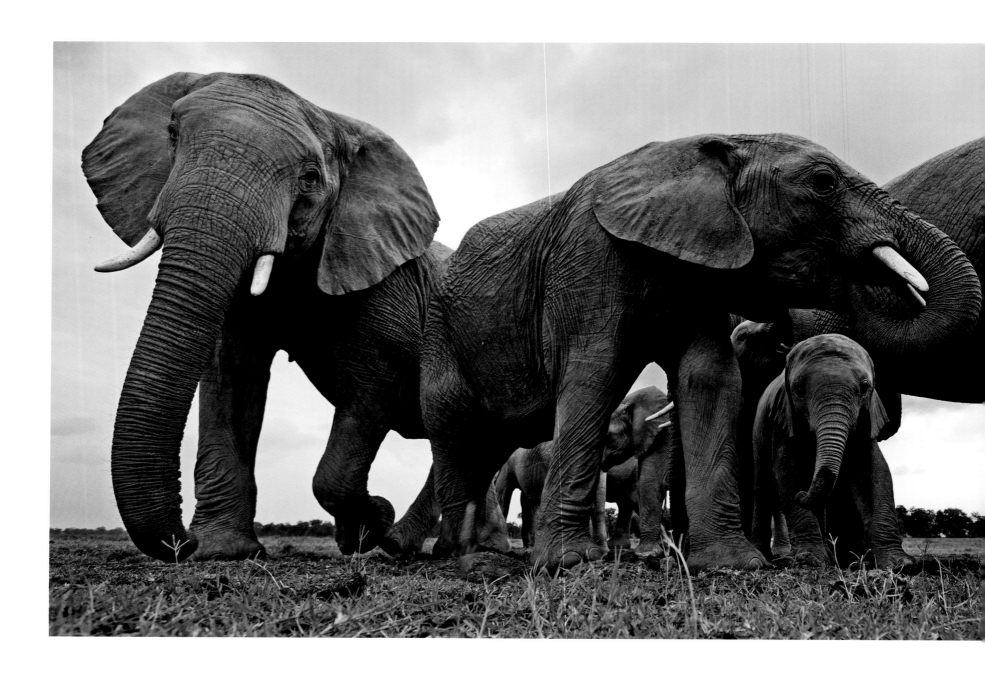

MUD-BATH TIME

These are truly relaxed elephants, and that's what I wanted the picture to convey – to show their giant, gentle presence, their close communication and relatedness when in their own, undisturbed space. The family are mud-bathing in a dried-out waterhole that has a little cooling mud left. The baby is trying to imitate its mother and aunts, and though it doesn't really know quite what to do, it's comfortable among their powerful and protective legs. Over time, I got to know the habits of these elephants and that they would visit this favourite mud hole towards the end of the day to bathe and drink. They were used to tourist vehicles and so took no notice of my car 50 metres away, and once they had established that my remote camera was harmless, they just got on with the business of the day.

Masai Mara National Reserve, Kenya, 2011; Canon EOS Rebel T1, 10mm lens, 1/1000 sec at f4, ISO 400.

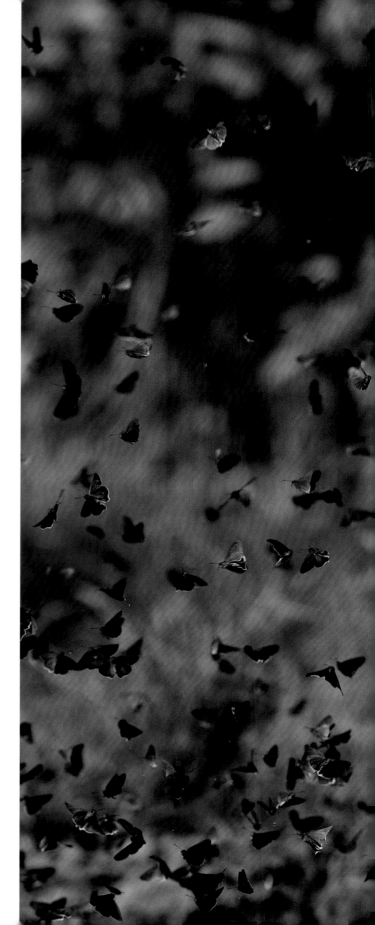

ANUP SHAH

MALUI AND THE BUTTERFLIES

Malui is the dominant female in a group of
western lowland gorillas, and she is usually
a morose and moody character. On this
occasion, her group had come out of the
forest to feed on plants in the swampy bai
[clearing], just when there was a mass
emergence of hundreds of butterflies. Most
of the gorillas were avoiding the butterflies.
But when Malui saw them, she got a gleam
in her eyes. I saw it and positioned myself
with the light behind me. Three times she
ran through the area where the butterflies
were, savouring the experience of the
explosion of wings. It was a game she clearly
enjoyed. My feeling was one of surprise and
elation – surprise because her behaviour was
out of character and elation because that
was probably what she felt.

Bai Hokou, Dzanga-Sangha Dense Forest Special
Reserve, Central African Republic, 2011; Canon EOS-1D,
200mm lens, 1/1600 sec at f5.6, ISO 800.

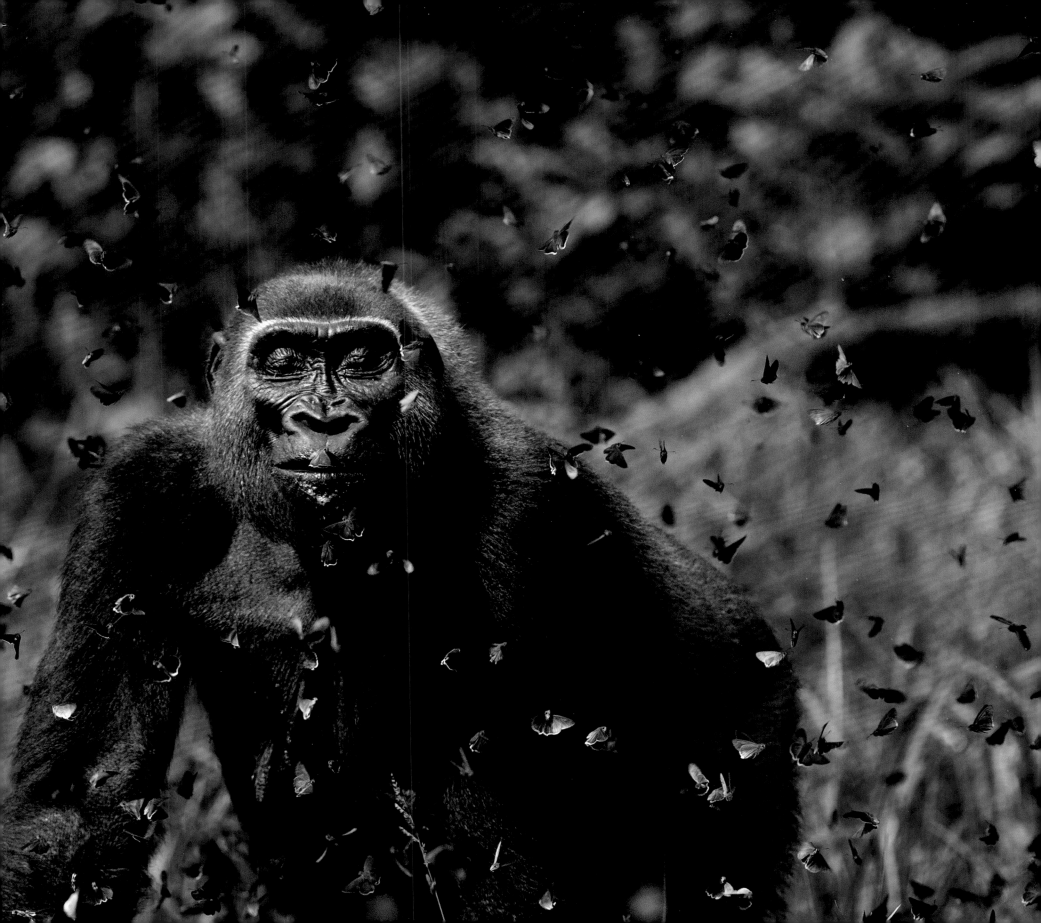

ANUP SHAH

A DAY AT THE BEACH

I'd always wanted to take a picture of Lake Tanganyika's wonderful pebble beach. But I hadn't planned on the Beach Troop. I spotted the baboons relaxing at the end of the day while on my way back from following chimpanzees in the forest. But as I was without a hide or remote, the picture had to be one taken completely on their terms. I crawled slowly along the beach towards them, and though the big male saw me, he glanced only briefly at the human on all fours and carried on with his meditation. The baboons allowed me to spend more than five minutes at eye level with them before they moved on leisurely to their sleeping place.

Lake Tanganyika, Gombe Stream National Park, Kenya, 2011; Canon EOS 5D, 31mm lens, 1/1250 at f5.6, ISO 800.

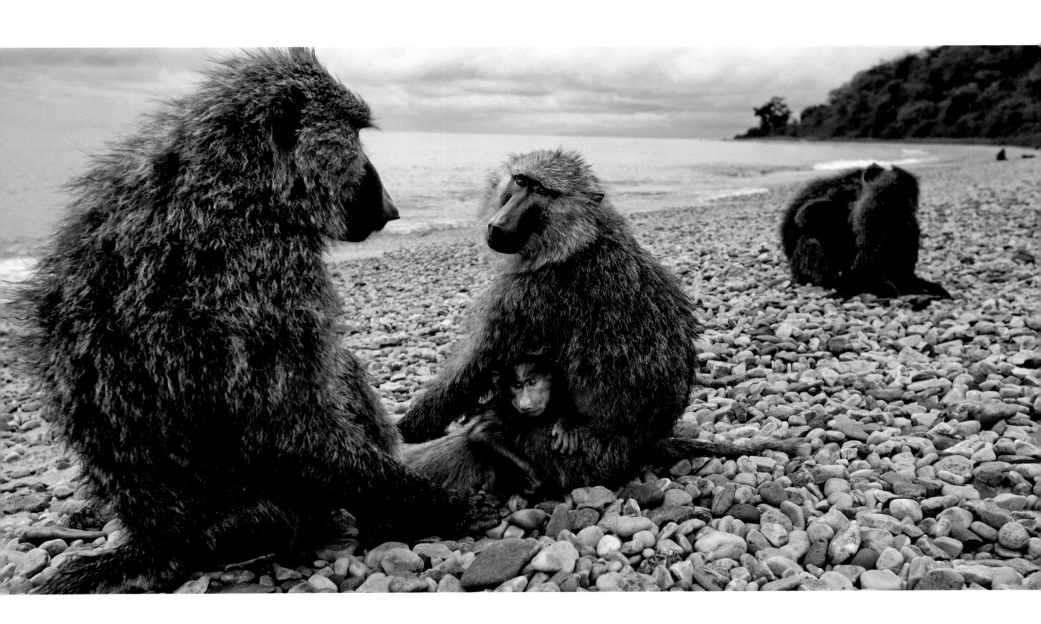

' I don't have favourites among species, but among the primate personalities I've photographed, there are those I'll never forget and friends I have made over time. All primates are fascinating to photograph, but like people, they deserve respect from the photographer. '

CAMERA POSE

I couldn't have asked for a better pose. The gang of youngsters had been playing on a fallen tree, but when I raised the camera, they rushed over to look at their reflections in the lens, pushing and shoving until a heap formed. There is so much innocence and curiosity and playfulness in the one picture. They are doing what you would expect human kids to do if you showed them a camera for the first time. The midday light was not good, but a high ISO solved the problem (I never use flash on animals), and the focus is on the diversity of their faces and expressions. Though I had been with these crested black macaques for a number of weeks, on this day I was presented with the gift of serendipity, which resulted in this special shot.

Tangkoko National Park, Sulawesi, Indonesia, 2011; Canon EOS 5D, 16mm lens, 1/60 sec at f3.2, ISO 800.

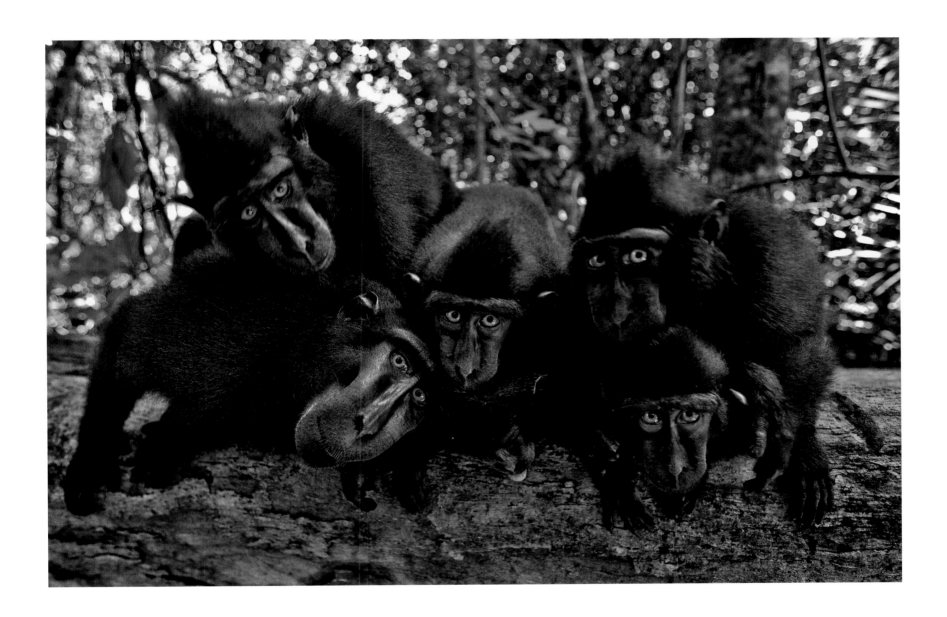

CHRISTIAN ZIEGLER

Ever since he was a small child, Christian Ziegler has been fascinated by how things work. He grew up in southwest Germany, with the forest and upland meadows as his laboratory and playground. Plants appeared to him as wondrous as animals – orchids in particular and their interaction with insects. Biology became his passion and eventually his university studies. Then, at 19, he travelled to Thailand and discovered the rainforest. 'Strangely, it was like coming home.'

Driven by his interest in rainforest conservation, a masters in tropical biology followed, with extended periods of field research in Thailand and the Ivory Coast. It was during this time that he taught himself photography, as a way of recording his subjects and discoveries. In 1997, keen to see the New World, he persuaded his old professor to let him be his field assistant at the Smithsonian Tropical Research Institute's station on the island of Barro Colorado in Panama. A two-month project turned into a year's thesis, by which time he had fallen in love with the place and the work. But photography had already begun to take over from data collection as a way to translate what he was observing.

'The Smithsonian is the epicentre of tropical research, discovering really fascinating things. But all this cool information was just published in academic journals, and I wanted to put this science into the public domain.'

The spur to turning professional was the arrival of Frans Lanting in Panama, on a major *National Geographic* assignment on global biodiversity at the turn of the millennium. Christian assisted him, and Frans gave him a valuable bit of advice: 'Work on your story until there is nothing left to be done and then take it to one of the big magazines.' The result was Christian's first story, on leaf-cutter ants, for *GEO* Germany, which is also where Frans got started.

Devising ways to light his subjects was the other challenge – essential when working in an environment where only a tiny percentage of the light that hits the canopy ever reaches the forest floor. He learnt by trial and error, devising his own techniques and equipment, but also analysing the work of lighting masters such as Michael 'Nick' Nichols and Frans.

The idea of a book had already taken hold, as a way to reveal some of the extraordinary

behaviour the scientists were uncovering in the rainforests of Panama – a project that came to fruition in 2002 as *The Magic Web*. More magazine features followed, and Christian also became an associate for communication for the Smithsonian Institution, allowing him to work closely with the scientists in Barro Colorado, where he is still based. Having tropical-ecology credentials has also given him a passport to work with scientists from other organisations including Princeton University and the Max Planck Institute and with environmental groups such as Conservation International and WWF.

Christian is now a contributing photographer for *National Geographic*, still majoring in rainforest subjects, with a special focus on conservation. His subjects for the magazine have varied from ants, orchid pollination and bats to bonobos and cassowaries. He's had two solo exhibitions, and prizes for his photography include the National Wildlife Foundation's Grand Prize and a number in Wildlife Photographer of the Year. Christian has also achieved his ambition to publish a book on orchids and their extraordinary and often devious interactions with their pollinators – *Deceptive Beauties*.

His science background has given him patience, both to devise technical solutions but also to wait for 'those rare moments when the magic happens'. It's also instilled in him a dogged determination. 'Most of my images take quite some preparation. I need to know how and where to find the organism, and then figure out ways to get the situation and the perspective in which I want to show it.'

Camera traps and remote camera systems fascinate him, and he's spent time working with *National Geographic* technicians to develop improved digital camera-trap systems. 'I use them as much as possible. They offer unique perspectives and show animals as they behave without human presence.'

His main interest remains the relationships and interactions between species. 'Stories are what I do, but the challenge is still to condense a story into one frame. I'm attracted to species people haven't seen before or showing more familiar ones in a new way. What drives me is a desire to share how special these forests are and that they need protecting.' But he also admits that 'I love how photography gives me a chance to get intimate with animals in a way no other profession does.'

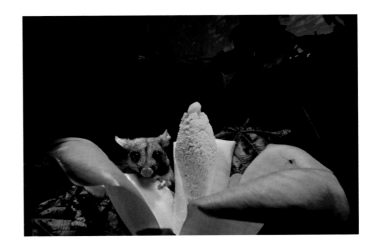

' Images can move people. They can change their emotions, their opinions, their values. And I see photography as a powerful tool for sharing stories – for inspiring people to care. '

SWEET INTIMACY

I thought a long time about the composition for this picture and how to create it. I wanted the magnificent hummingbird in its full glory, close-up and intimate, clearly pollinating the orchid while sipping its nectar. The lighting was very difficult to set up. It took two strobes hitting the feathers at the right angle to bring out the metallic colour, two to illuminate the flower and two the background. I used a custom-made wide-angle lens, which was literally touching the flower, and angled so the second purple spike was in the frame. The set-up was triggered remotely. But for two weeks, the male who patrolled this bit of rainforest went to every flower but this one. The *Ellianthus* flower was just a few feet off the ground, forcing any visitor to fly down low. Also hummingbirds are scared of snakes and nervous about anything strange near their food. And he may have been scared by his reflection in the lens. I was about to give up one dark and rainy afternoon, when this male flew in at just the right angle. The magic touch is the violet pollinia stuck to the end of his beak. It's how you can tell the orchid is bird-pollinated – pollen for insects is usually yellow.

Cerro Punta, Panama, 2008; Canon EOS 5D Mark II, 17mm f2.8 lens, 1/60 sec at f22, ISO 400, 6 flashes, remote.

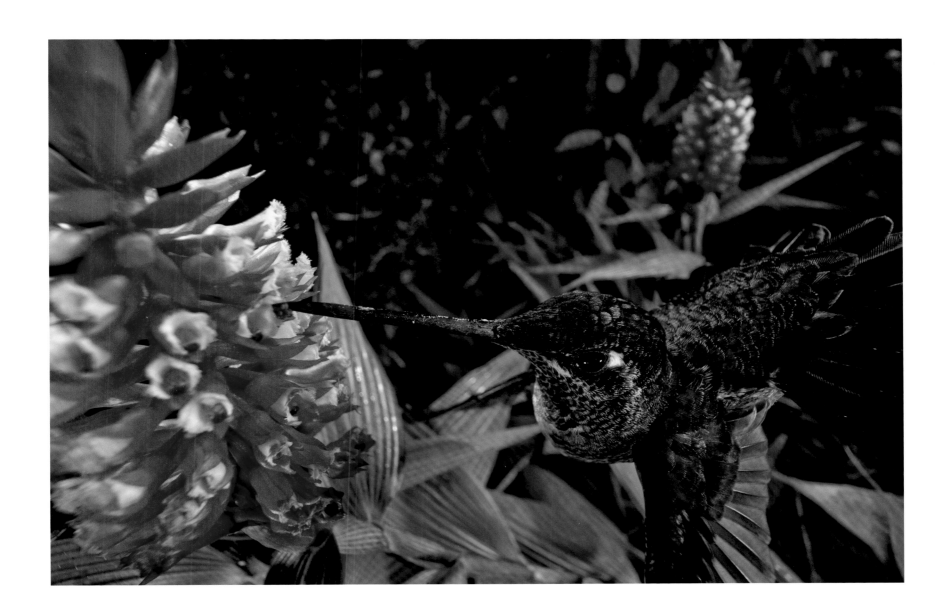

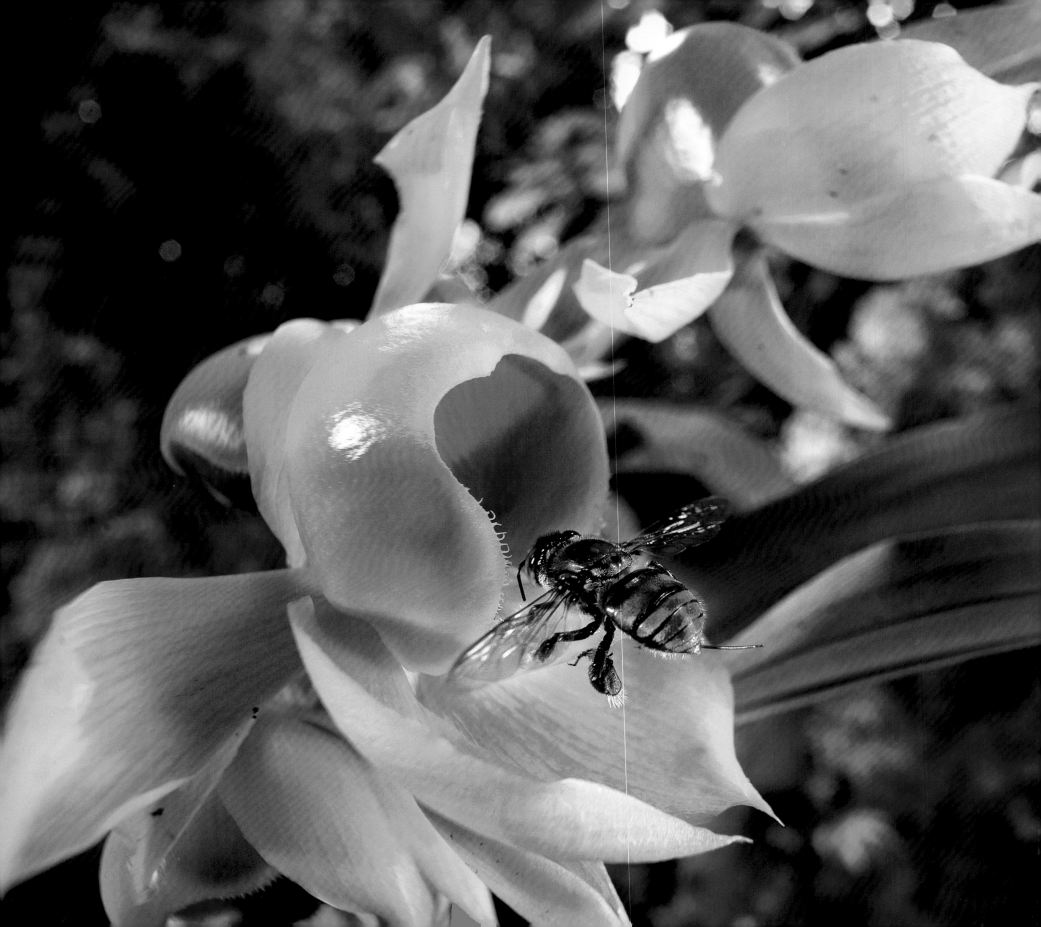

CHRISTIAN ZIEGLER

THE PERFUMERY

A beautiful bee visiting a beautiful orchid –
a visual feast and a really cool bit of
behaviour, but also a photographic challenge.
The *Cathasethum* orchid offers a sweet,
highly aromatic perfume rather than food to
attract the males of a particular *Euglossa* bee
to pollinate it. The males use the perfume to
court females and will fly miles searching for
it. When the bee crawls inside the orchid
and starts putting the perfume into pouches
on his hind legs, the flower punches
its pollinia onto his back. The surprise
encourages the bee to fly away to find
another flower. To get a wide-angle view of
the orchid I usually use a remote, to avoid
vibrating the camera when pushing the
button. In this case, the orchid was 20 feet
up in a tree. So I fixed my camera and three
flashes on a ladder beside the flower and
then sat on a chair below, with my coffee and
binoculars, and just enjoyed the action.

Barro Colorado, Panama, 2006; Canon EOS 5D Mark II,
17mm f2.8 lens, 1/60 sec at f16, ISO 400, 3 flashes, remote.

CHRISTIAN ZIEGLER

THE LURE OF SEX

This is a devious orchid and these are weird wasps, a combination offering photographic colour, action and drama. The wingless female wasps emerge from their pupae underground, climb up a stem and start emitting a sexual perfume to attract males. Males vastly outnumber females, which means there's lots of competition. A lucky male grabs a female and takes her to a food source. She feeds while they mate. Then he flies her to where she can lay her eggs – on a beetle larva. The king spider orchid mimics the wasps' sexual scent to trick the males into mating with it. When a male lands on the hinged red lip of a flower and starts to rub against it, the flower drops back, throwing the wasp down its throat so pollen sacs get stuck to its head. I really wanted to catch the colour and the action – to create a story in a single shot but also show the balletic beauty of the action. But I first had to find an unopened orchid so I could set up before the wasps got to it. I was told by an orchid botanist that the wasps were around but that they arrive very fast, as soon as they pick up the scent. I put a plastic bag over the orchid before it opened and set up, angling the camera so the Australian blue sky would be the background. I lay on the ground, took off the bag, and a minute and a half later, the wasps arrived, one already with pollinia on its head. Two minutes later, the ravaging was over and the flower was in pieces.

Albany, Western Australia, 2008; Canon EOS 5D Mark II, 100mm macro lens, 1/200 sec at f18, ISO 200.

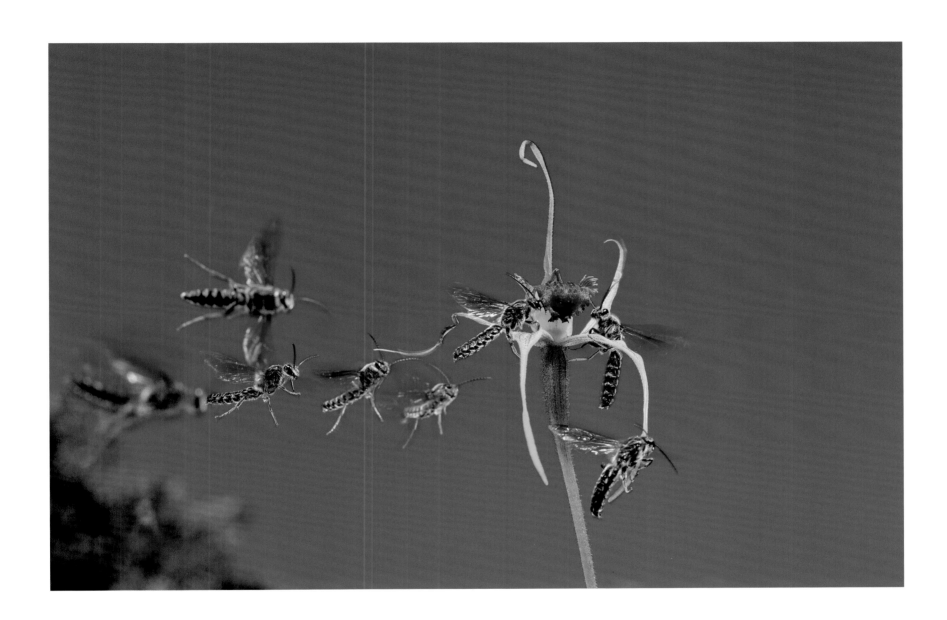

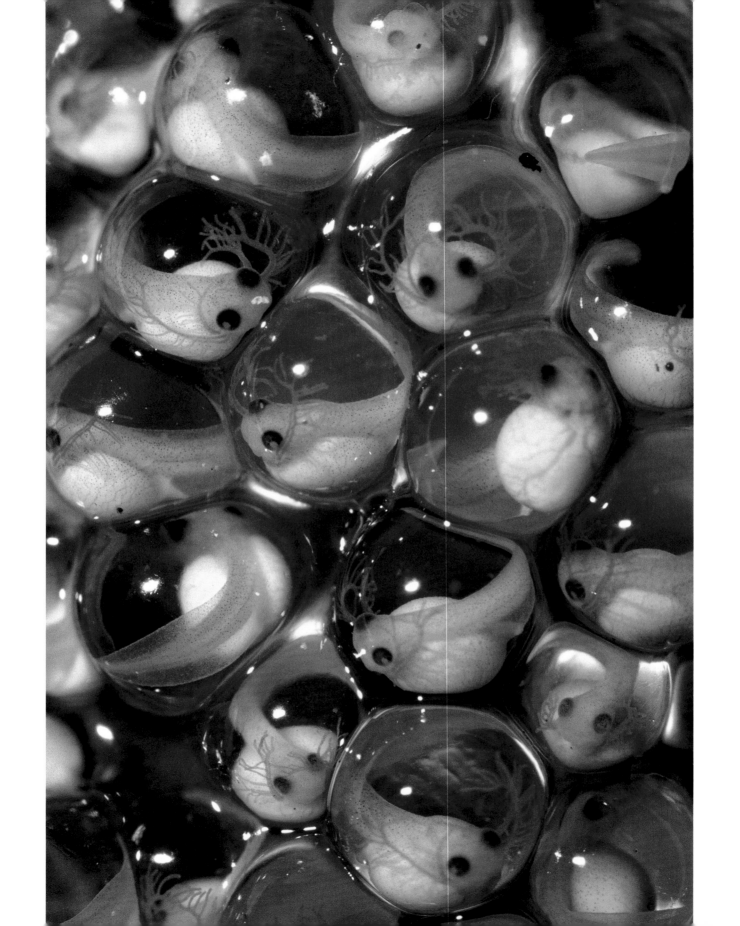

' Most rainforest activities happen out of sight, either hidden or because they take place in miniature scale. A camera can give us insight, but for every glimpse gained, there are hundreds of shots that fail, when the crucial moment is missed or the technology doesn't work. And that's the challenge. '

LIFE'S LITTLE WONDERS

I love the way the little embryos are just hanging there, looking out. The clutch of eggs is glued to the underside of a leaf about five feet over a pond in the rainforest. When they are old enough, the tadpoles will drop into the water below. I normally only ever see red-eyed tree frogs up in the canopy, but on moist nights at a certain time of year, the males and females climb down close to ponds to mate and lay spawn. These eggs are four days old – old enough to feel the vibration of a snake attacking the clutch, which they can distinguish from the wind, and to hatch prematurely and drop to safety. The picture is a simple one, but when I look at it, I still marvel at the wonder of it all.

Barro Colorado, Panama, 2000; Canon EOS 1, 100mm macro lens, 1/60 sec at f16, Fuji Velvia 50.

CHRISTIAN ZIEGLER

FRUIT BAT SNACK

For years I'd tried to photograph bats feeding on figs up in the canopy. As soon as I'd locate
a tree with figs about to ripen, I'd rig up a crane. But figs ripen together. So the chances of
a bat coming to the fig my camera was focused on were minimal. In the end, I made use
of a huge flight cage that the bat scientists had built in the rainforest on Barro Colorado to study
how bats find fruit. Bats will fly long distances between food and roost, often further than birds,
and ripe figs attract them from miles away with blasts of perfume. After grabbing a fig, a bat
flies off to eat it in a safe place, away from snakes and other predators that may be lurking in
a fruiting tree. It squeezes out the juice, discards most of the rest and, in flight, defecates any
seeds it's swallowed. This makes bats important seed-dispersers in the forest. I wanted to show
the energy of the moment when a bat takes a fig. To freeze the wings of this big fruit bat but
throw an even light on it, I used a low flash from six strobes. It took a week to get the lighting
right, but in the end, the colour and composition were exactly as I visualised they might be.

Barro Colorado, Panama, 2006; Canon EOS 5D Mark I, 16-35mm lens, 1/200 sec at f18, ISO 100.

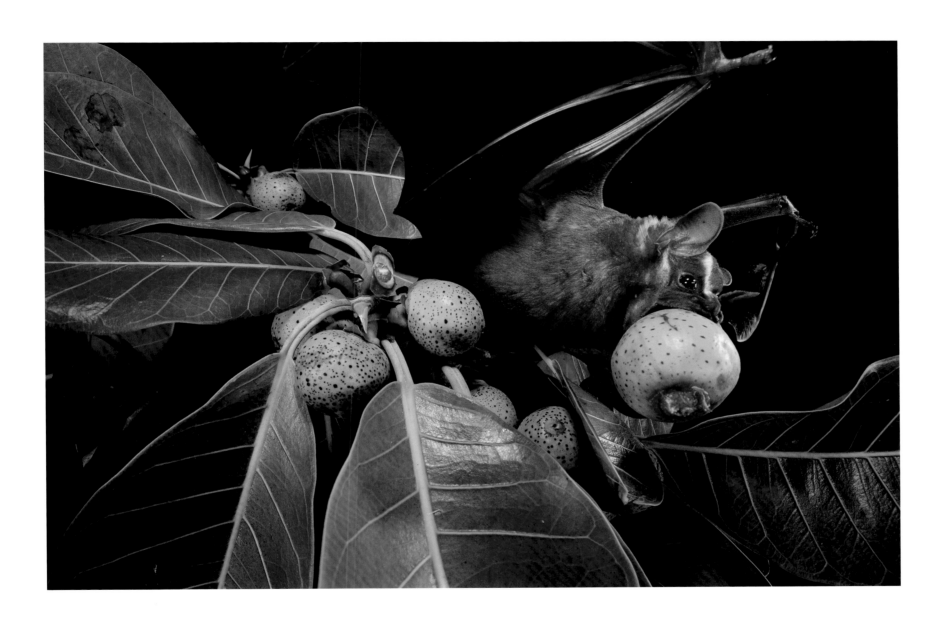

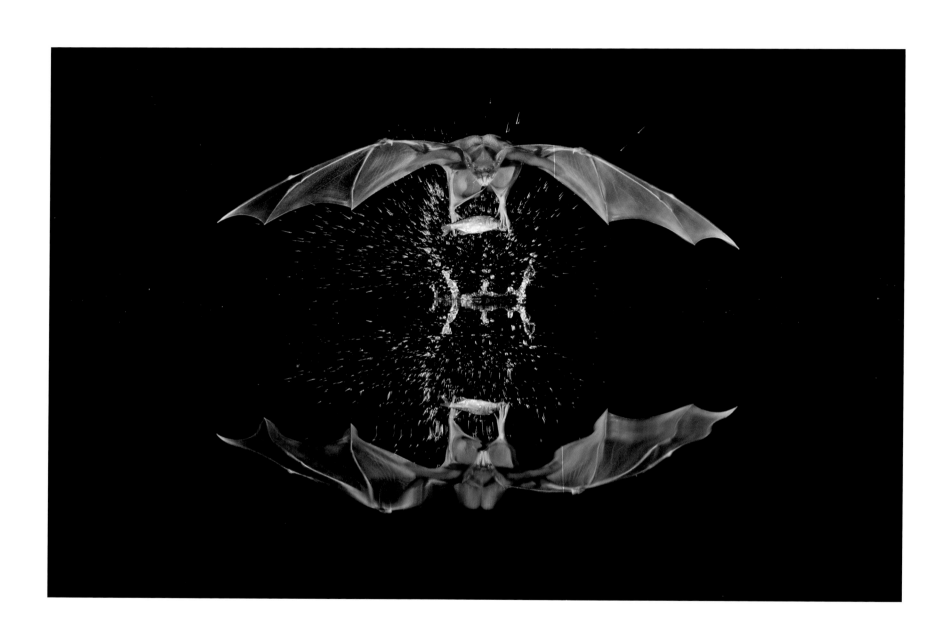

' I see my role as an educator. There are so many incredible stories out there to tell. I want people to see not only how truly amazing the natural world is to see but also why a healthy environment is so important for humans. '

PERFECT TRAWL

The greater bulldog bat is ugly – hence the name. But it's one of my favourite bats. It fishes on the lake surrounding Barro Colorado Island, using its long claws like rakes to collect insects on the surface. It also catches minnows. The bat researchers had created a small lake to study the bats' sonar more easily. I made use of it. But getting the set-up right took weeks. The bats fly in fast and low, scanning for the bumps of fish lying close to the surface. I wanted perfect symmetry in the shot. In the end I used nine flashes. Three were fired from above and one from behind. Five faced the possible flight path – two straight on, two low down and close to where it would catch a fish, to get the underside of the wings, and one low shooting along the water under the camera. I thought the bats would never catch a fish. They have habits – one just hung up beside the water and watched. So I had to bet on a favourite fishing spot and then try many, many times. But in the end I got the shot, showing a bat doing something that is absolutely amazing.

Barro Colorado, Panama, 2006; Canon EOS 5D Mark II, 70-200mm lens, 1/200 sec at f16, ISO 100.

CHRISTIAN ZIEGLER

REFLECTION ON HUMANITY

This picture would not have been possible
just a few years ago. To get enough natural
light from a black animal in a dark rainforest
needs an ISO of up to 6000. I was able to get
such an intimate shot because the bonobo
is one of a community that's been studied
for more than 10 years by scientists from the
Max Planck Institute. The institute has also
bought out the hunting rights at its field site
in Salonga National Park. Elsewhere in the
Congo Basin, many bonobo populations have
disappeared, and it's very much endangered.
The bonobo is genetically our closest relative –
a very gentle, intelligent one. After a month
of travelling with this group, they knew
I would show up every morning, and they'd
let me get really close some days. It was
a wonderful situation to be in. This young
female is taking a nap after a big meal and
after eating clay – the lipstick on her mouth –
to compensate for a bellyful of unripe fruit.
She's looking at me. I would have loved to
know what she was thinking.

Salonga National Park, Democratic Republic of
the Congo, 2011; Canon EOS-1D Mark IV, 300mm lens,
1/160 sec at f5, ISO 4000.

THE NECTAR BAR

Sitting in the crown of a flowering balsa tree is the closest I've ever got to the feel of an African waterhole. The tree starts flowering in late October when there's little other food in the forest, and everyone who eats fruit and nectar is very hungry. The flowers are in the top of the crown and open for business at dusk. So I built scaffolding 100-feet tall alongside three different flowering trees, set up my remote camera next to a new flower every night, fixed lights and a cable release, and sat about 25 feet away in the dark. It was just wonderful sitting high in the canopy, listening to the jungle sounds of the night and waiting to see what would happen. The first to arrive would always be a woolly opossum. It's the smallest of all the non-flying mammals that come to drink and gets chased out of the tree by everyone else. So it comes at sunset, when the others are still asleep, and laps up as much nectar as it can while the goblet is full. After about 45 minutes, the common opossum arrives, which is much heavier and mean. Half an hour later the kinkajou turns up and chases off everyone else. I wanted a picture showing a tongue. So for this shot, the lens is in the flower. The kinkajou wouldn't get near the camera. But though the woolly opossum was at first scared away by the click of the shutter, when I wrapped fabric round the camera to muffle the noise, that did the trick. Bees had drowned in the nectar of this flower, and it lapped them up, too. For me, this is a particularly intimate portrait – a rare glimpse of a life that we seldom get to witness.

Soberania National Park, Panama, 2012; Canon EOS 5D Mark II, 17mm f2.8 lens, 1/30 sec at f22, ISO 400, 4 flashes.

CHRISTIAN ZIEGLER

THE NECTAR GOBLET

Kinkajous seem to spend more time drinking than the other evening visitors that come to the balsa bars. Here a kinkajou is about to bend a flower like a wine glass before sticking its head in and drinking it dry. Its pollen-dusted cheek shows it's had at least one drink already. To get the shot, I had to have a 25-foot boom-pole built, which I hauled up the scaffold. But a counterweight was needed for the camera, and the pole ended up being so heavy that it had to be wheeled out on rails on the scaffold. Each day I'd choose one of the 50 to 60 flowers likely to open in the crown and move the boom-pole near it, with a live cable link to the laptop so I could see the frame and trigger the camera. As well as two flashes, I placed an additional light over the tree, using 20-feet of PVC plumbing tube, and used two lights to illuminate the background. It's a portrait that for me sums up the character of this little mammal in its hidden world high in the canopy.

Barro Colorado Island, Panama, 2009; Canon EOS 5D Mark II, 16-40mm lens, 1/100 sec at f18, ISO 400, 4 flashes.

' The biggest excitement is getting to know individuals. I really enjoy that – to partake in their day. What's going on in their world? It's selfish really, but I just love being there. '

FATHER'S BIG CHICKS

Cassowaries have a reputation for being nasty. I wanted to show them as awkward but sweet – to collect sympathy points by showing family life. They only attack if they feel threatened. This male is a bit cranky, but then he's just being territorial. And he has chicks to look after, for at least a year – here they're about four weeks old. I used a remote camera with a pocket wizard that would allow me to be up to 150 feet away, so as not to annoy him. To bring out his colour, I used three flashes, one on the camera and two on the ground off to the sides. This picture was my favourite out of 200 taken over six days while a pandanus tree was fruiting. The family came every afternoon to the same spot to eat segments of these huge fruits – a colourful stage for a characterful family portrait. I can recognise this male by his casque. No one knows what a casque is for. It could be to do with the subsonic booming calls cassowaries make, or it could just be a protective helmet – they mostly walk around with their heads down as they move through dense vegetation. Head down is certainly how I will remember these huge, crazy birds.

Inisfail, Queensland, Australia, 2011; Canon EOS 5D Mark II, 16-35mm lens, 1/40 sec at f8, ISO 640, 3 flashes, remote.

WILDLIFE PHOTOGRAPHER OF THE YEAR

is the world's longest running and most prestigious competition championing the art of photography featuring wild places and wild species. It is owned by the Natural History Museum, London, and BBC Worldwide.

www.wildlifephotographeroftheyear.com

A FIREFLY BOOK

Published by Firefly Books Ltd. 2013

Copyright © 2013 Natural History Museum, London
Photographs Copyright © 2013 the individual photographers

First printing

Publisher Cataloging-in-Publication Data (U.S.)

A CIP record for this title is available from the Library of Congress

Library and Archives Canada Cataloguing in Publication

A CIP record for this title is available from Library and Archives Canada

Published in the United States by Firefly Books (U.S.) Inc.
P.O. Box 1338, Ellicott Station
Buffalo, New York 14205

Published in Canada by Firefly Books Ltd.
50 Staples Avenue, Unit 1
Richmond Hill, Ontario L4B 0A7

Printed in Italy by Trento Srl

First published by the Natural History Museum,
Cromwell Road, London SW7 5BD

Writer and editor:
Rosamund Kidman Cox

Designer:
Bobby Birchall, Bobby&Co Design

Colour reproduction:
Saxon Digital Services UK

JIM BRANDENBURG
USA
WWW.JIMBRANDENBURG.COM

DAVID DOUBILET
USA
WWW.DAVIDDOUBILET.COM

PÅL HERMANSEN
NORWAY
WWW.PALHERMANSEN.COM

FRANS LANTING
USA
WWW.LANTING.COM

THOMAS D MANGELSEN
USA
MANGELSEN – IMAGES OF NATURE
WWW.MANGELSEN.COM

VINCENT MUNIER
FRANCE
WWW.VINCENTMUNIER.COM

MICHAEL 'NICK' NICHOLS
USA
WWW.MICHAELNICKNICHOLS.COM

PAUL NICKLEN
CANADA
WWW.PAULNICKLEN.COM

ANUP SHAH
UK
WWW.SHAHROGERSPHOTOGRAPHY.COM

CHRISTIAN ZIEGLER
GERMANY
WWW.NATURPHOTO.DE